Personal Exposures

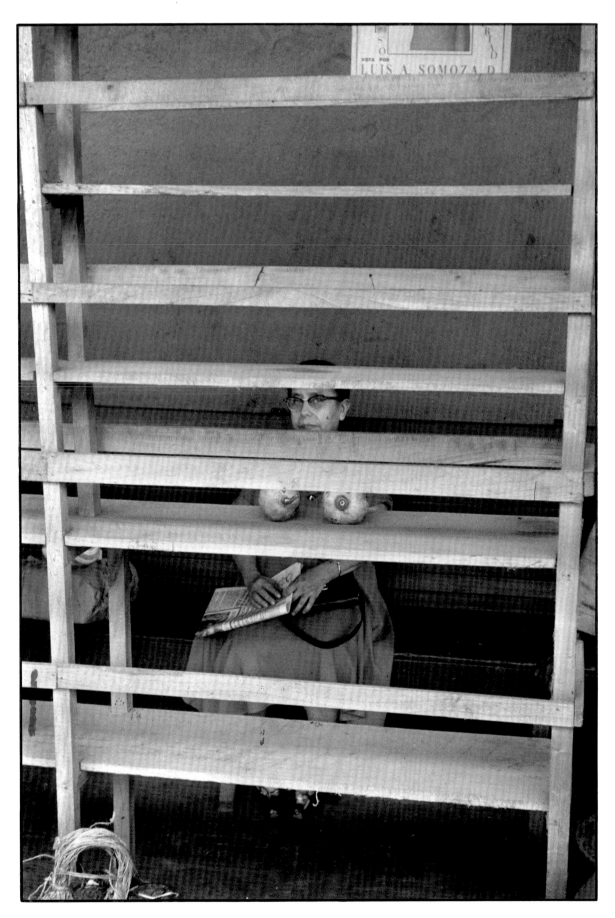

Managua, Nicaragua, 1957

Elliott Erwitt | Personal Exposures

W. W. Norton & Company · New York London

Published simultaneously in Canada by Penguin Books Canada Ltd, 2801 John Street, Markham, Ontario L3R 1B4

Printed in Switzerland by Imprimerie Jean Genoud SA.
Book designed by Katy Homans

ISBN 0-393-02616-7

W. W. Norton & Company, Inc., 500 Fifth Avenue, New York, N.Y. 10110
W. W. Norton & Company Ltd., 37 Great Russell Street, London WC1B 3NU

5 6 7 8 9 0

Library of Congress Cataloging-in-Publication Data

Erwitt, Elliot.
 Personal exposures/Elliott Erwitt.
 p. cm.
 1. Photography, Artistic. 2. Erwitt, Elliott. I. Title.
TR654.E76 1988 88-19581
779'.092'4—dc19 CIP

2 0 0 6 0 0 4 0 2 0

For my wonderful children—Ellen, Misha, David, Jennifer, Sasha, and Amy—
who have had to endure my checkered life...and for my other friends and
colleagues who have helped me to retain my sanity and to assemble this book,
which was hatched in difficult times...and for all the people who have
influenced my personal outlook, from Benito Mussolini, who chased me out
of my country when I was young, and for Nicephore Niepce, without whom
my life of photography would have been impossible.

Dedication

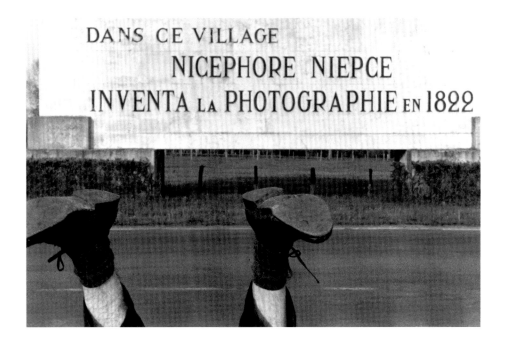

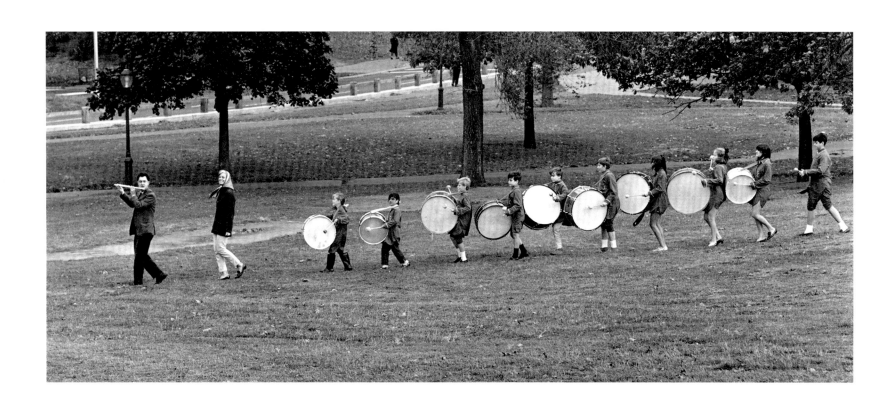

MAKING PEOPLE LAUGH IS ONE OF THE HIGHEST achievements you can have. And when you can make someone laugh *and* cry, alternately, as Chaplin does, now that's the highest of all possible achievements. I don't know that I aim for it, but I recognize it as the supreme goal.

When photography is good, it's pretty interesting, and when it is very good, it is irrational and even magical...nothing to do with the photographer's conscious will or desire. When the photograph *happens*, it comes easily, as a gift that should not be questioned or analyzed.

Sometimes, humor is in the photograph, not in the scene you photograph. I mean, you can take a picture of the most wonderful situation and it's lifeless, nothing comes through. Then you can take a picture of nothing, of someone scratching his nose, and it turns out to be a great picture. What occurs in a scene, in a situation, and what you get in the photograph can be totally different.

People tell me I'm good at visual puns. I guess that's true. I also enjoy verbal puns. Some people hate them; I love them. When I get together with my friend Murray Sayle, a wonderful writer, we drive everybody crazy; we're impossible. I don't know why puns are funny. I don't know what humor is. That would be something, wouldn't it? To understand what humor is and to be able to produce it at will.

Some people say my pictures are sad, some think they're funny. Funny and sad, aren't they really the same thing? They add up to normality.

The camera puts a barrier between me and the experience. Once, I had an assignment to photograph cancer surgery. The day before the shoot, I went to see the procedure so I'd know what to expect. When they started lifting out the bloody lung, the surgeon saw I was about to faint and asked me to leave. But the next day, with my camera in hand, nothing bothered me. Whatever was gruesome, or frightening, was being taken in by the camera. I was on the other side.

In general I don't think too much. When I talk about my pictures, I have to think a little bit, and I'm honest, but I don't know what's really from me or what I've heard from someone else or just where the words are coming from.

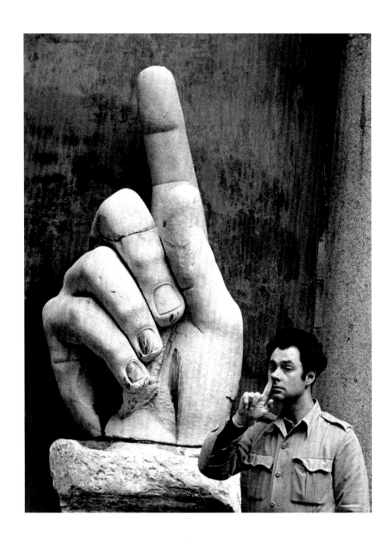

I certainly don't use those funny words museum people and art critics like. Things should be left open to interpretation. If you can take it apart, maybe it doesn't mean anything.

I got stuck with the term "anti-photos" for my pictures. It was the invention of a clever copywriting friend. I thought it was an amusing catch phrase, and it did get attention. There was also Malraux's famous book *Anti-Memoirs*, and that sounded pretty intellectual. Quite a few people remember my "anti-photography," so the term fulfilled its purpose. But I don't use it anymore. It's behind me.

For forty years, I've taken my personal "snaps" because I like to. Suddenly, about twenty years ago, they became valuable. Not just mine, of course. The same Ansel Adams prints that had been selling for a few dollars in Yellowstone and Yosemite gift shops went up to twenty thousand dollars a print in fancy galleries and at auctions. Then another phenomenal thing happened, until the

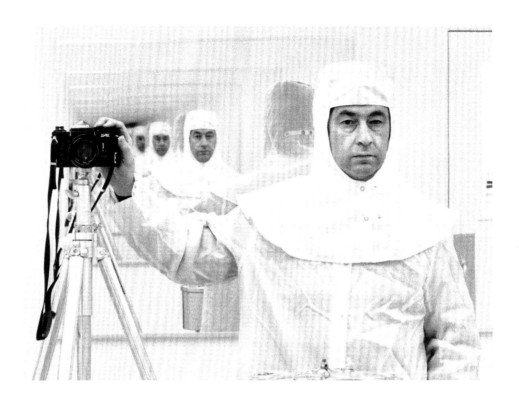

IRS clamped down on it. Brokers would buy prints in quantity for people who were looking for tax shelters, and these people would hold on to them for a legally specified time and then donate them to an institution, a library or museum. That windfall bought my house in East Hampton, New York.

Of course, people sometimes buy my pictures because they actually like them.

Maybe this should be a secret: photography is a lazy man's profession. You don't have to train, like a musician or a doctor or a ballet dancer. You only need the modest ability to achieve order and composition, or find the right balance of mood. And, occasionally, you may reveal a message in what you do. That is sufficient. Being in the right place at the right moment can also help.

There are two compositions. There's the composition framed by the viewfinder, and there's the composition in the picture, the dynamics of it. The second one can be there even if the first one is badly organized. So I'm not against cropping, when it's really necessary. Some people have a fetish about it, but it's not immoral to crop. Of course, it's better if you don't have to, if you find the picture's dynamic composition and marry it to the composition in the viewfinder.

I never forget Flaubert's statement: "A work of art is never finished. It is merely abandoned."

I rarely stage pictures. I wait for them...let them take their own time. Sometimes, you think something's going to happen, so you wait. It may pan out; it may not. That's a wonderful thing about pictures—things *can* happen. It's not that I'm against staging, or anything else, when you're not cheating or working with false purposes. Even as you wait, you are, in a way, arranging and manipulating. You're getting ready to frame the event, when it happens, the way you want it to be framed. Maybe I'm contradicting myself. Well, okay.

Everything in photography can and should be technically good these days. You have enormous choices in easy-to-use equipment. You still have to adapt the tools to the situation, but there's hardly anything that isn't easily attainable and of high technical quality.

There are an awful lot of competent photographers, but not so many good ones. You can develop skills and attitudes, but you probably can't learn how to take really fine pictures if you don't have the gift. I suppose, say, you could do a great many interesting things with eggs, given the right context; I mean, a lot of people photograph eggs and flowers. But to take something that has lasting value, you have to go out into the world. Obviously.

I don't think people should spend their lives testing lenses or in the darkroom or should necessarily make all of their own prints (I don't any more), but I do think you owe it to the craft to learn and understand the technical aspects even now with the advent of the microchip. I can make a very good print, or I can give someone else directions that will yield the exact result I want. I'm not one of those photographers who say, "I don't know what I want, but I'll recognize it...."

The dedicated photographer works with his *own* sensibility, instincts, and experience. He stays curious about everything visible. He looks, looks some more, and then looks again, because that is the fundamental basis of photography. And that's all...just looking and making your own unique connections. (Well, then, of course, you have to hope that Providence will wave his—or her—magic wand and make it real and good.)

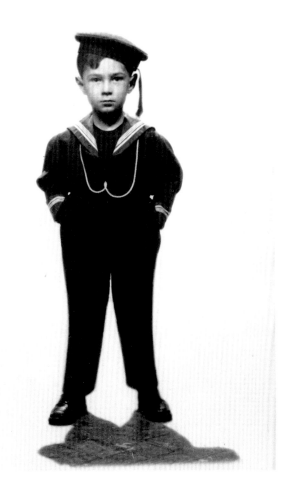

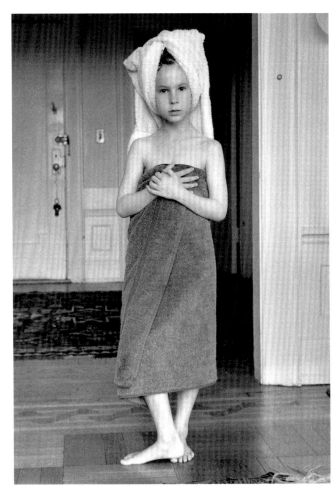

Elliott Erwitt, age 5.
Daughter, Amy, about the same age.

THANKS TO BENITO MUSSOLINI, I'M AN AMERICAN. MY parents had to leave Russia after the Revolution. I was born in France, and named Elio Romano Ervitz—Romano, because my father had once attended the University of Rome. I guess he liked it. My first ten years were spent in Italy, but Fascism drove us out in 1938. I wound up with my father in southern California, in Los Angeles in 1941. My mother eventually followed and still lives there. The marriage was long over.

I'm not aware of artistic influence in my family. Back in Italy, my father tried to be an architect after graduating from the university. That didn't put food on the table, so he went into business. At about age sixty-five, he became a photographer. He said he wanted to follow in his son's footsteps! And he's not bad, not bad at all. In 1960, my mother went to a school in Los Angeles to learn painting. According to the family, her grandfather was a minor seascape painter in Russia. He'd do a horizon line and about three feet of sea, chop it off, and sell it. My

11

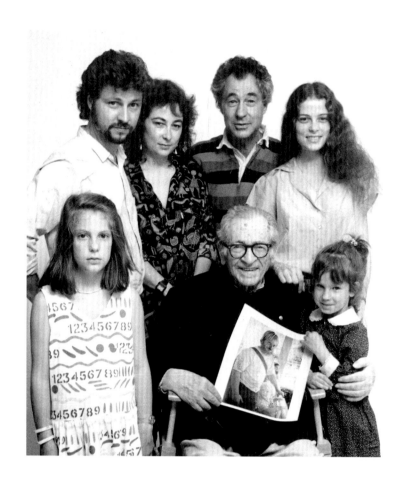

oldest son is a damned good New York–street-wise photographer. So there may be a loose cannon in our genes somewhere.

Immigrants are different. If you've had to change countries and languages a number of times, as I have, you get toughened up. You can take a lot of things that might cave in people who haven't had those experiences. I have four languages, and that's a big help in the thinking process of my profession. It's unpleasant when you're going through it, the change in languages, but long-term it's marvelous.

My parents are unusual. My father's career has included selling furs, making electrical objects for the Italian navy, working in a factory in the Bronx, importing European antiques to New Orleans, and taking portraits of people. He's always lived modestly and got by. He was a socialist and blames my mother for having to leave the Promised Land of the Soviet Paradise. In Japan in the 1950s, he was ordained a Buddhist priest. My maternal grandfather was Jewish; my maternal grandmother was devoutly Eastern Orthodox. She starved to death in

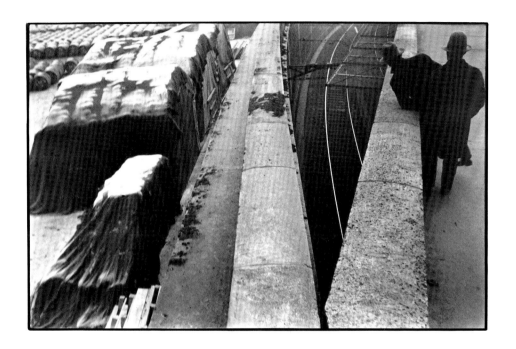

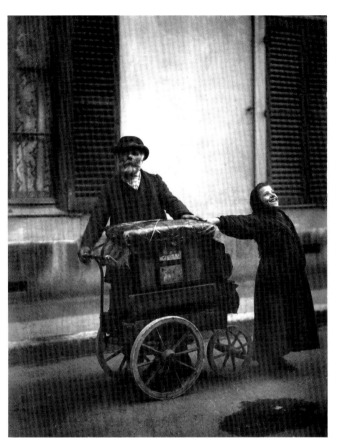

France during the Occupation. My mother was embarrassingly rich as a young girl. Here, in the U.S., in her later years, she was a practical nurse treating alcoholics and terminal patients. She's never had one shred of self-pity. Not ever. Nor has my father. This is a marvelous quality.

Shyness helped to make me a photographer. In high school I discovered that a camera gets you into situations where you don't really belong. Then, it was proms; now, it's the White House or the back rooms of the Kremlin. My first camera was an antique glass-plate camera, which I bought more or less as an object in itself when I was fourteen or so. Because I had to begin supporting myself when I was fifteen, I found a darkroom job printing movie stars' photographs. I got a Rolleiflex, the camera of the day. Luminaries like Fritz Henle used it to take pictures of pretty girls in bathing suits. My dentist was my first customer, then came people's houses and children, then the senior prom.

Henri Cartier-Bresson's photo of a train depot...it jumped out at me from the pages of a book on technique. I was young and impressionable; I had never

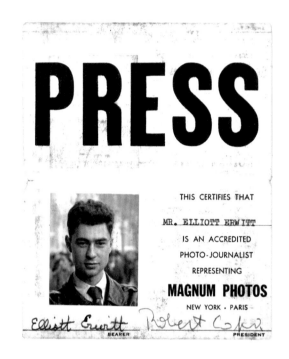

PRESS

THIS CERTIFIES THAT

MR. ELLIOTT ERWITT

IS AN ACCREDITED
PHOTO-JOURNALIST
REPRESENTING

MAGNUM PHOTOS
NEW YORK · PARIS

Elliott Erwitt Robert Capa
BEARER PRESIDENT

reacted to a photograph like that before—the mood, the tight rectangular com-
position, the casualness of it. It was a scene available to anyone. You didn't need
models, you didn't have to set anything up, and you didn't need anything special
except your own personal equipment for noticing things. That was an interesting
way to go, I thought. It was a revelation. And the wonderful picture by Atget of
the organ grinder and singer was the other photograph that sent me on my
irrevocable way.

And there was Modigliani. In fact, I wanted to *be* Modigliani. The glamor of the
bohemian life was part of it. And I thought his drawings were superb, even more
interesting to me than the paintings. See, color has never interested me, even in
the beginning. It was his line, instead, and his composition. And those long
necks. I liked those long necks. Still do.

I left southern California because, for me, nothing was happening there. In New
York, I found Steichen very helpful; he arranged my first commercial job. I also
met Robert Capa, who was running this little agency I'd never heard of, founded
by a group of photographers. I was off to the army, and Capa told me to look him
up in Paris sometime. While I was in the service, stationed in France, I showed
him some of the work I was doing for magazines. When I got out of the army in 1953,
I had learned what a select, prestigious outfit Capa's Magnum agency had become.
I took off my uniform and signed up with Magnum about twenty minutes later.

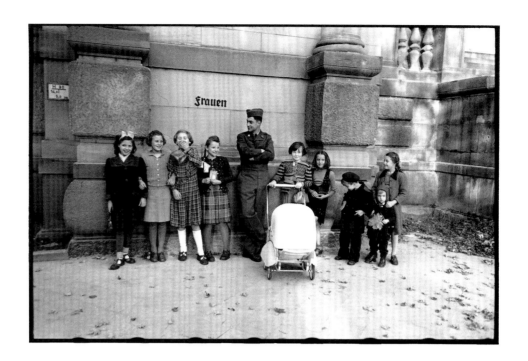

I free-lance. I couldn't survive otherwise. Always, the idea of working for
someone else on a regular basis was just horrendous to me. I need to be in
charge of my own time. It's odd that I have such strong feelings about this, really,
because I've only had three jobs in my whole life. In high school, I worked in a
darkroom and I tried being a soda jerk, but I was soon fired, for some reason or
other. Then there was the army during the Korean War. My friends all thought I'd
be fired from there; in fact, I surprised everyone, including myself. I had a
wonderful time. My tests showed that I should be an anti-aircraft gunner. All of
those positions were closed, and I was made a darkroom assistant with a Signal
Corps photo company. Half went to Korea; I was in the half assigned to Europe.

My first important recognition came while I was still in the army. I always
carried around a Leica with a collapsible lens in the pocket of my fatigues. I had
lots of pictures of soldiers just lounging around. *Life* magazine had a contest,
and my winner was "Bed and Boredom," a little story of army life including the
shot of a private lying on his bedsprings, looking bored and maybe annoyed with
life. I won $1,500, an astronomical amount at the time. I bought a little car and
named it "Thank you, Henry," for the publisher, Henry Luce. The commanding
general wrote me a letter of congratulations, and from then on I was treated with
respect by my sergeant. See how a picture can change your life?

I BARK AT DOGS. THAT IS WHY THE LITTLE DOG IN ONE OF my photographs has jumped straight up into the air. A lot of people ask about that. Well, I barked. He jumped. I barked. He jumped.... Once I was walking down a narrow street in Kyoto behind a lady who was walking a dog that looked interesting. Just to see, I barked. Immediately, the lady turned and kicked her bewildered dog. I guess we had the same kind of bark.

My first published dog picture was taken in 1946. I don't remember the circumstances or what I had in mind. Probably nothing special. The dog looked funny. Every so often, I would go over my contact sheets to see what was on them, and I noticed that there were a lot of dogs. That's how the dog business started. One of the first dog-related jobs was for a *New York Times Sunday Magazine* fashion assignment about women's shoes. I decided to photograph them from a dog's point of view because dogs see more shoes than anybody.

The dog in the cemetery with the skull... I wondered if that was too tricky for the book. I was filming one of those mystery house parties in England, a kind of Agatha Christie weekend where actors act out murders for you to solve, and other spooky things. For one of the scenes, I had a dog trained to dig up a skull in the cemetery. Of course, he happens to be licking his chops in the picture. I didn't set up that part.

One of my wives thought I saw myself in the dog pictures. She thought I identified with them. Maybe. Maybe. She was a very clever lady. All of my wives have been beautiful and smart. That may sound like bragging, but it's so.

The dog pictures work on two levels. Dogs are simply funny when you catch them in certain situations, so some people like my pictures just because they like dogs. But dogs have human qualities, and I think my pictures have an anthropomorphic appeal. Essentially, they have nothing to do with dogs... I mean, I hope what they're about is the human condition. But people can take them as they like.

If somebody likes what I do on *any* level, that's fine with me.

I prefer to photograph French dogs. They have personality, although I can't explain why... not a single national personality, but personality *period*. I cer-

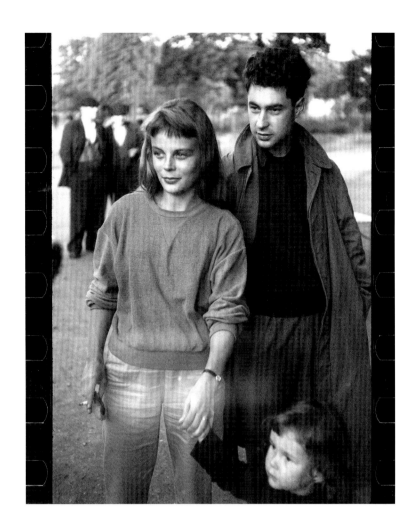

tainly wouldn't travel to Central or South America especially to photograph the dogs, just because they are the most miserable creatures on earth, but when I am there I generally put aside some time for that.

I'm thinking of doing another book about dogs...but only *working* dogs. I want to include dogs who are professional companions to people, who have to travel around in taxis, who are ashamed when they have to sit up and beg. Dogs that work in security, farming, medicine, training, police, space exploration, theater, armed forces, interior decorating, as mascots, etc. Working dogs. Why should they be different from us?

TO MY DELIGHT, I'VE DISCOVERED I HAVE A FOLLOWING ...people I never imagined. College students tell me they saw my pictures in a book, and they found a direction for their own work. To have an effect on someone...that's a wonderful thing. Maybe it's just a little insight into a different

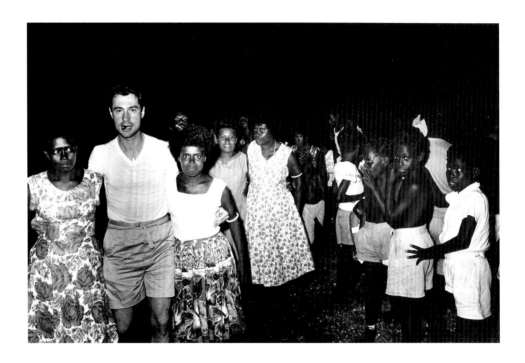

sense of life, or an attitude, or a way of looking at things. That's how Cartier-Bresson's picture of the train depot helped me.

If my pictures help some people to see things in a certain way, it's probably to look at serious things non-seriously. Everything's serious. Everything's not serious.

You know how people race through the Smithsonian, going like an express train because there's so much to see. I had a big exhibit there, and I went often to count the house. People would rush through my hall until about half or a third of the way through...and then they'd suddenly stop, and start all over again, because something didn't seem quite right. Their eye hadn't caught the whole picture right away. They'd go back, and then it was just marvelous....People laughing, being interested in a way that was very rewarding to me. Terrific reaction! I loved watching people race in, stop, and start all over. I went back several times.

YOU DON'T HAVE TO FIGHT YOUR CAMERA, OR EVEN reason with it. You just get behind it, point it,...and always remember to use a long lens at sunset.

Very good things come from leisure and contemplation. Photography is nothing more than intense leisure and contemplation that end up in a good black-and-white print properly fixed and rinsed so that it doesn't fade too soon.

Or, as Napoleon said, *"On s'engage et puis on voit."* ("You engage in battle and see what happens.")

The work I care about is terribly simple. I observe, I try to entertain, but above all I want pictures that are emotional. Little else interests me in photography. Today, so much is being done by unemotional people, or at least it looks that way ...I mean, work that's fascinating and fun and clever and technically brilliant. But if it's not personal, then it misses what interesting photography is about.

Finding a gentleness in my pictures, that's about the highest compliment I've had. Certainly, you can't avoid taking cheap shots sometimes, but you ought to throw them away.

I'm not interested in landscapes. Just people. I like plastic flowers.

I have a strong attraction to the American South. People there have this marvelous exterior—wonderful manners, warm friendliness—until you touch on things you're not supposed to touch on. Then you see the hardness beneath the mask of nice manners. But I love that surface, because, being a photographer, I deal with surfaces more than anything else. What *appears to be* is what I deal with.

I use the rectangular format because the proportion of 1 to 1½, close to the "golden section," seems particularly right. In almost everything, including architecture, it's more pleasing to the eye. It's also the 35-mm format, of course.

There's a profound difference between the simple non-reflex, direct-viewing camera (such as a range-finder Leica) and a single-lens reflex. With a reflex, you tend to make the picture in the camera; with the other, you have to see the picture and then put a frame around it. The range-finder camera is also faster,

quicker to focus, less noisy, and smaller, but these advantages are much less important than the fundamental difference.

Simplicity. I have a large arsenal of equipment for my professional work, but for my informal pictures I mostly use a 50-mm lens, sometimes a 90-mm. I work within a narrow range. I like to work with only one kind of film at a time, because I get confused easily. When I mix films, I often make a mistake and shoot with the wrong one. Tri-X is the most useful to me. I don't like to make tests. I like for other photographers to make the tests and give me the results. I believe them. As for extreme wide-angle lenses or telephoto lenses or pinkish graduated color filters and so forth, they're to add interest where there is no interest. You may get a clever result that has nothing to do with observation. I've done lots of tricky, gimmicky stuff on commission, but that's Work and it can be fun, but it is a totally different mind-set, little more than creative obedience.

I don't keep color pictures for my "personal exposures." Color is for Work. My life is already too complicated, so I stick to black-and-white. It's enough. Black-and-white is what you boil down to get the essentials; it's much more difficult to get right. Color works best for information.

I don't follow anyone's system of philosophy, but famous phrases come to mind, sometimes about how to work. I never forget the advice of Field-Marshal Ferdinand Foch of France; "Time spent on reconaissance is seldom wasted." Here's another: "The most important advice to photographers is f:8 and be there." I'm not sure who said that. Let's call him "an unidentified deceased photographer." It's good advice. And finally, (Red) Baron Manfred von Richthofen's classic reply for success (in his line of business): "*Erst muss man den inneren Schweinehund besiegen*" or "First you must overcome the inner *Schweinehund*." Presumably once you have overcome the inner *Schweinehund*, all the other *Schweinehunde* are duck soup.

Ideas, wonderfully entertaining as they can be in conversation and seduction, have little to do with photography. Photography is the moment, a synthesis of a situation, an instant when *it all* comes together. That's the elusive ideal.

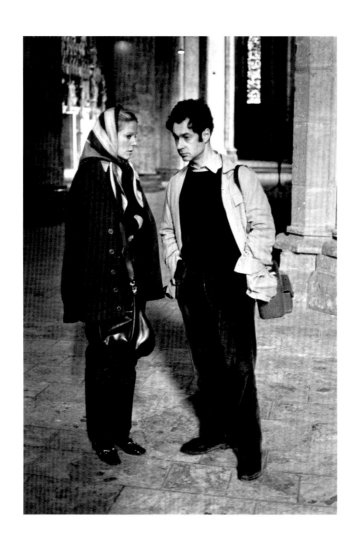

GOOD VISUAL SENSE PROBABLY CAN'T BE TAUGHT, NOT AT a profound level. It's eye, but it's also heart. I believe I have a good visual sense of other people's pictures, yet sometimes I don't really see my own pictures right away. Years later, after I've passed over stuff and thought nothing of it, I look again and see that some of it is pretty good (or that some of what I thought was good is pretty lousy). I just hadn't recognized it yet. Boy, I wish I knew why that was. Did I change? Did the picture change?

You can't be arrogant with the gift of visual sense. You're not seeking out some rare bird; you're taking photographs for other people to see. You want them to see what you see. So, while you recognize that you may have an unusual talent, you can't make the mistake of patronizing, of assuming that few people will really appreciate what you do. At all points, the public should be able to understand what you've done even if they don't understand how you've done it.

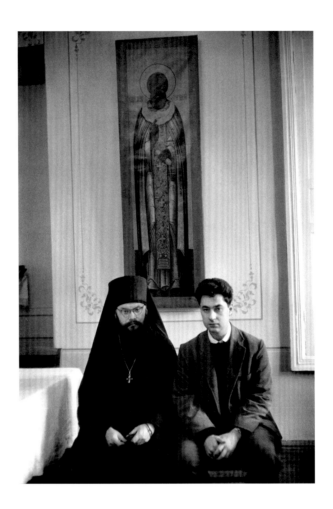

Unfortunately, most people are insecure about judging or reacting to pictures. They gravitate toward what's familiar, established, safe. That's true even of some "experts," editors who are paid to read contact sheets and pick occasional good pictures out of a whole mass of lousy ones. They don't know how to look. Or they're unsure of what they see. But it's just as true that there are ordinary, nonsophisticated people who often are unusually insightful about visual things.

MY PICTURES ARE POLITICAL IN A WAY. THEY ARE intended to comment on the human comedy, and isn't that politics? If I were asked whom I dislike more, Nixon or Johnson, I'd be hard-pressed to give a clear-cut answer. Johnson was the embodiment of vulgarity, but does that show in the pictures? You tell me.

Nobody was more anti-Nixon than I was, but I took a picture that some people think was very helpful to him. Westinghouse had sent me to photograph their refrigerators in 1959 at an industrial exhibition in Moscow. Naturally, in the

Soviet Union, I was trying to see ten other photographic possibilities at the same time. Vice President Nixon was in town, rather stupidly saying things like "You eat cabbage and we eat red meat." Khrushchev got so annoyed he said, "Go screw my grandmother," an old peasant expression that sounds less offensive in Russian than in English but still means "Stuff it." (That was the true intellectual level of the famous so-called kitchen debate.) Nixon was playing for the U.S. press. Khrushchev was just being himself, because at that time the Soviets didn't have much press coverage of this informal type and didn't really understand public relations. My photograph delighted the Nixon crowd, of course, and possibly started William Safire's political career. He was doing PR for Macy's, but he saw instantly that this photograph could give Nixon the image he wanted, as the one guy "tough" enough to stand up to the Russians. Someone got hold of a print and it was used everywhere in the 1960 campaign...*without my permission*. I was angry, but I couldn't do anything about it. A few years ago, there was a reunion of the kitchen-debate alumni in Washington, and the *New York Times* photographed Nixon and me (I took the part of Khrushchev) recreating the scene. I don't hold grudges.

I went to several of the shah of Iran's coronations. After a while, he'd crowned himself so often that he couldn't get Grade A people to attend, just movie starlets, bank officials, and so forth. He got to be like Imelda Marcos, giving a big party. The shah's best one was at Persepolis, for the supposed five thousandth anniversary of the kingdom. Everybody remembers the special tents they set up, but you weren't permitted to stay in one unless you were a chief of state or a hairdresser. That's the truth. Hairdressers for the wives of the chiefs of state—perhaps for the chiefs themselves.

I've seldom put the Marilyn Monroe and company picture on display, but people track it down. It's become one of my best-selling prints. Physically, she was surprisingly unattractive; the beauty was manufactured. But she was extremely intelligent and sensitive. And likeable.

Pierre Salinger and I had been a photographer/reporter team at *Collier's*; when he became JFK's press secretary he was able to get me a White House press pass, even though I didn't live in Washington—supposedly a requirement—and I was a frequent visitor on a variety of editorial assignments during his administration. After President Kennedy was shot, I very seldom used my old privilege.

The picture of Nixon walking casually out of his house is interesting in context. Eisenhower had just eaten the onion rings that gave him what seemed to be a heart attack. Naturally, the focus was on this nerd who might become president. It was my job to follow the vice president around for a few days... just in case, you know.

Pure luck got me the first pictures of the first Soviet missiles, in 1957, at the parade for the fortieth anniversary of "the great October Revolution." I speak some Russian and just insinuated myself with a Soviet TV crew, bypassing three rings of guards around Red Square. Of course, no foreigners were allowed, much less foreign photographers! I got the pictures, telephoned *Life*, and developed the photographs in my hotel room so the film wouldn't be destroyed by X rays at the airport. *Life* arranged for a darkroom team and set-up to meet me in Helsinki, where the pictures were printed in great haste and distributed as a world-wide scoop.

THE VERY GOOD PICTURES CAN HAPPEN ANYTIME AND anywhere. Even while working on a commercial assignment. Such little miracles, though, are not likely to find their way into the client's publication. Miracles are too often separate from Work, but hope springs eternal!

For Work, I like to use a large view camera when it is appropriate. You don't have to spend a lot of time editing, because you take just a couple of pictures. There's nothing unexpected; you know what the client wants before you do it. Often there is a drawing to follow or a storyboard. If it's an advertising job, you show the agency art director and the client a Polaroid equivalent or the video tape, and the rest is history. You get paid a lot of money, way out of proportion to the effort expended and the ability required. You're assured of success. That's earning a living. For fun, I want to emphasize, and for that rare, exceptional client, taking pictures is essentially looking for the unexpected. A kind of fishing, and the results are usually worth the risk.

Here's what some work is like. Once I was hired to do a funny essay on Mount Fuji. Climbing to the summit, you know, is supposed to be a purifying religious exercise; you should be there just as the sun rises. But as you climb up the day before, there's nothing but garbage, excrement. Sleazy concessions are there to

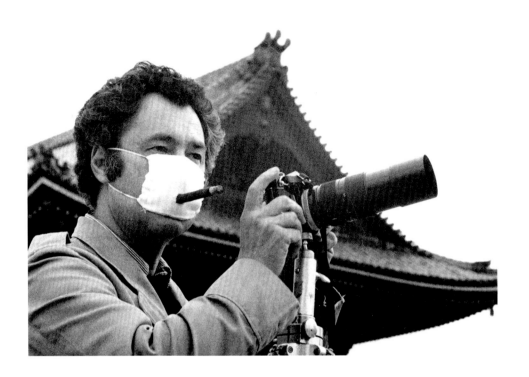

gouge you twenty dollars for a Coke or some noodles because you're hot and thirsty, that kind of stuff. Well, I took some funny pictures, I thought. When I showed the slides to the editors, they just said, "Very nice, very nice, but we hired you to take funny pictures." So I went through the carousel again, stopping to say, "See, this *is* a funny picture." The second time through, they agreed that it *was* a funny-picture story, and everyone was happy.

Nowadays there are fewer magazines where good pictures appear, and even these are corrupted by the need to make money, to be popular. Museums and galleries take up some of the slack, but they rarely have anything really interesting going on.

There's something aggressive about editors. They impose their taste on the public. Take a certain few slick magazines right now, with their celebrity photos, or the passionless erotic stuff that's around everywhere. . . . I'd call it aggressive to push one trendy, fashionable look, the visual fad of the moment. Photographers, if they want to work, have to perform. This year, maybe, many of the slick and perfect print ads, commercials, *and* editorial essays use blue smoke and graduated filters; you can't tell them apart, but they're all beautifully crafted. Next year, it'll be red smoke. Everybody will be the same again, but in a different way.

Why do some pictures get published all over the place? Not necessarily because they're better than others but because they're available and someone somewhere needs them. That's half the secret. You have to have an organization supporting you, making your work readily available....then it gets used, and you're recognized.

I'm unspecialized in a very specialized profession. Some commercial clients aren't quite sure how to take me. Some probably think I'm dead because I've been around so long. And then I was out of touch the last six years, concentrating on making movies. Maybe I can't be summed up. I hope so.

AVERAGE PEOPLE ARE QUITE RIGHT NOT TO WANT THEIR picture taken. I certainly wouldn't want someone poking a camera in my face. I try to be quick so the subjects won't notice. It's not that I feel any guilt, any sense of using people against their will, but I'd suffer a bit if I thought I was making anyone unhappy. (I might suffer more if I got beaten up.) Otherwise, everybody's fair game, so long as you don't hurt them.

It's almost embarrassing, but I do have one trick for taking portraits on commission. I carry a little bicycle horn in my pocket, and once in a while, when someone is sour-faced or stiff, I blow my horn. It sort of shatters the barriers. It's silly, but it works. Except...once I was photographing the board of directors of a megacorporation I won't name, and they were all sitting around a big dark table, mahogany paneling all around, looking grim, having their own thoughts and problems. I took out my horn and blew it. No one changed expression, except the PR man, who looked as if he was about to have a coronary. I was never asked back. But it worked on Khrushchev. I wanted him to turn around and relate to me. I beeped, he turned to the strange noise, and, click, I got the picture. Didn't bother him. Sometimes, I leave it in my pocket and go "beep-beep," and the subject doesn't know what to think. You see, the horn communicates something. It says that we both know that what we're doing together is kind of silly anyway, so we might as well make the best of it. It's nonverbal communication that leads to a better feeling. And I get a more human picture.

Of course, there's also the view of the ancient general Sun-tzu: "No plan survives contact with the enemy."

Only one person I can remember has ever been uncooperative in a portrait sitting. She was a dowager in Boston, one of those uptight nasty horsy ladies, and she took an instant dislike to me. Maybe she figured I was Jewish, or Catholic, or black, or something. Clearly unsuitable. In fact, she refused to be photographed further after I'd gotten off a couple of exposures, told me to go away, and complained to the client, *Vogue*. I never found out why. But that was one isolated case out of thousands. Really. Normally I have a very fast, good rapport with people when I am working.

AS A FREE-LANCER, YOU WORK TWICE AS HARD, BECAUSE when you're not working you're worrying about when the next job is coming, and looking for it. Some people can't stand the insecurity, but I've never been overly bothered by it. I've been lucky. I've been able to conduct my life living here in Manhattan, traveling around the world, taking pictures, printing them. I couldn't ask for more.

Commercial photography can be wonderful, because you need discipline, and some ability. Generally, you have to be prompt, accurate, neat, and reliable. Occasionally, though, you can go far with a studied pose of unreliability and orneriness; wisely applied, this could suggest great depth, talent, and capacity for introspection—in other words, it's a highly salable commodity when you're dealing with some of the insecure clients you frequently meet in the fashion and advertising worlds.

A lot of the time, I'm working at home—making arrangements, doing darkroom stuff. Outside of the numerous people I meet in work, I don't meet too many new people. Except for wives, I've kept my friends. I have the same friends I've had for a long, long time. And I can't complain about the solitude of my work because it's always broken up by really intense and interesting spells. I was in London last week to do stills for a Monty Python movie, in Paris the week before that arranging an exhibition, and up in Massachusetts to do a portrait of John Updike just before that. This week I'm in New York about to do a "before and after" story about four women with hair and scalp problems, for a fashion magazine. Next week I'll shoot a story on the genetic management of cows in Minnesota and Wisconsin.

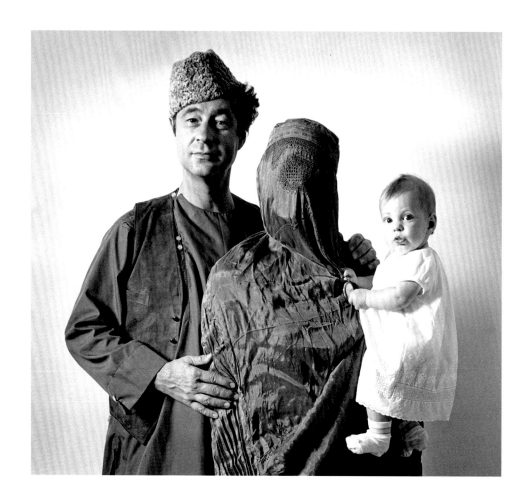

Alone in company...that is what I love. It is good to watch people from a safe
distance.

I think I'm truthful in saying this.... Whether I'm living in high luxury or in
difficult circumstances doesn't matter much to me. I'm used to both, and I feel
no particular sense of loss if I'm threatened by hard times. It's been harder on
my wives and girlfriends. They get used to a certain standard of living and
comfort; they figure this is real life, and it isn't. The insecurity is worse for them
than for me. They can't control it. They're watching from the sidelines, and the
pendulum swings, and there's nothing they can do about it. It wears them out. It
must. They haven't stuck around.

I've had a grand life—Venice, Paris, and Tokyo in a whirl—and then the need to
pay the bills at the end of the month. I've had all sorts of responsibilities...three
wives, six children. Somehow, Providence has been with me. I've never been
delinquent, and I've never held up banks. I've always taken tremendous
chances that I couldn't afford to take and it's always worked out. So far.

Some of my best-known advertising pictures have come from various travel, airline, institutional, and national campaigns, like the French government's tourist campaign, which I did for many years. We had a rather heady group—the legendary Bill Bernbach, and copywriter Mary Wells—but it was a simpler time, a more reasonable time. Everyone seemed more alive, less nervous and angry at the world. Younger....and you didn't have to test every damned ad or picture you worked on.

All professional lives need promotion to survive and flourish. The same for photographers. But when and if the rewards come, it is always wiser to attribute one's success to talent, to the highest and purest of motives, and—to stoke one's self-esteem—to view all success and praise as proof of integrity and artistic ability and, even better, strike an attitude of touching humility.

I MEANT FOR THE PICTURES IN THIS BOOK TO STAND
alone. So...I would encourage the viewer to be my co-conspirator. Take a blank sheet of paper, or a shirt cardboard, and mask one page or the other from time to time. Better yet, tear out the pictures to make your own combinations, and then go out and buy a new book to replace the one you've ripped up.

I have favorites. The picture taken in the Marriage Palace in Bratsk, Siberia, is my standard wedding present to friends. It just seems like a funny thing for that moment. Perhaps because of my own checkered marital record, it seems to suggest the inevitable fate of most marriages. A funny thing?

In this collection, the pictures on facing pages sometimes have something to do with each other...even when they've been taken years apart. I think that's kind of good. It shows I've had a unified way of looking at things for more than forty years. I also hope there's been a development, of course. I aim to be consistent, not static...unified, but not doing the same thing over and over. Other people will have to judge.

This book is the whole story. My personal work is not going to change radically. I'm almost sixty, and have been taking pictures since I was sixteen; mathematically, there's no time for big changes. I'll take some more pictures, but the

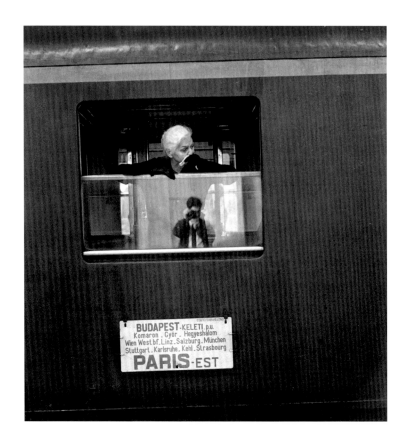

symmetry is already there. It all reflects a certain way of seeing and feeling. That's what I hope. That's very important to me.

Putting this book together has been difficult. I've always carried a camera with me, and so there are the pictures, looking like a diary. Much of my life is there. I was reminded of many things, some pleasant and a lot unpleasant...mistakes, and things I could have done better, and the loss of friends who are dead and gone. Digging through your past is not the most pleasant occupation.

The very emotional photograph of the young boy hanging onto his father at the dinner table was done on assignment, but rejected. The client wanted cheerful pictures of happy children. I had to go back and find a happy cowboy kid. My reaction is purely personal, I guess; the picture reminds me of me. The boy lived with his grandparents, and his father visited for Sunday dinner. As everyone was talking, the boy suddenly reached over and held onto his father. Look at the man's eyes when that happened. They speak.

Maybe my work will become fashionable next year.

Elliott Erwitt
May 1988

Personal Exposures

The photographs on pages 51 and 62 were at Republican Party Conventions. The photo on page 63 was taken the day of the Rosenbergs' execution. The photo on page 165 is of a Soviet atomic maneuvers schematic.

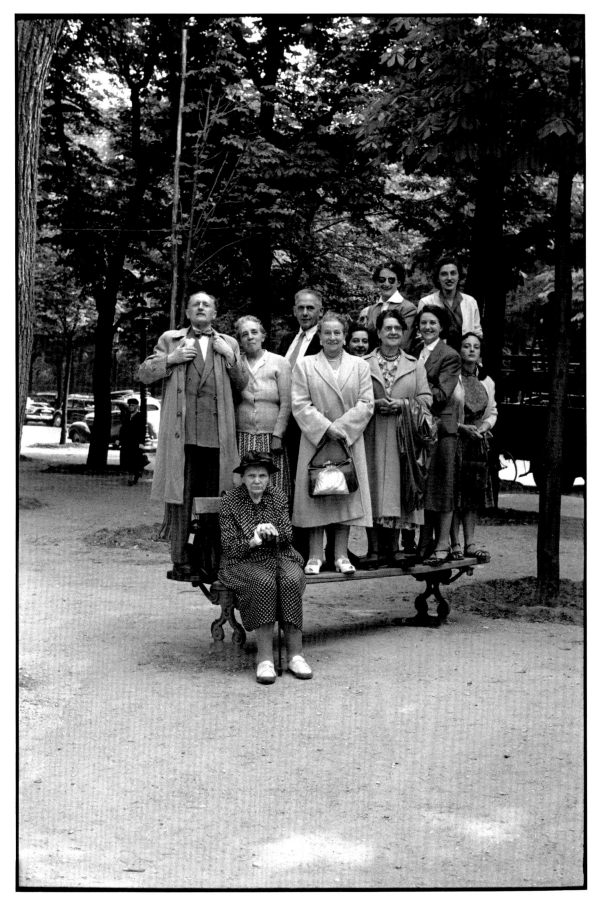

Paris, July 14, 1951

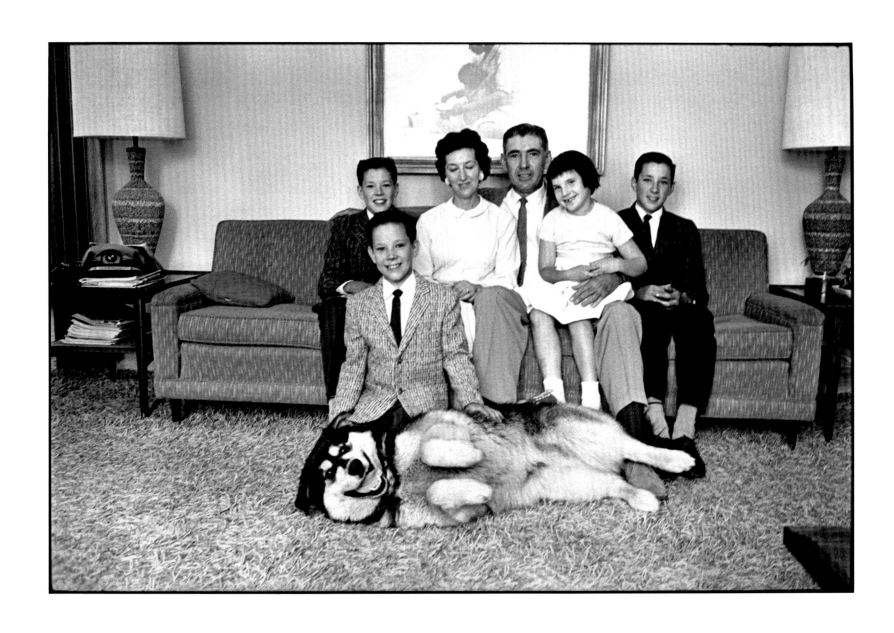

U.S.A., 1964

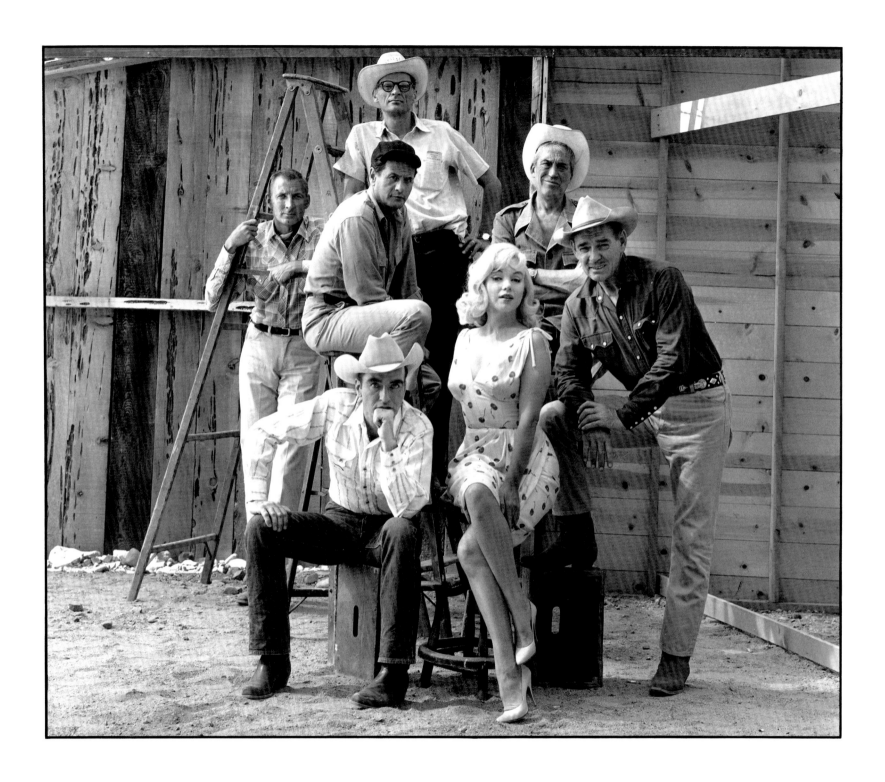

Reno, Nevada, 1960

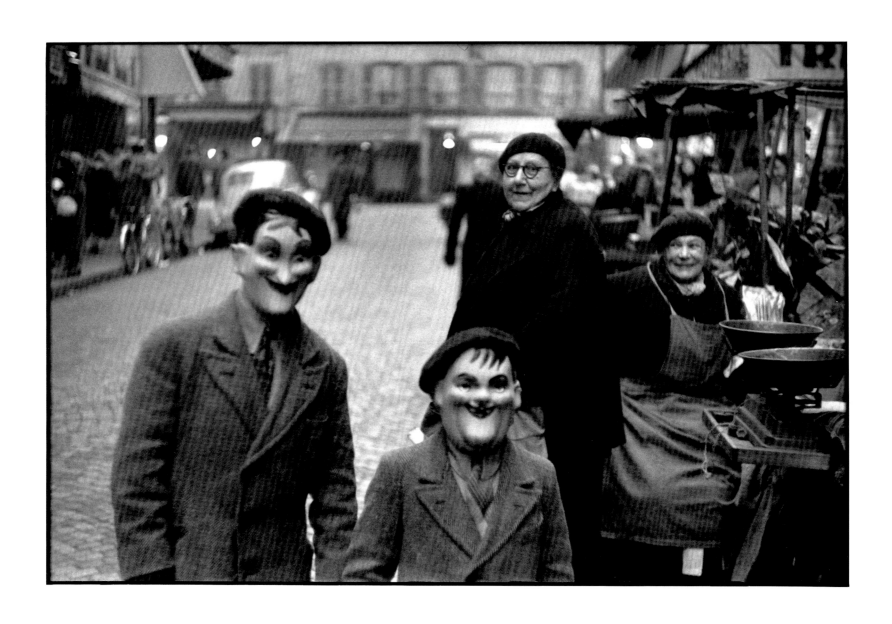

Paris, 1949

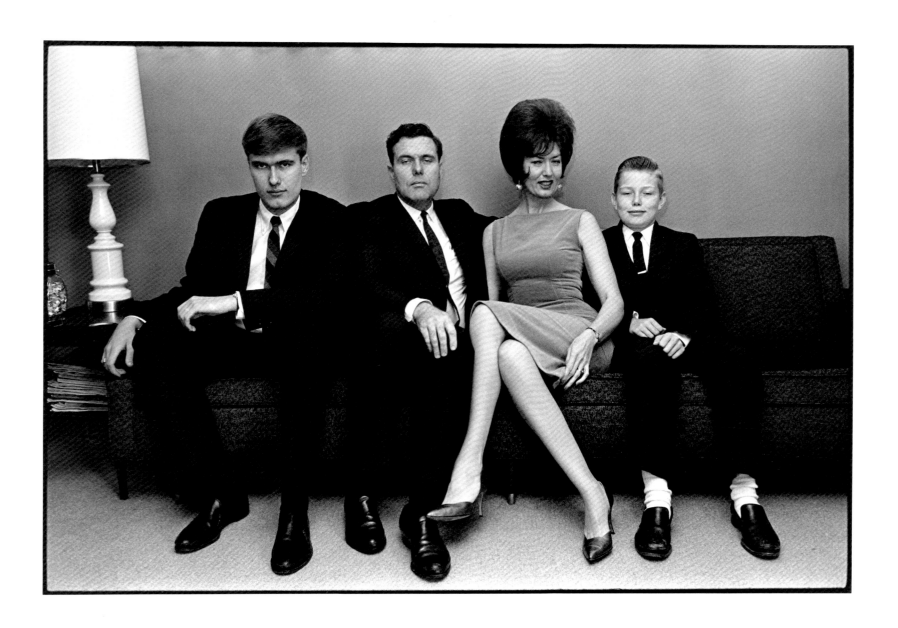

U.S.A., 1962

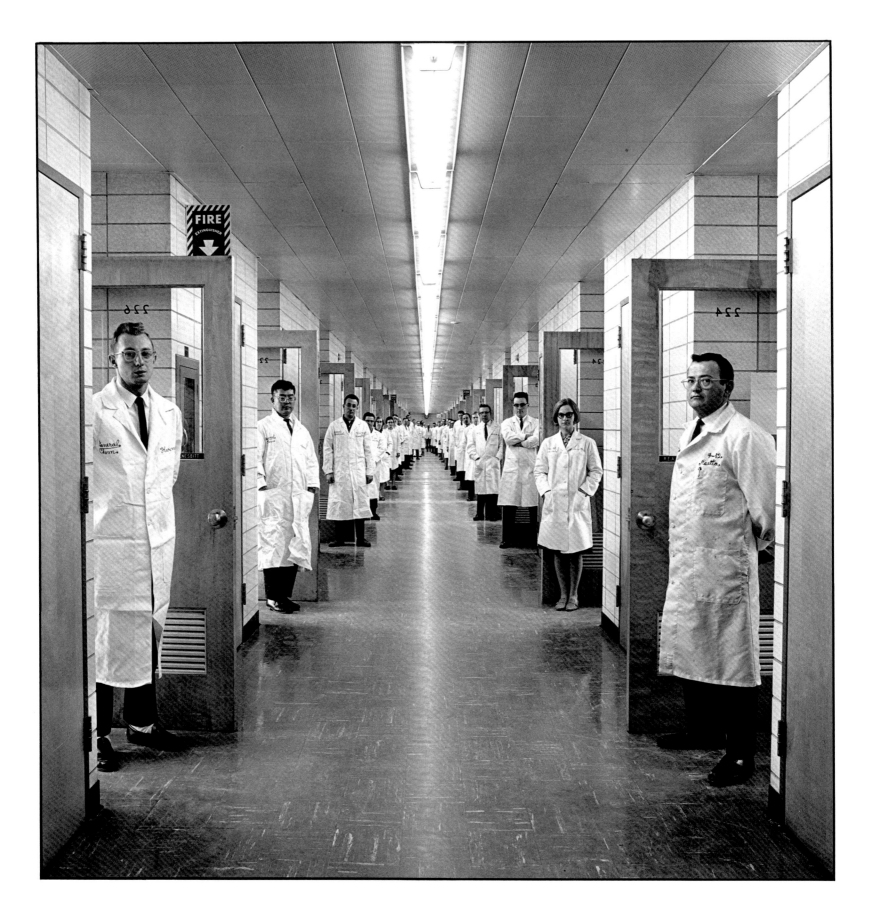

New Jersey, 1966

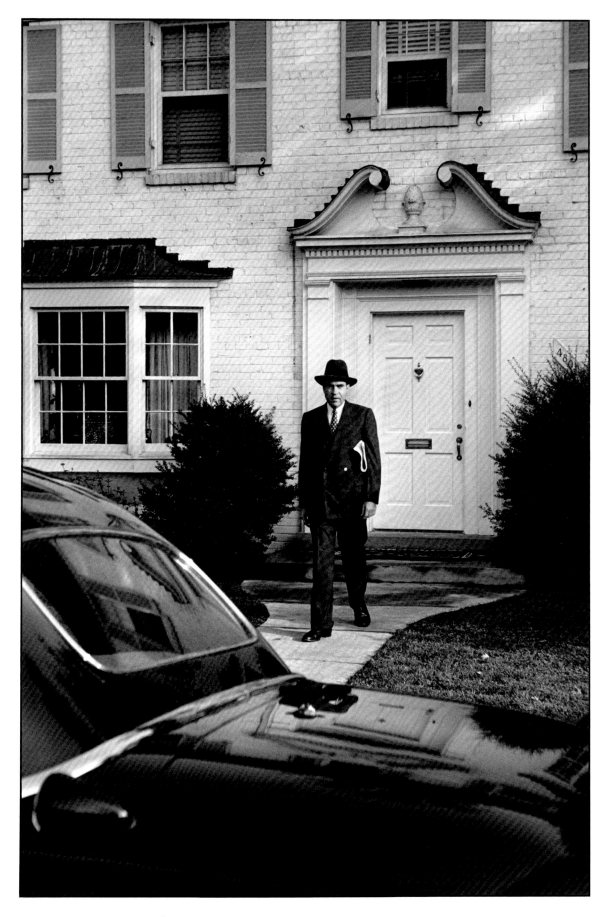

Washington, D.C., 1955

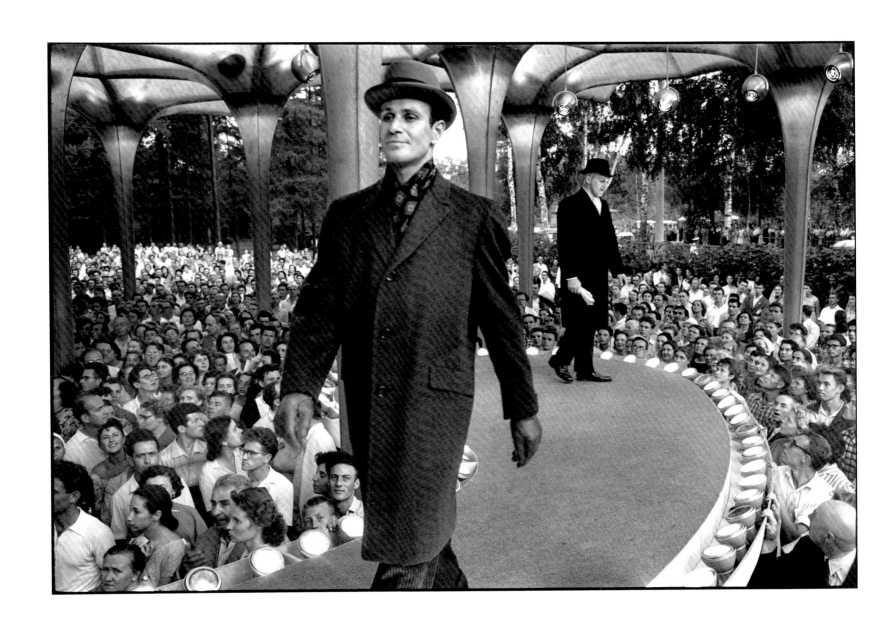

Moscow, 1959

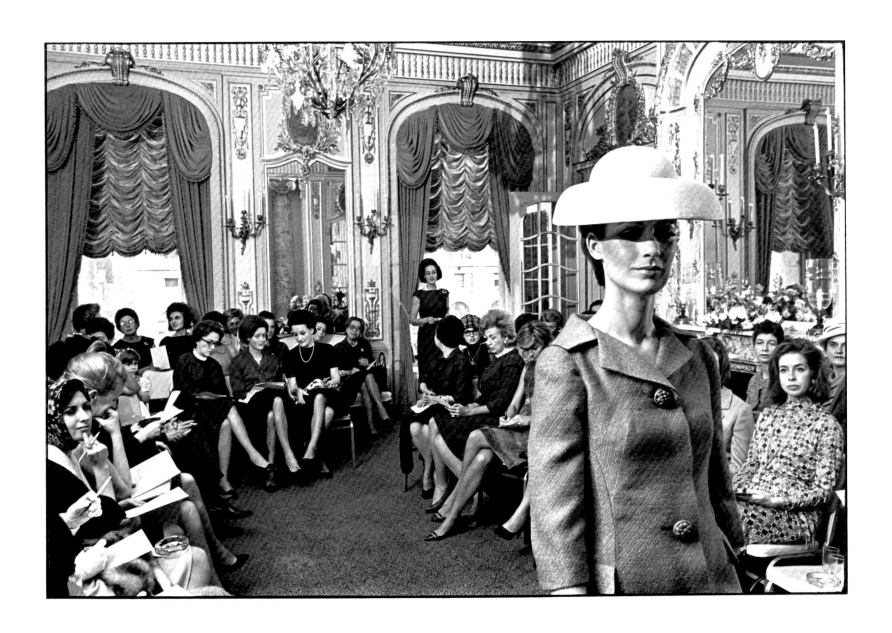

New York City, 1964

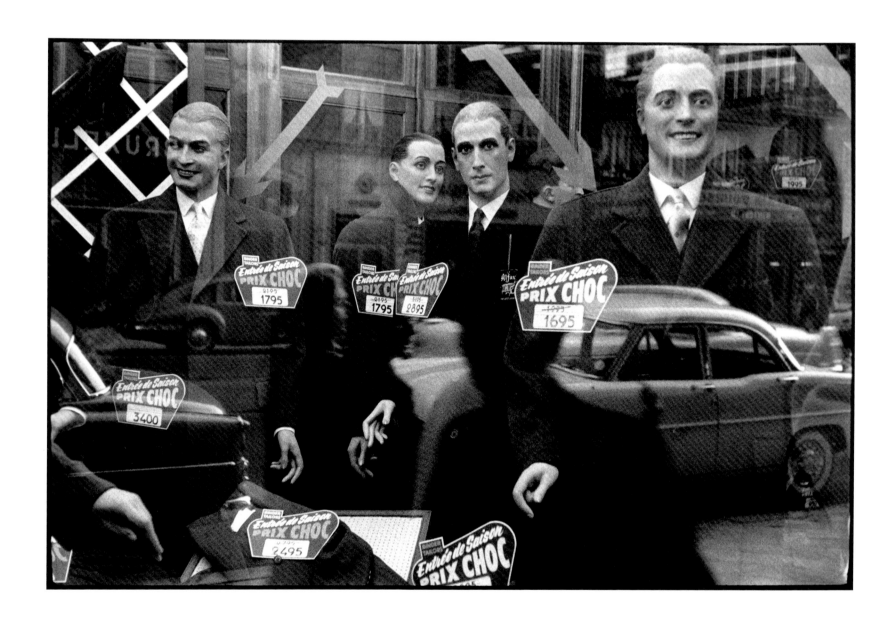

Brussels, 1957

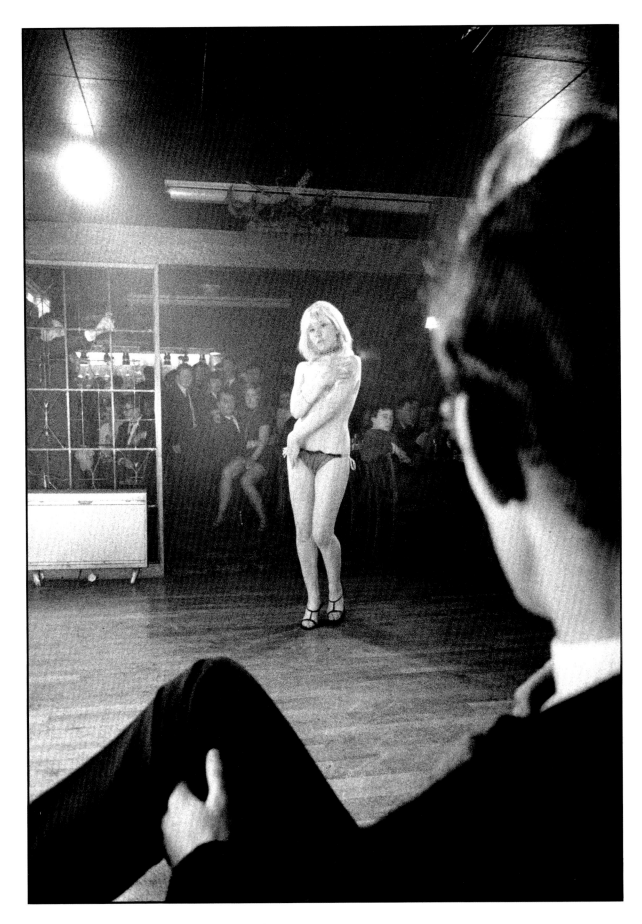

Newcastle, England, 1969

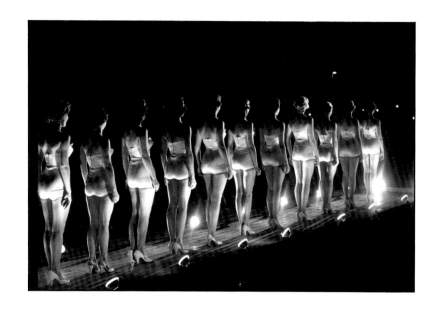

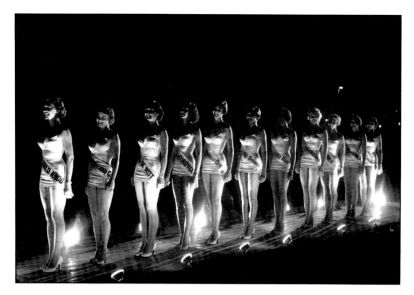

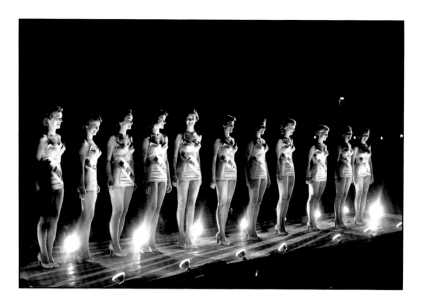

Arkansas, 1954

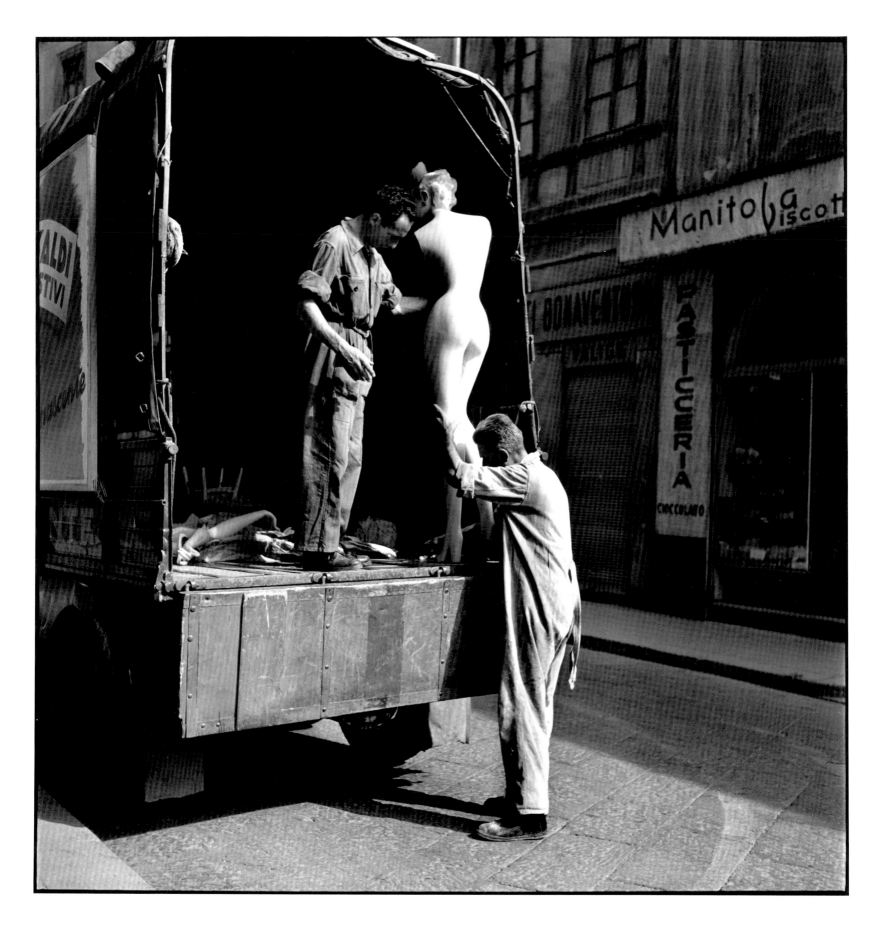

Milan, Italy, 1949

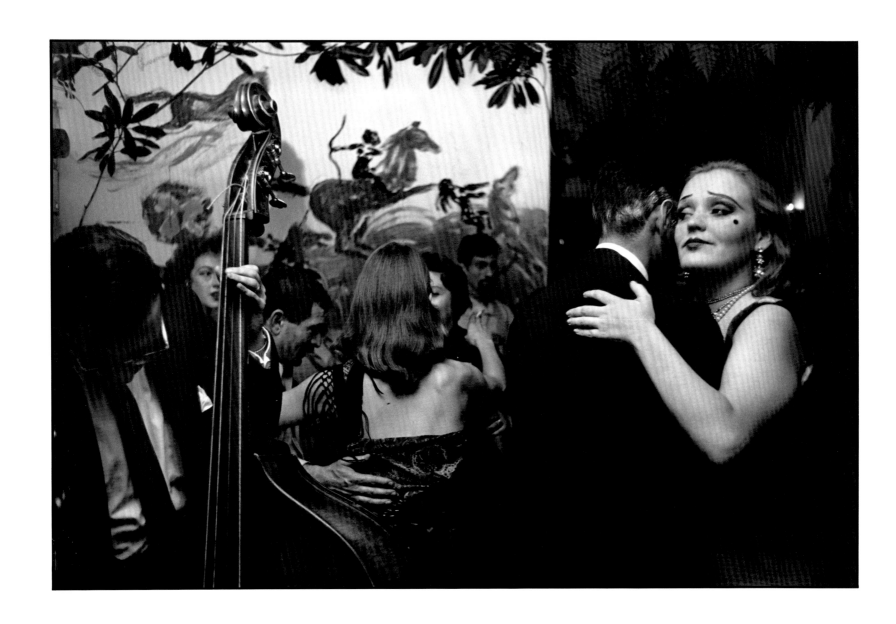

New York City, 1955

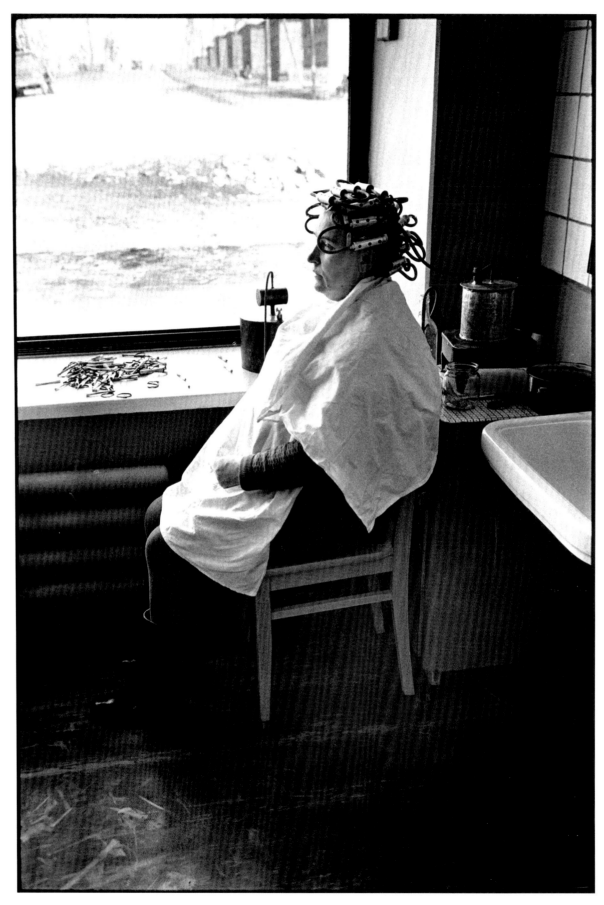

Bratsk, Siberia, 1967

47

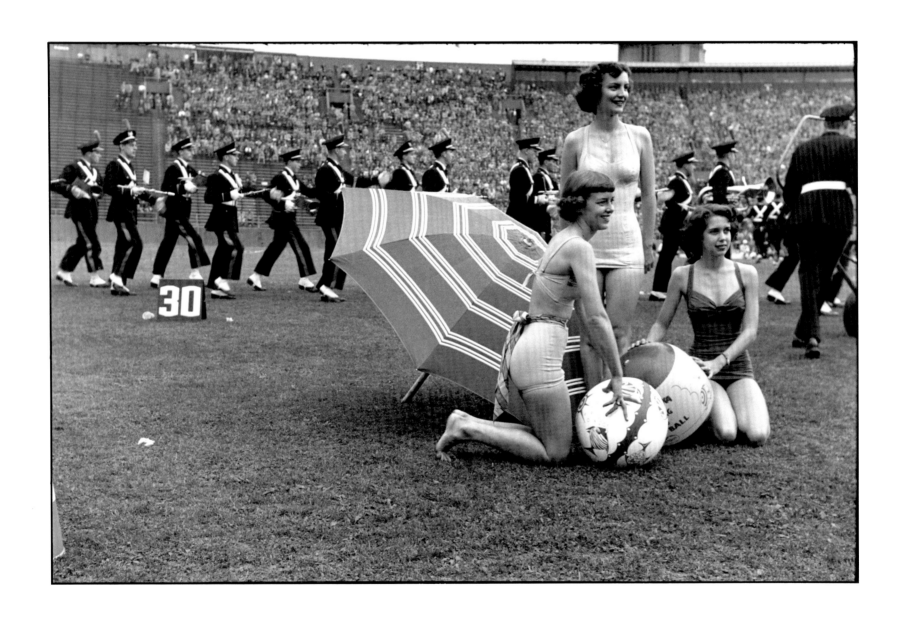

Pittsburgh, 1950

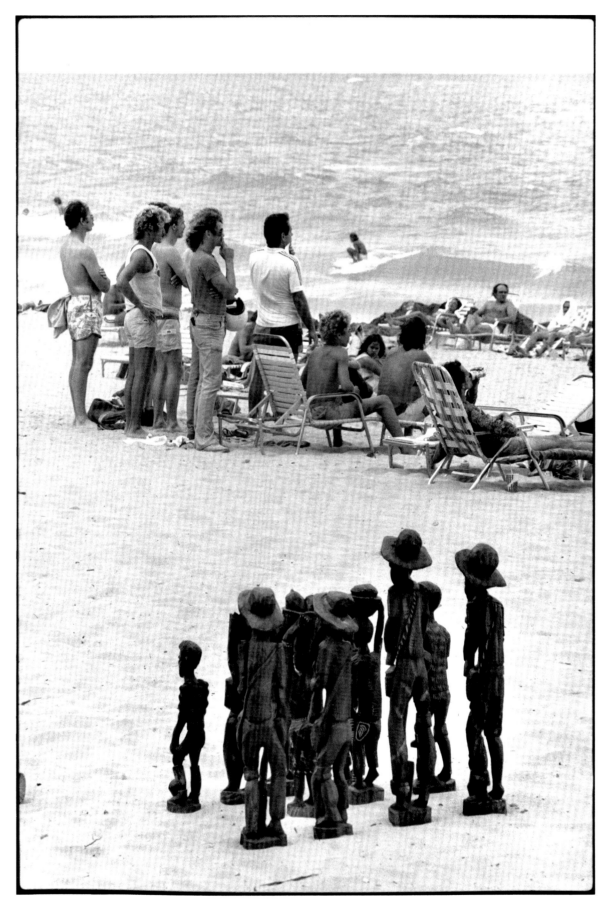

San Juan, Puerto Rico, 1978

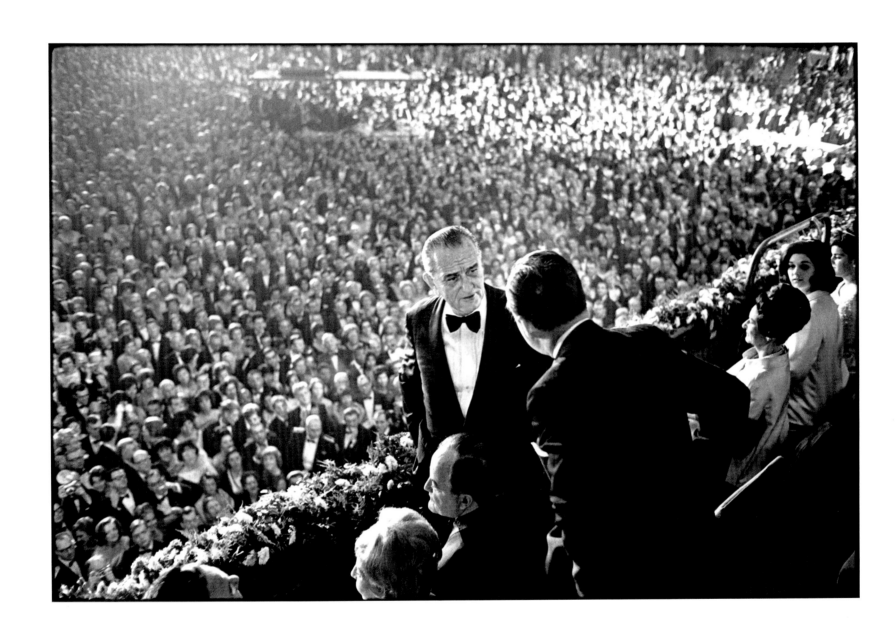

Washington, D.C., 1965

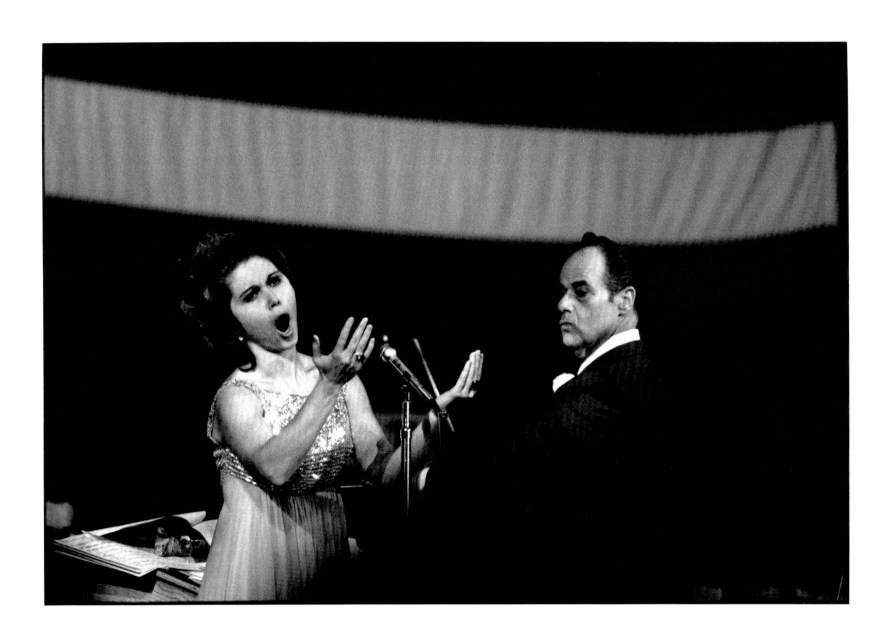

Miami Beach, Florida, 1968

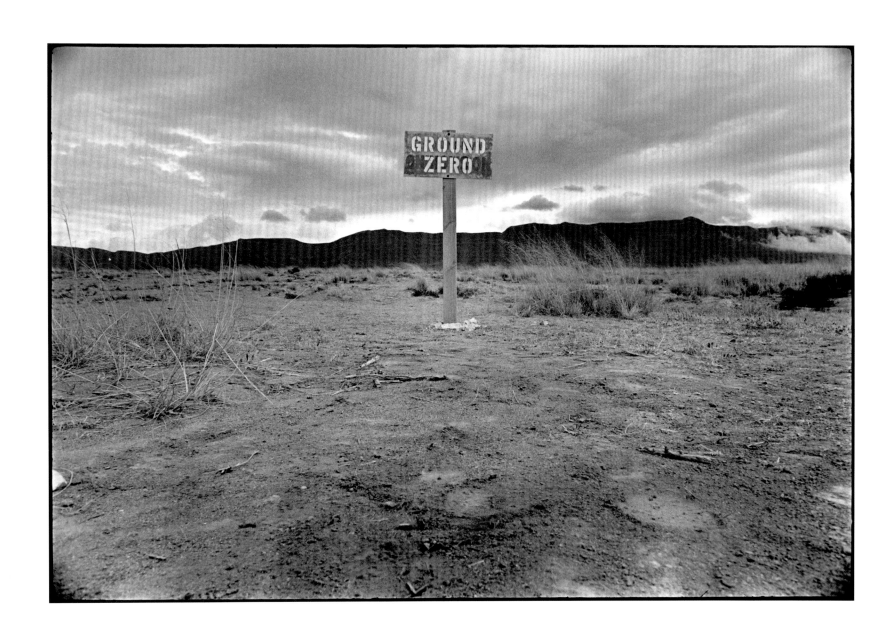

Epicenter, Alamogordo, New Mexico, 1965

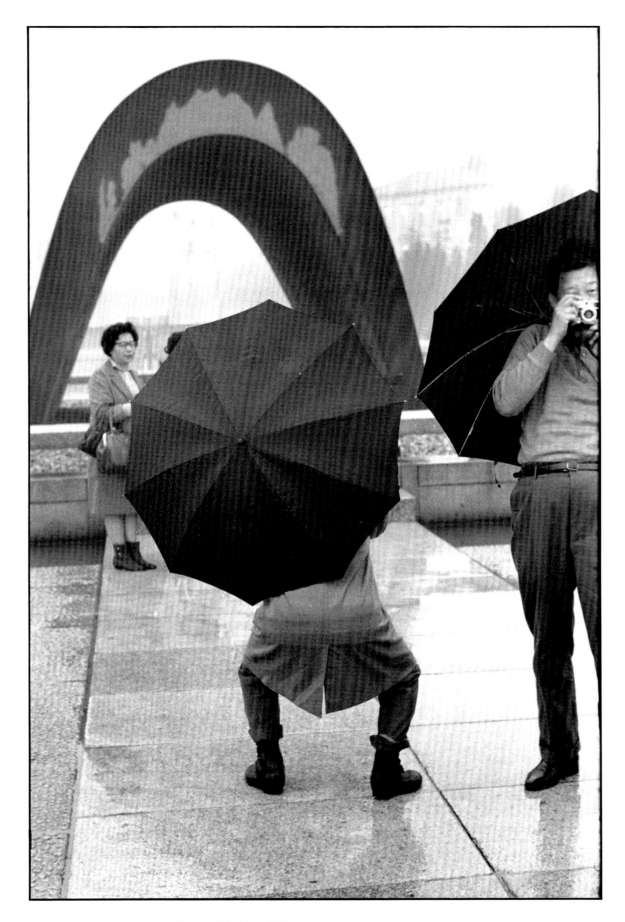

Epicenter, Hiroshima, 1970

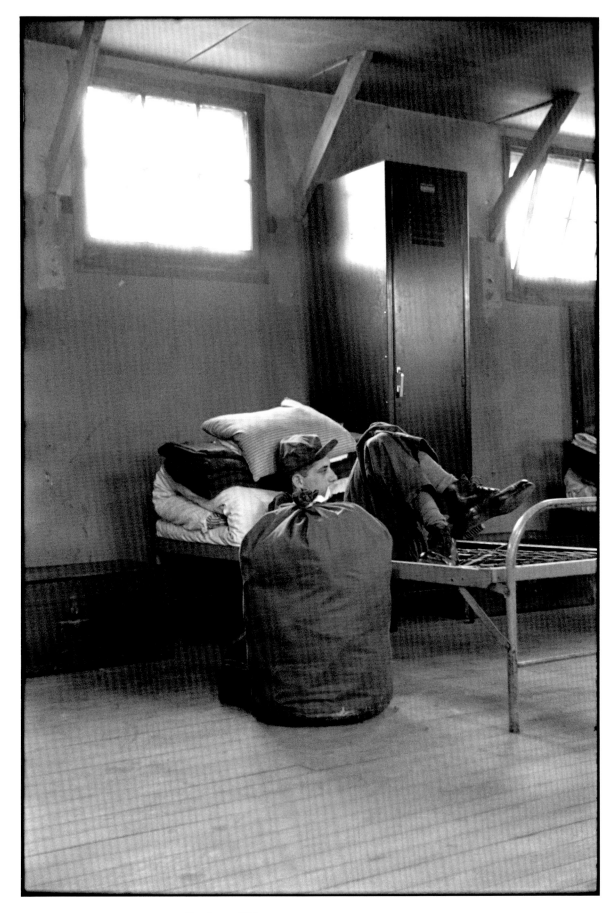

New Jersey, 1951

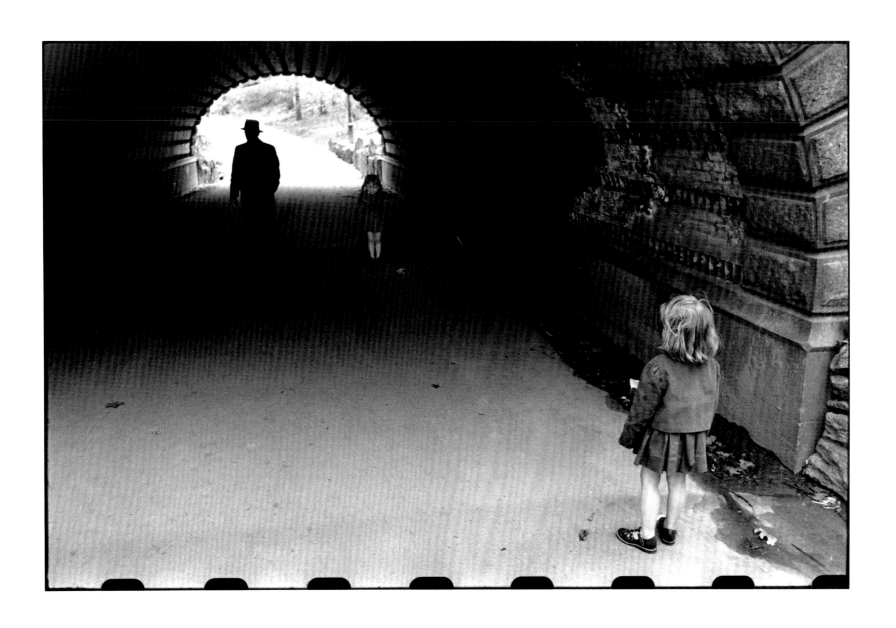

New York City, 1953

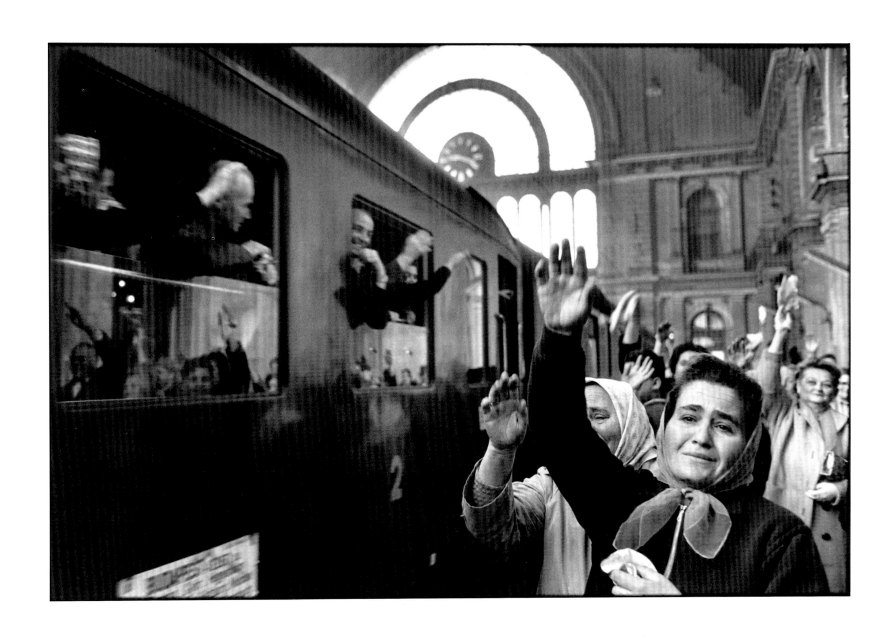

Budapest, 1964

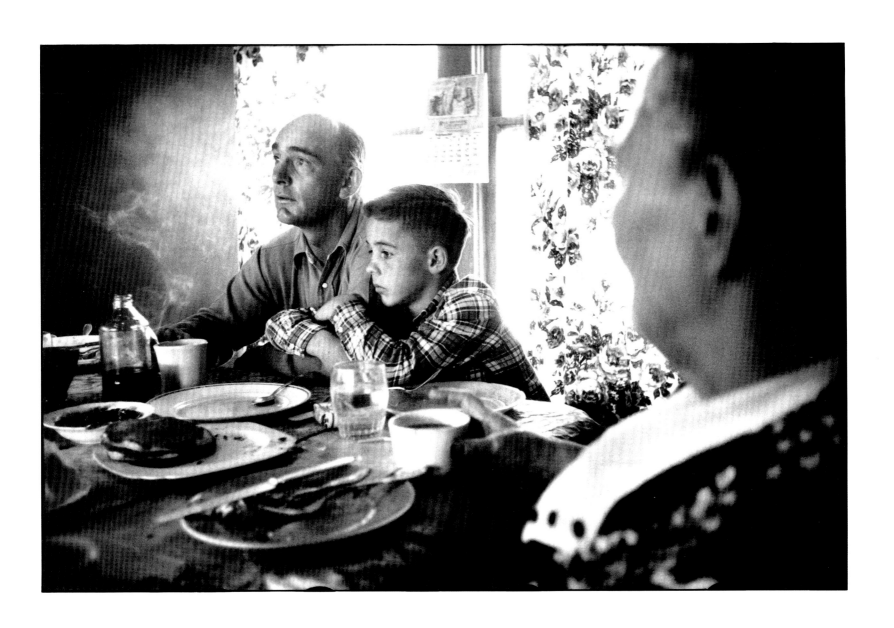

Wyoming, 1954

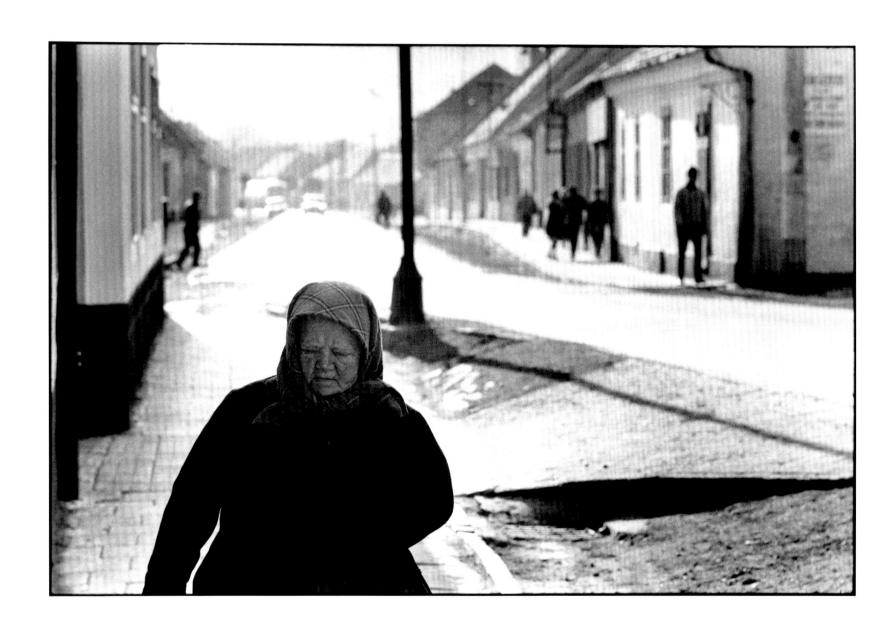

Czechoslovakia, 1964

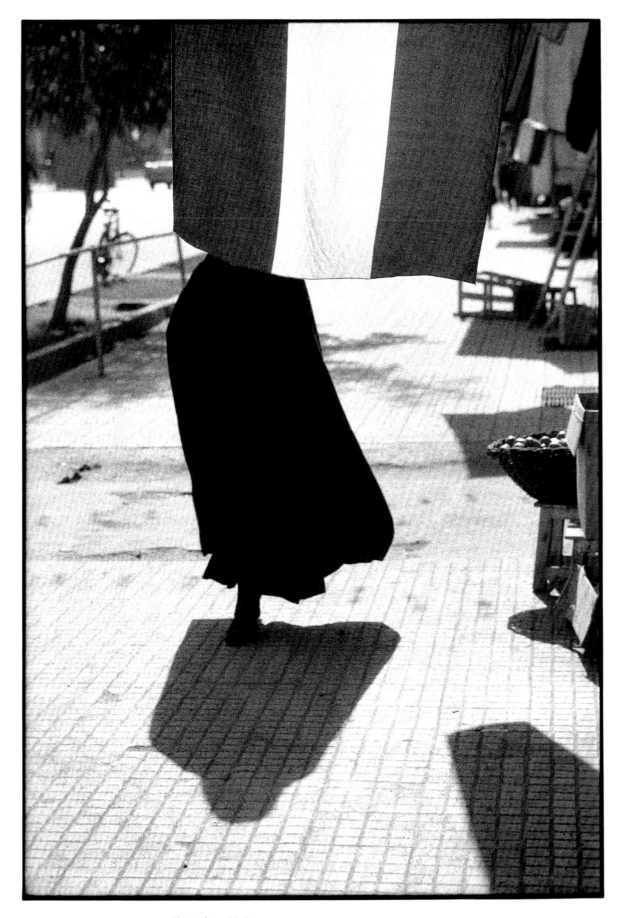

Shīrāz, Iran, 1967

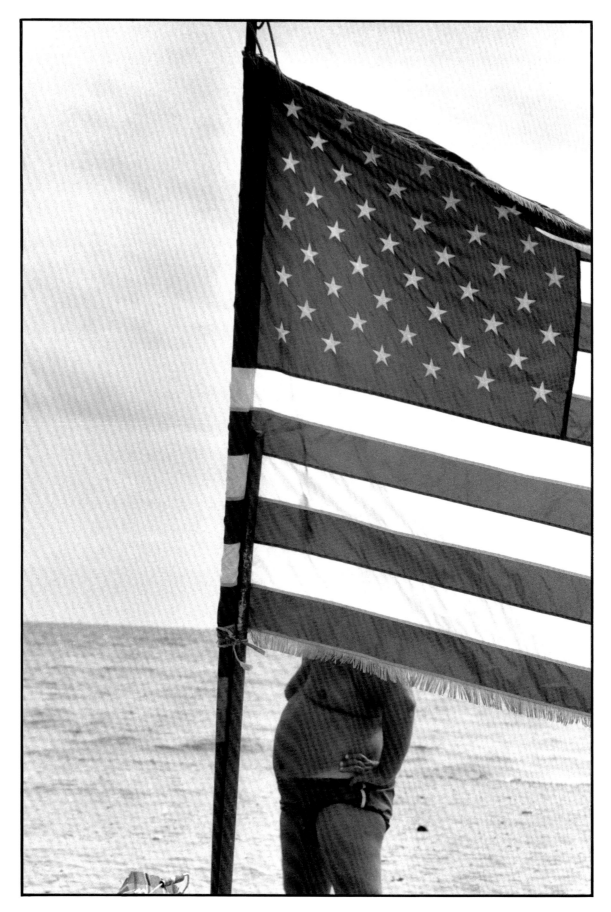

New York City, 1975

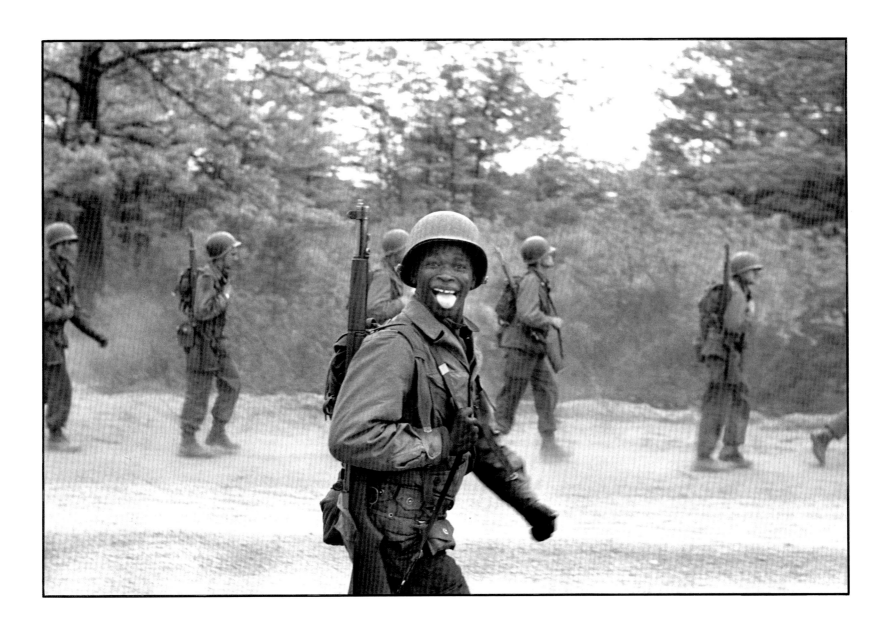

New Jersey, 1951

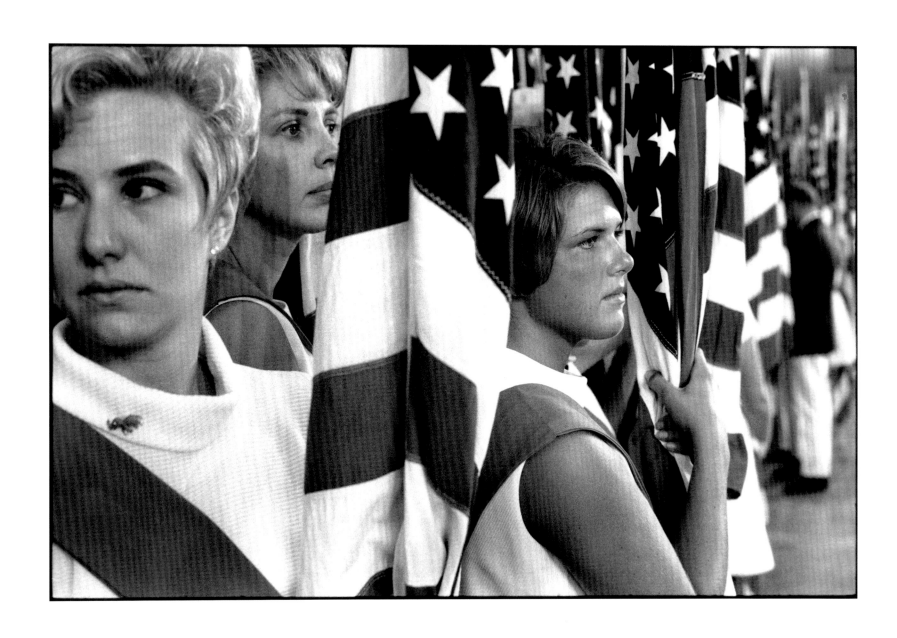

Miami Beach, Florida, 1968

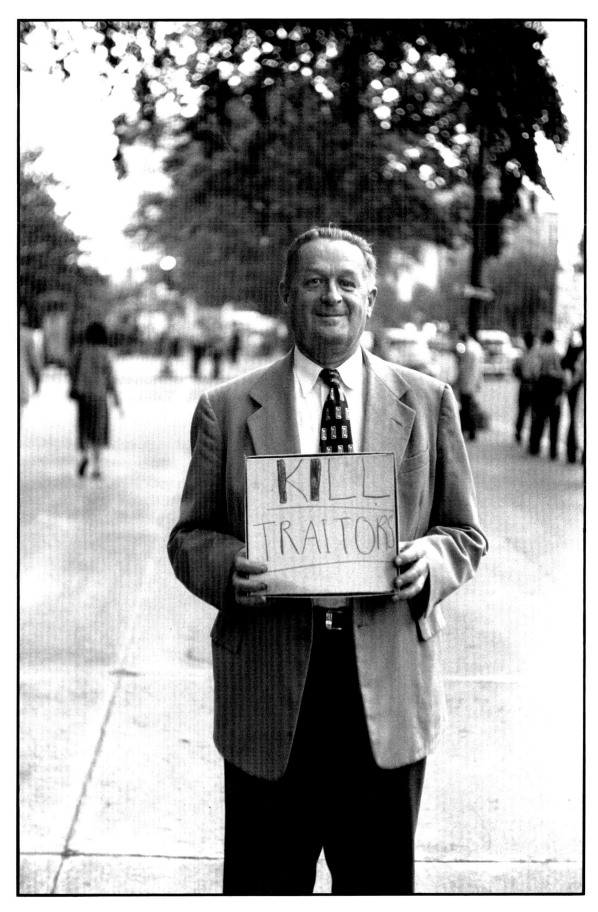

Washington, D.C., 1953

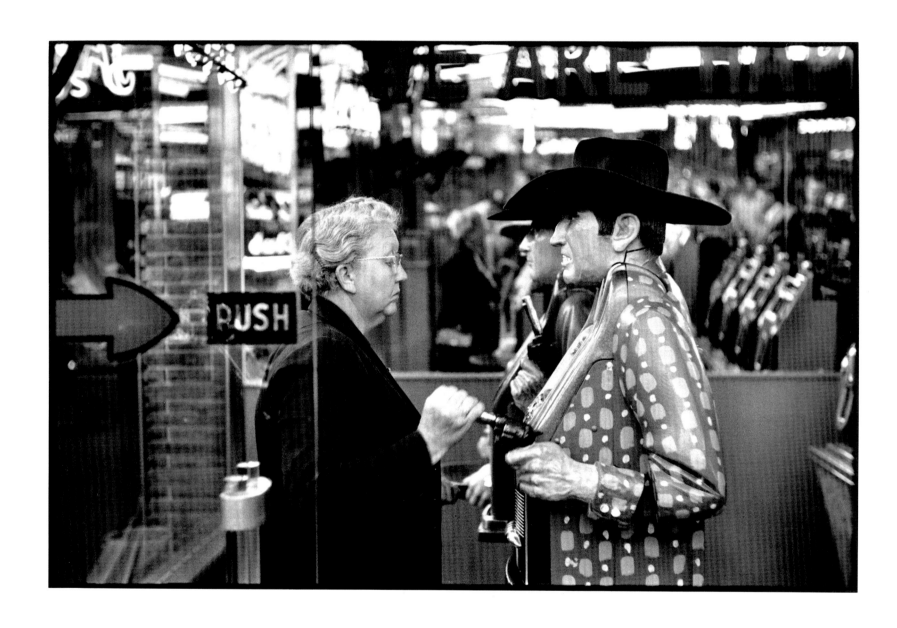

Las Vegas, Nevada, 1954

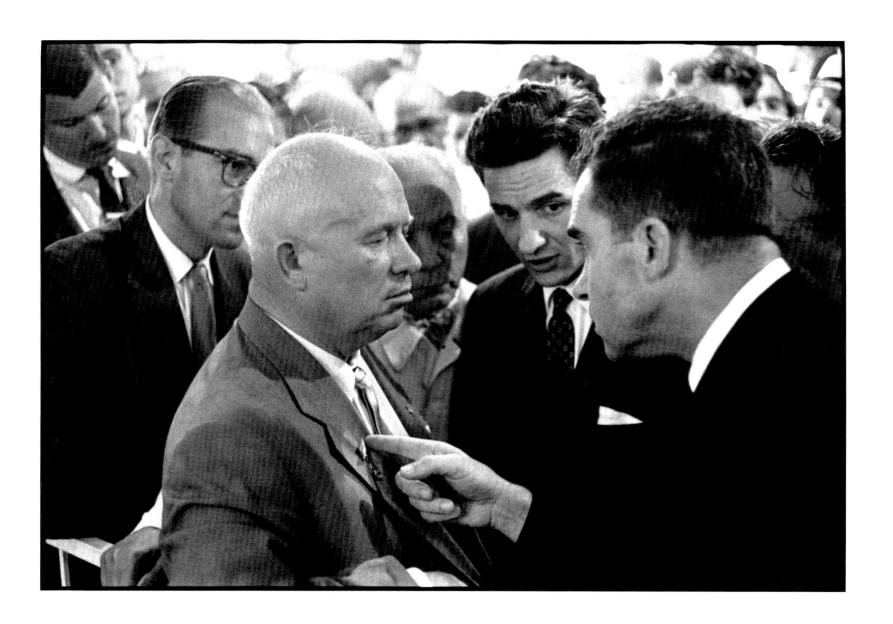

Moscow, 1959

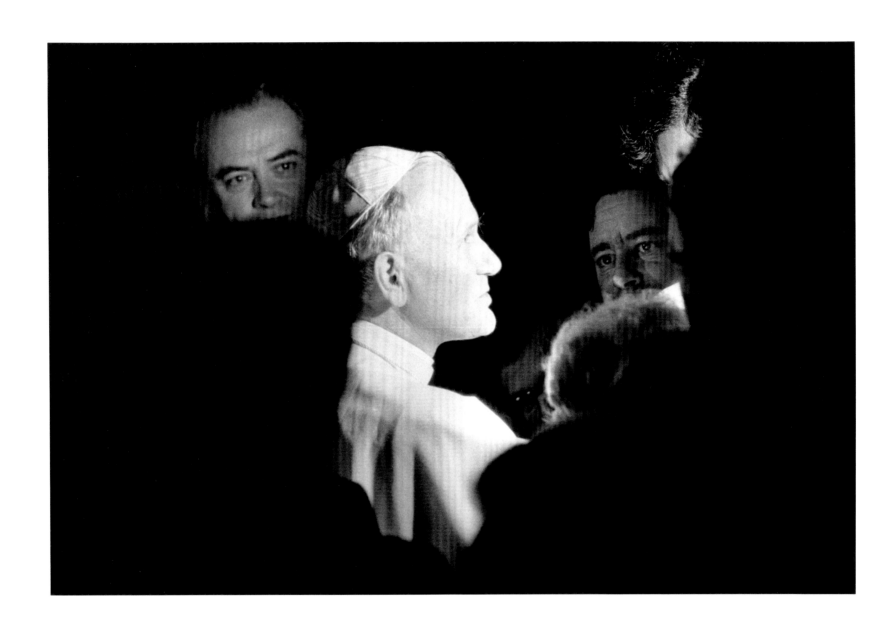

Rome, 1978

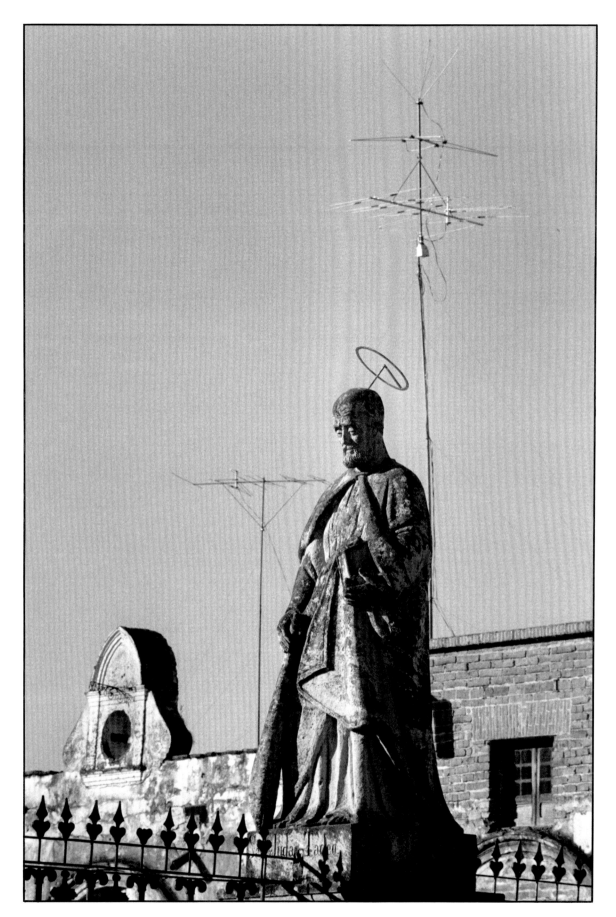

Mexico, 1973

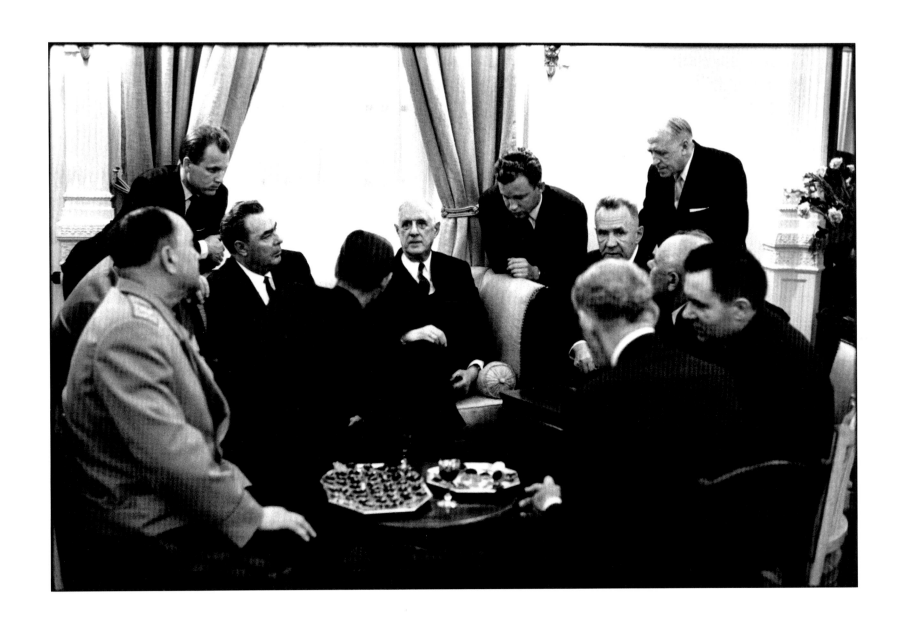

Moscow, 1966

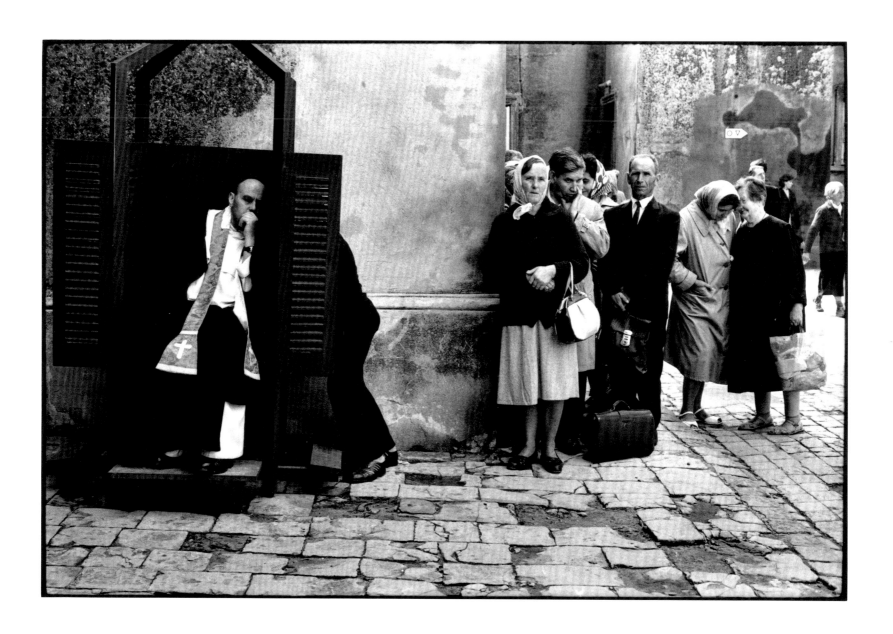

Czestochowa, Poland, 1964

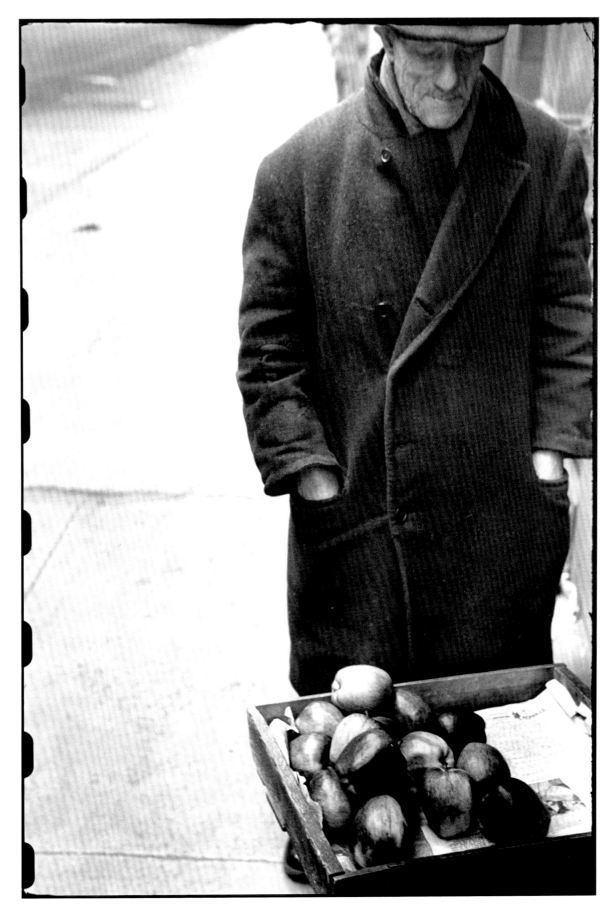

New York City, 1951

70

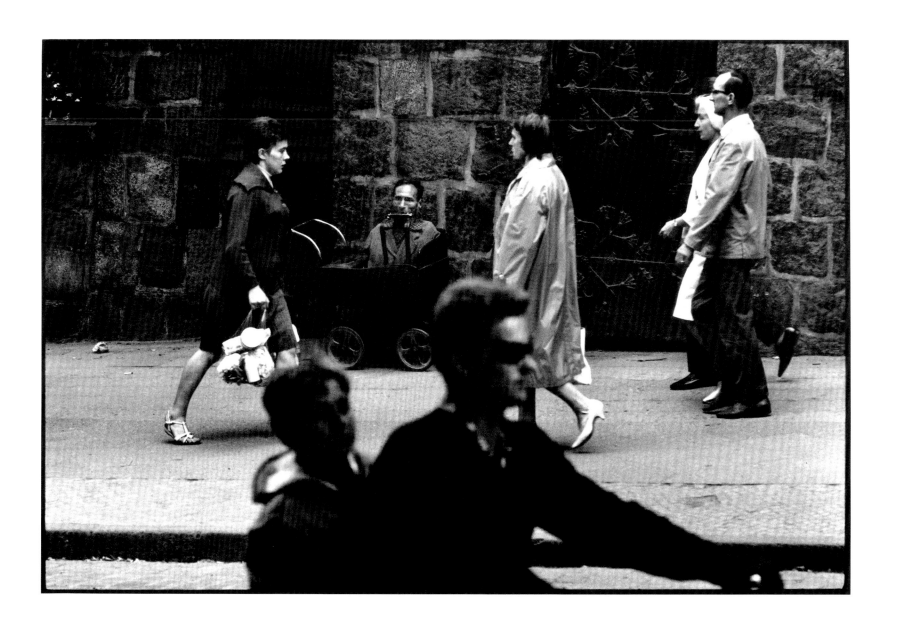

Gdańsk, Poland, 1964

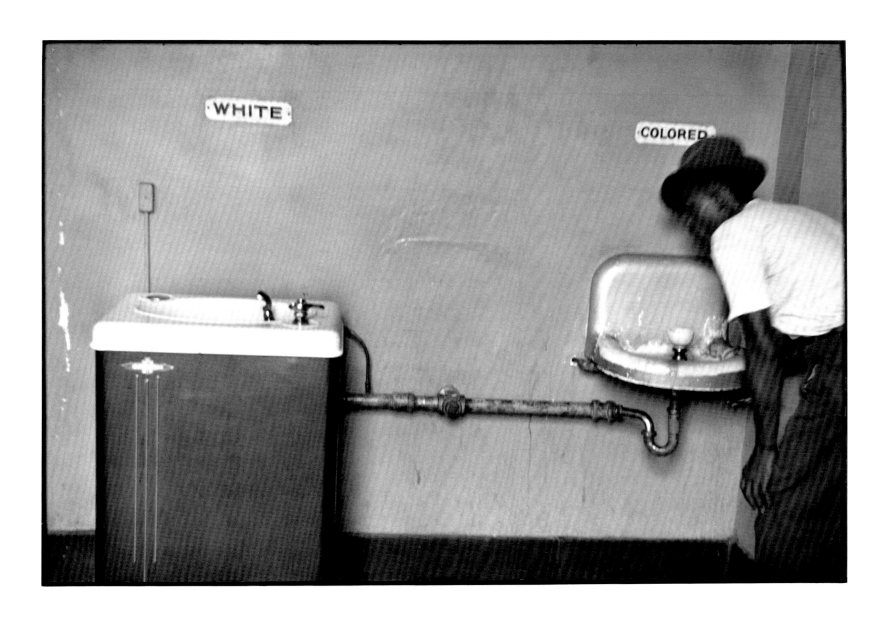

North Carolina, 1950

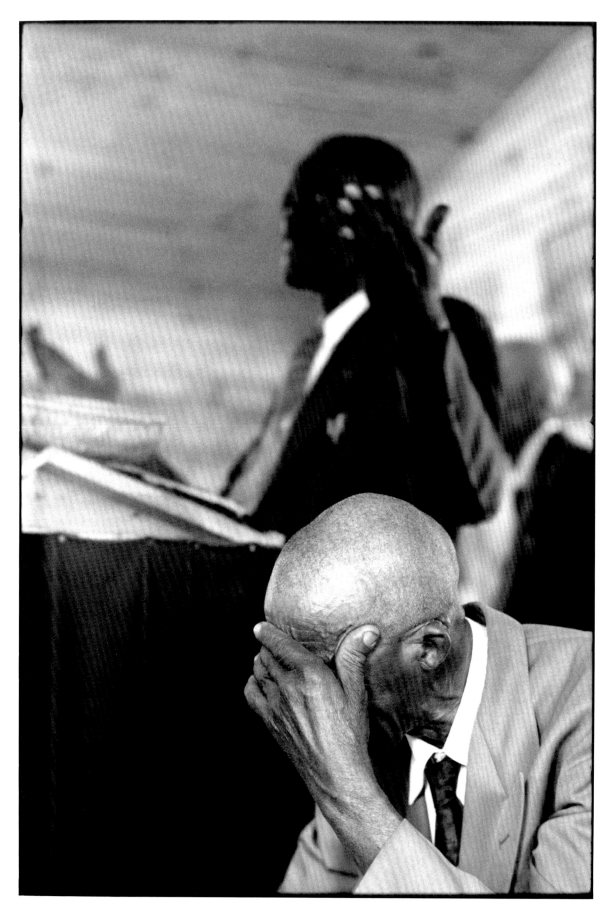

Arkadelphia, Alabama, 1954

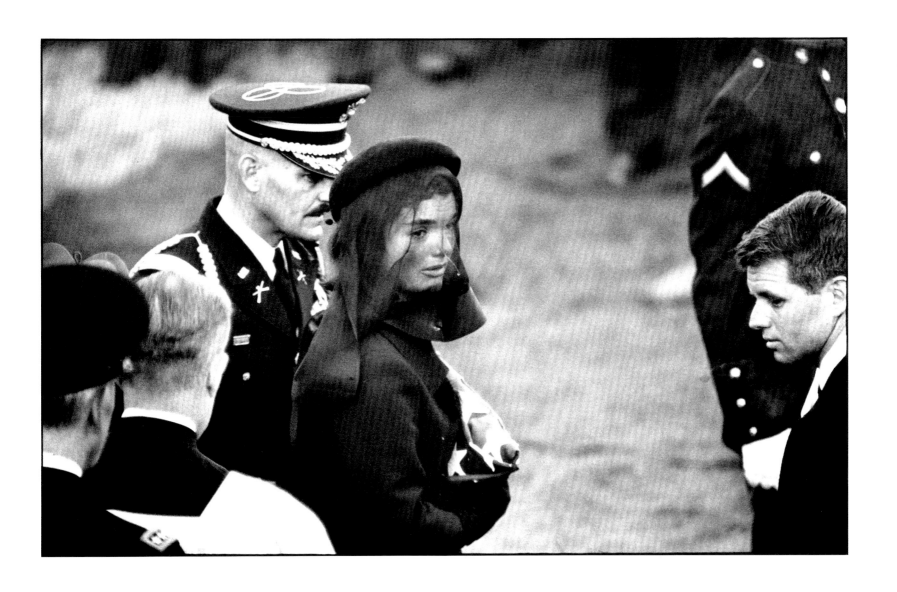

Arlington, Virginia, 1963

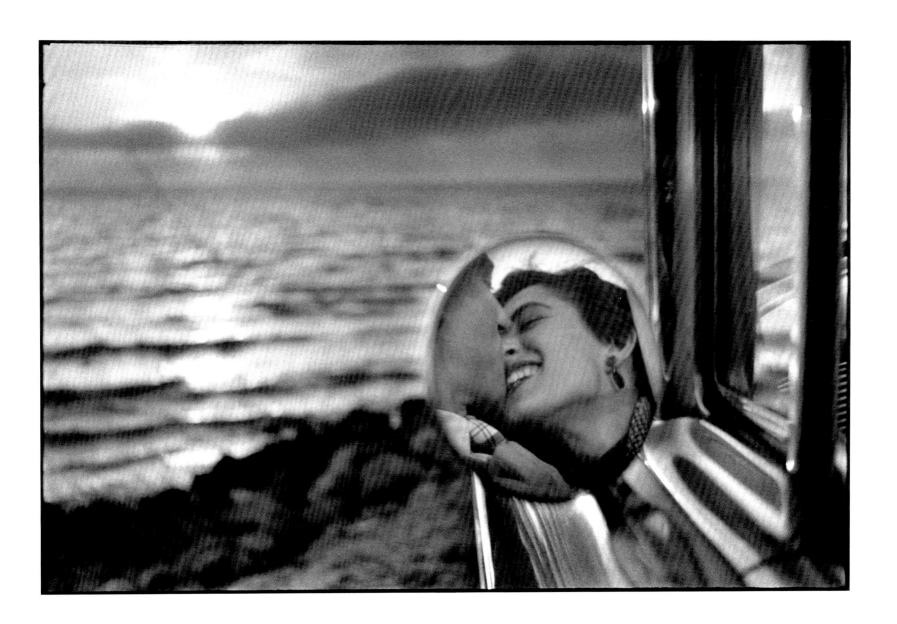

California, 1955

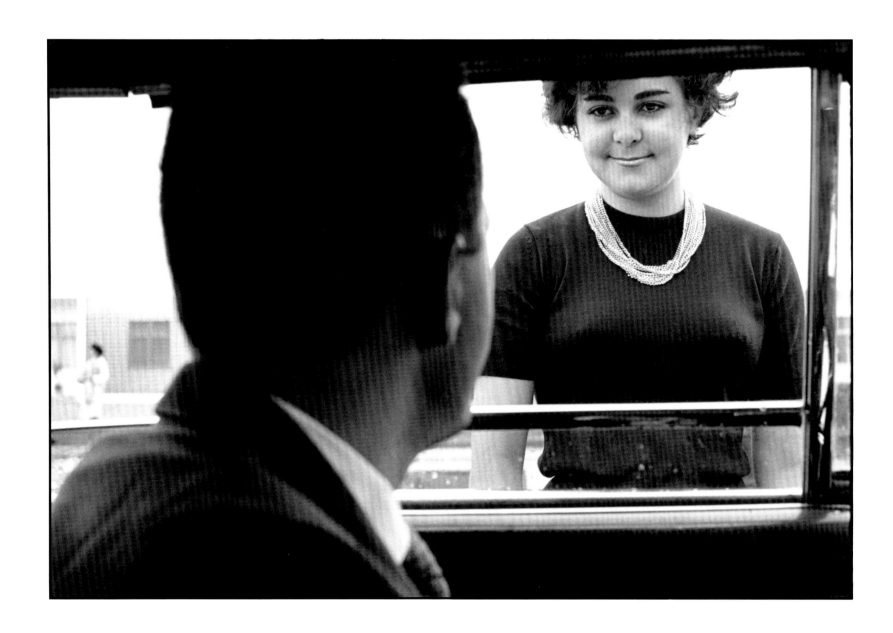

Brasília, 1961

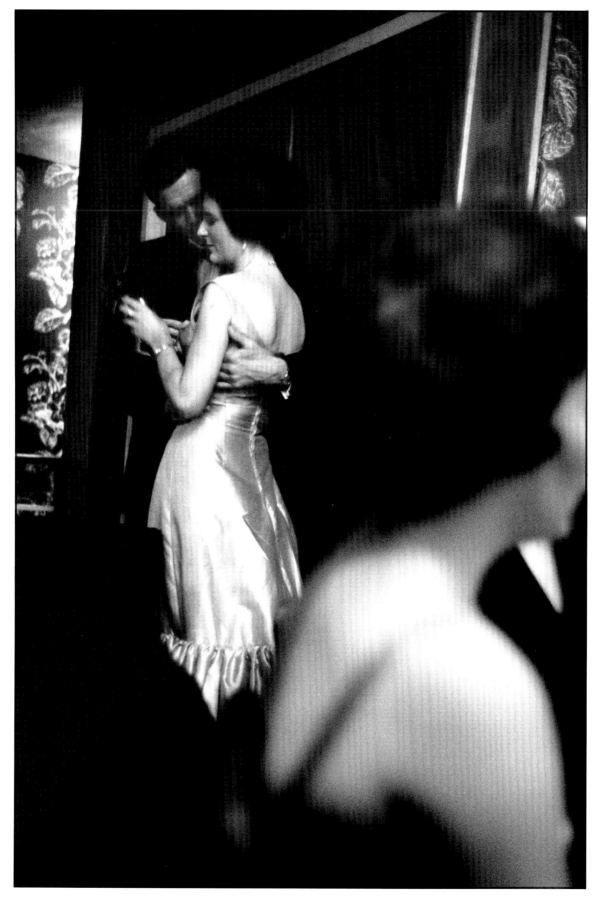

Dublin, 1962

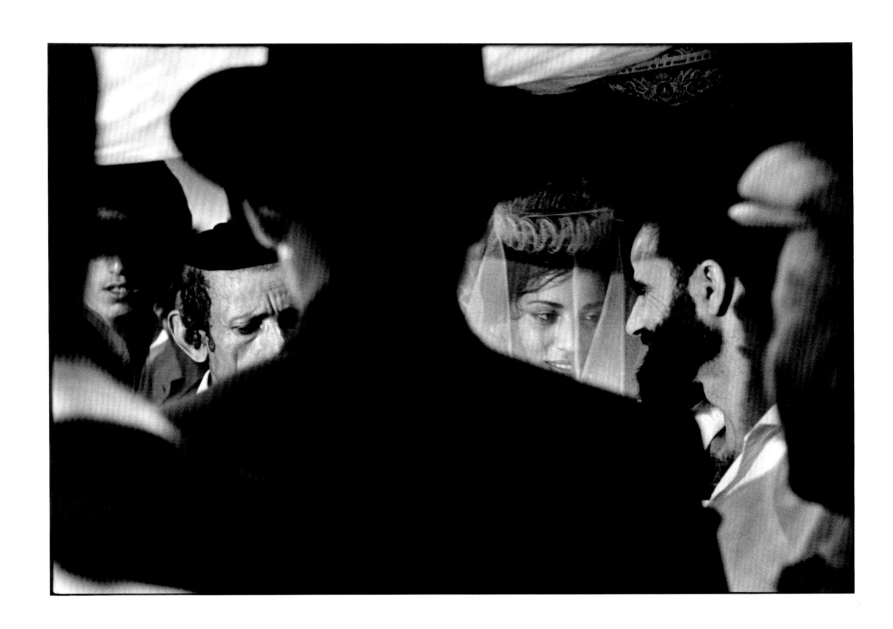

Israel, 1962

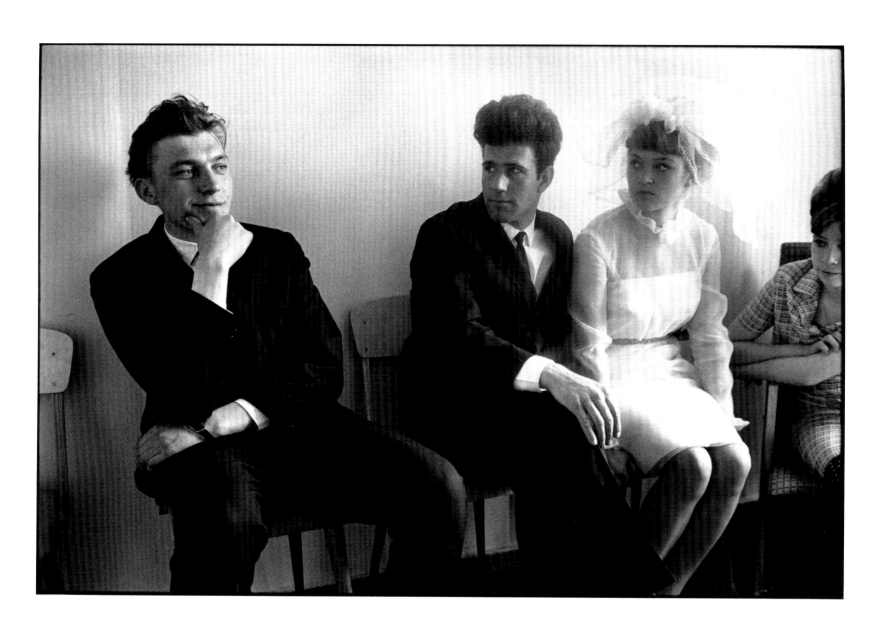

Bratsk, Siberia, 1967

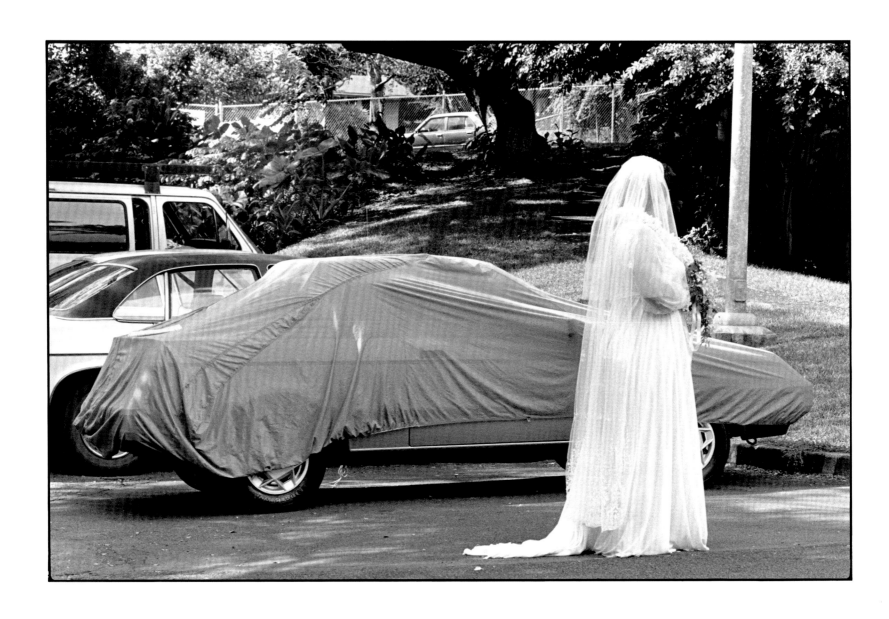

Honolulu, 1983

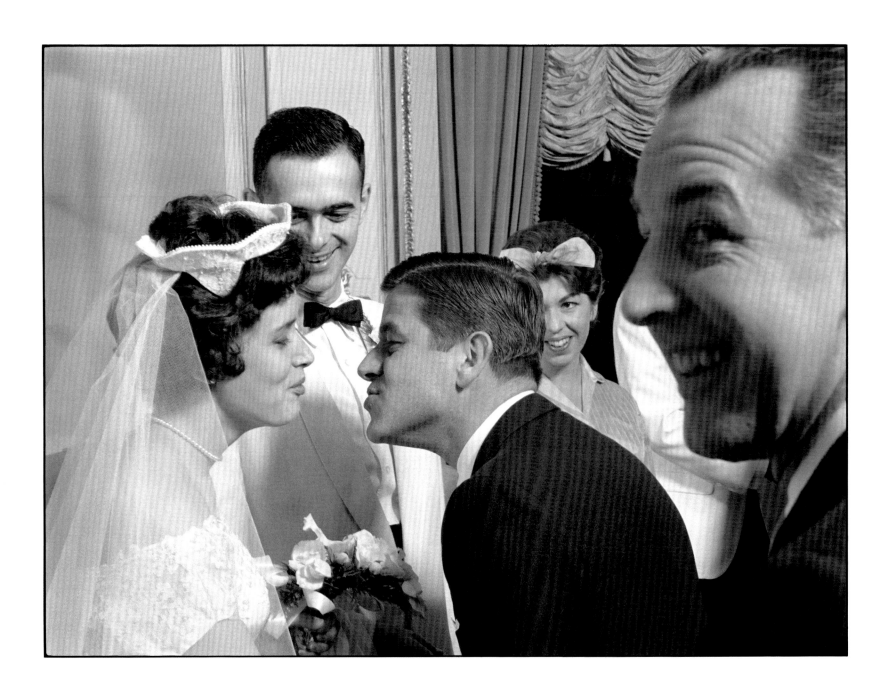

New York City, 1962

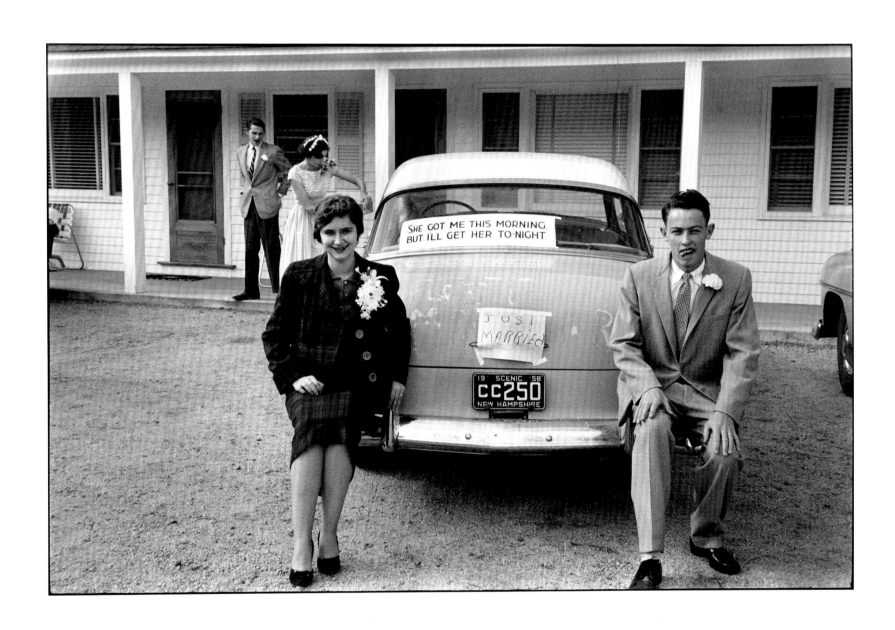

New Hampshire, 1958

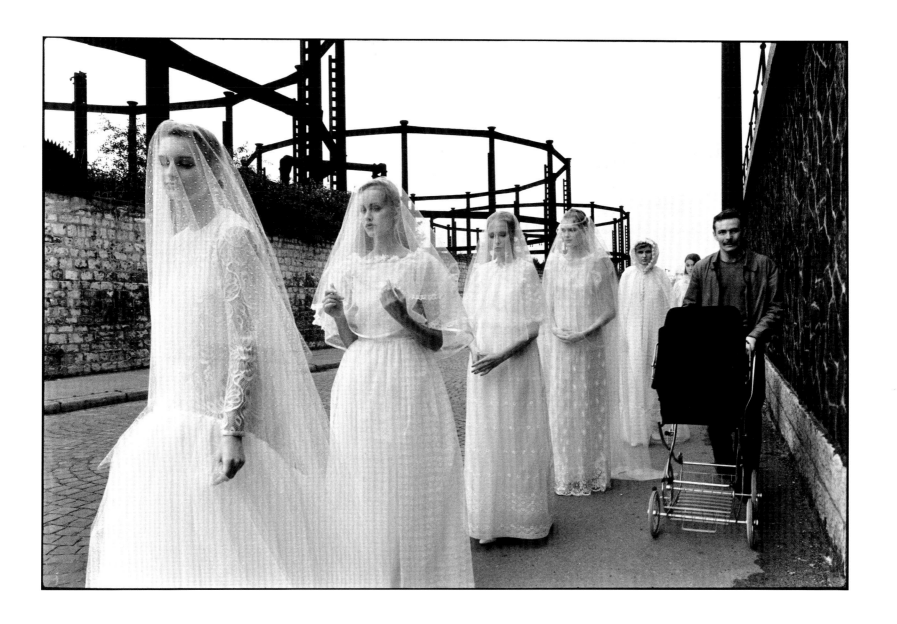

Paris, 1978

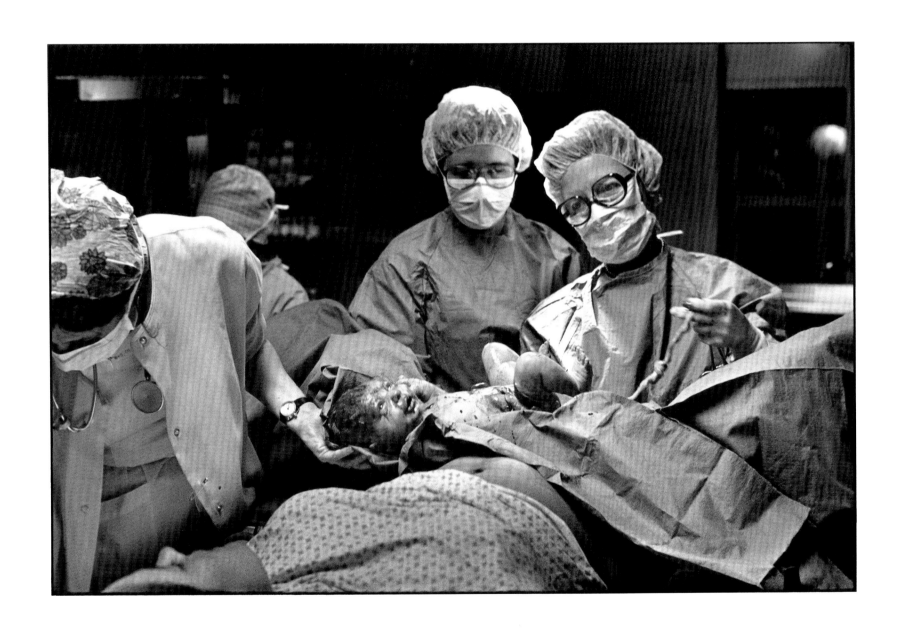

New York City, 1977

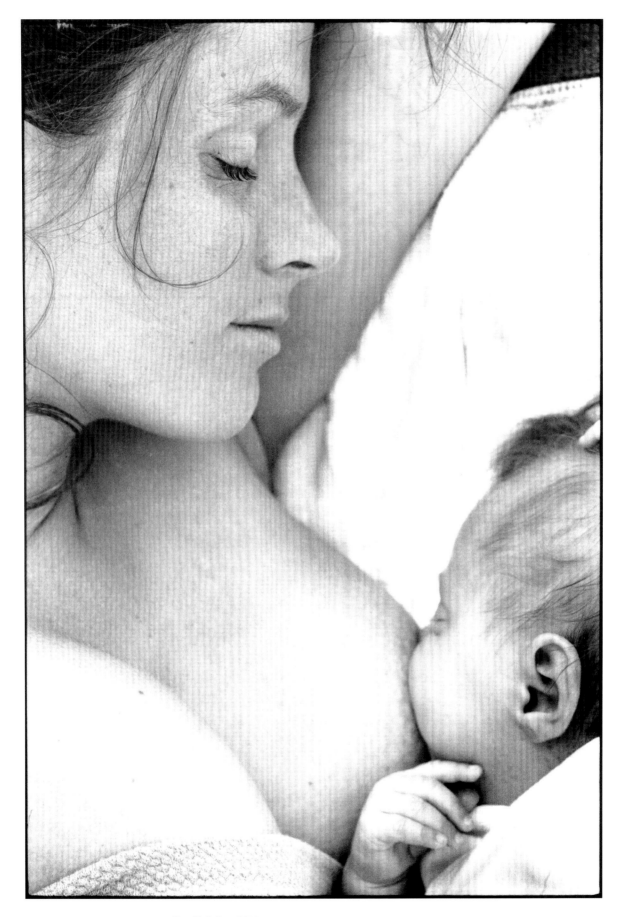

New York City, 1977

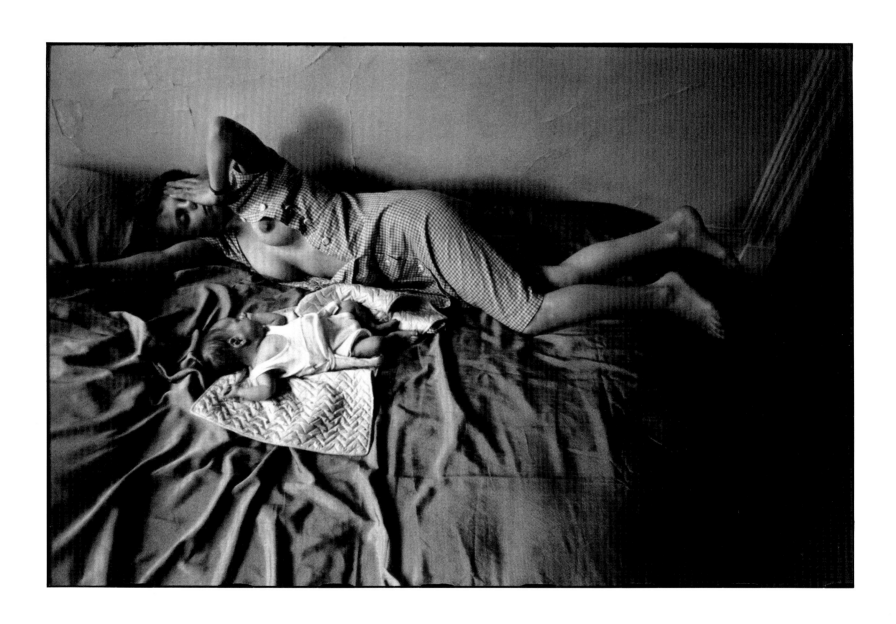

New York City, 1953

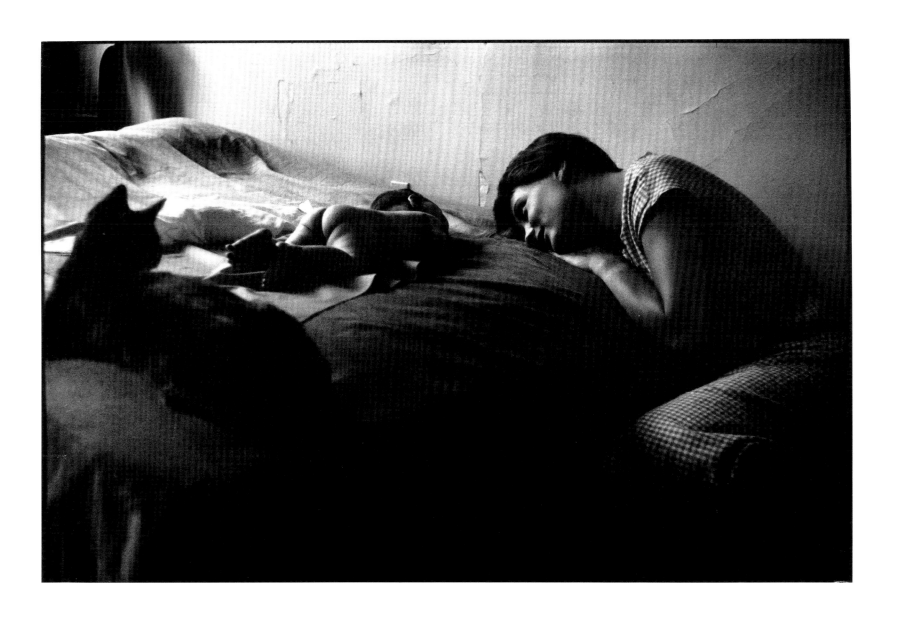

New York City, 1953

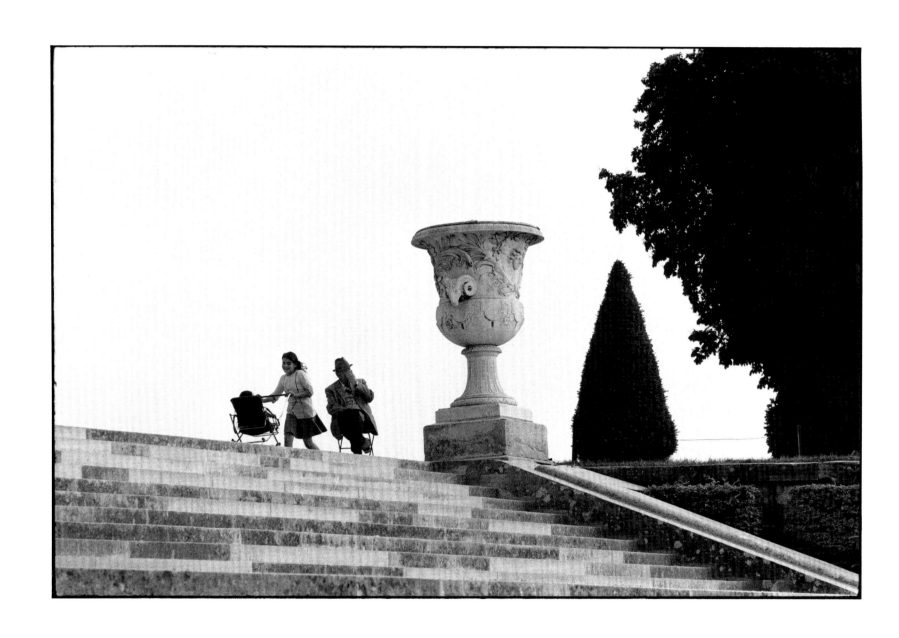

Versailles, 1975

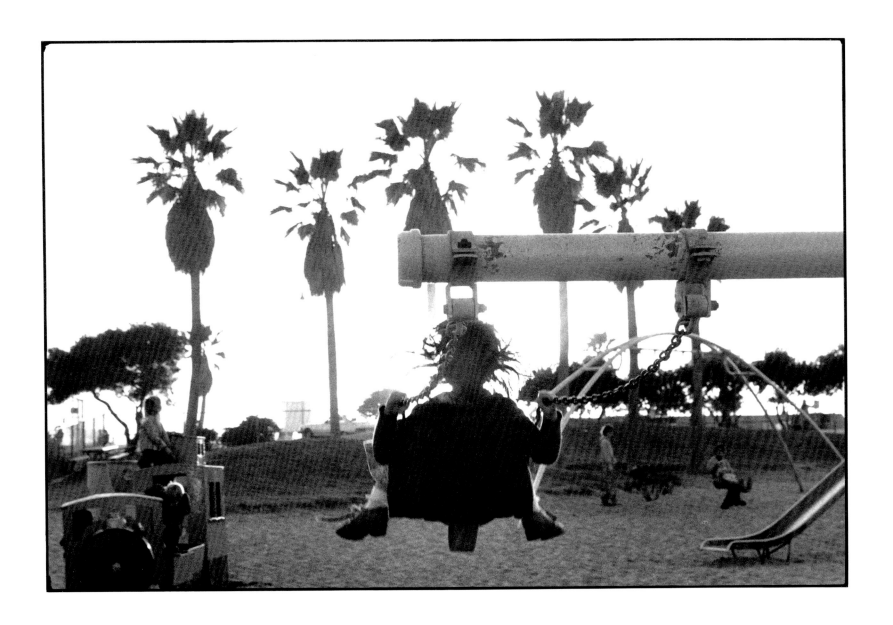

Venice, California, 1976

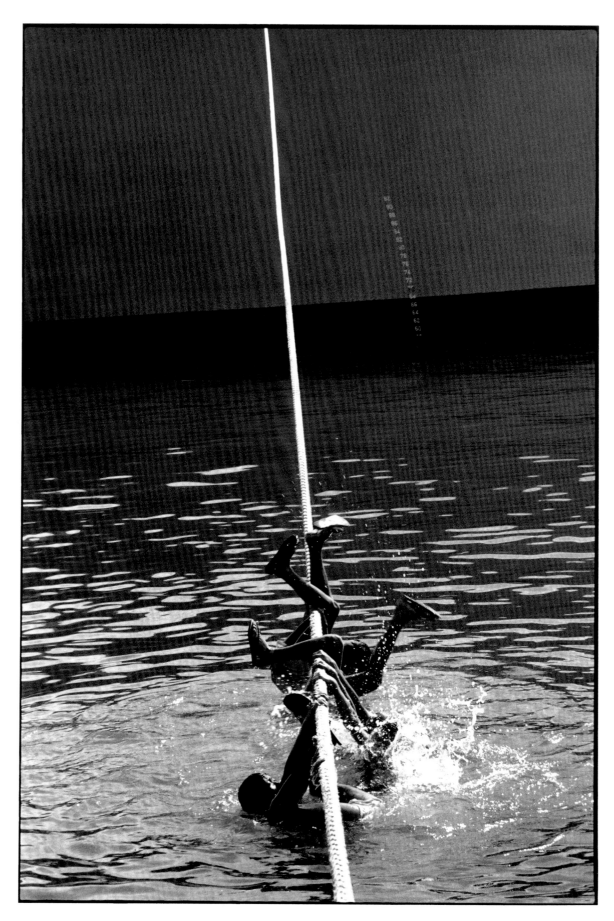

Papeete, Tahiti, 1980

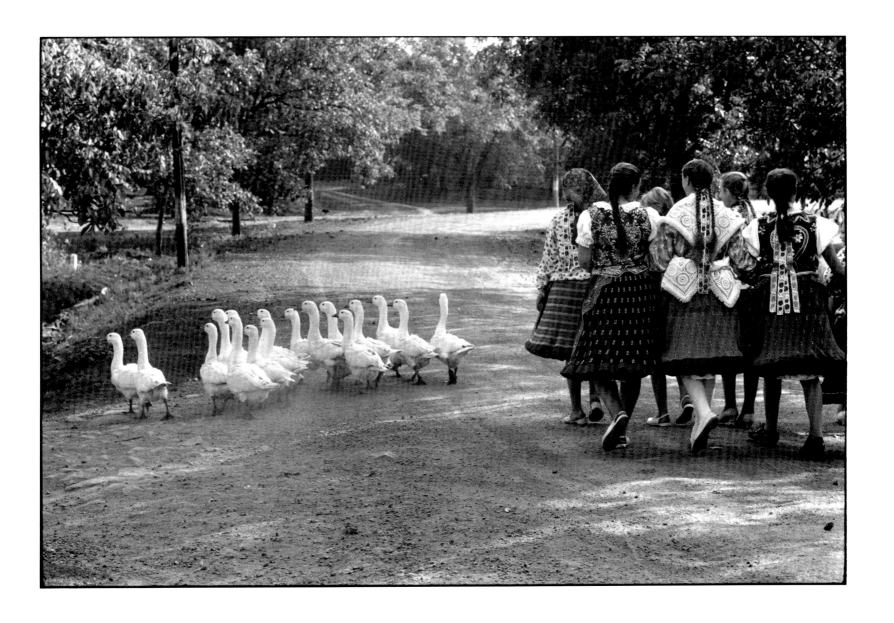

Hungary, 1964

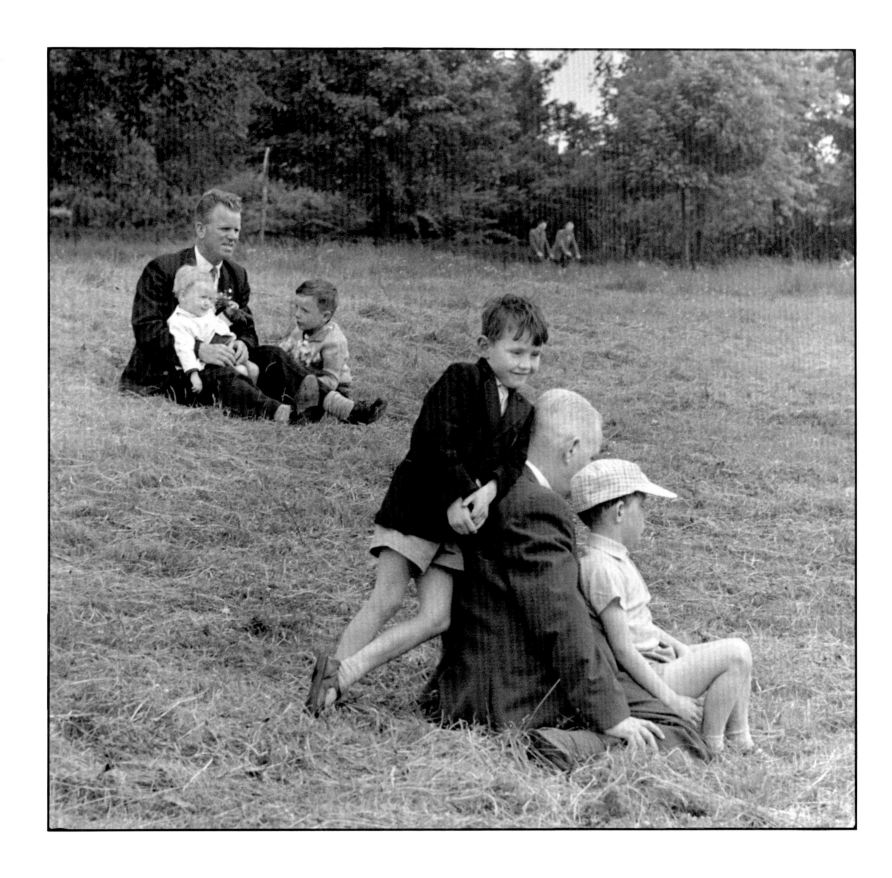

Dublin, 1962

94

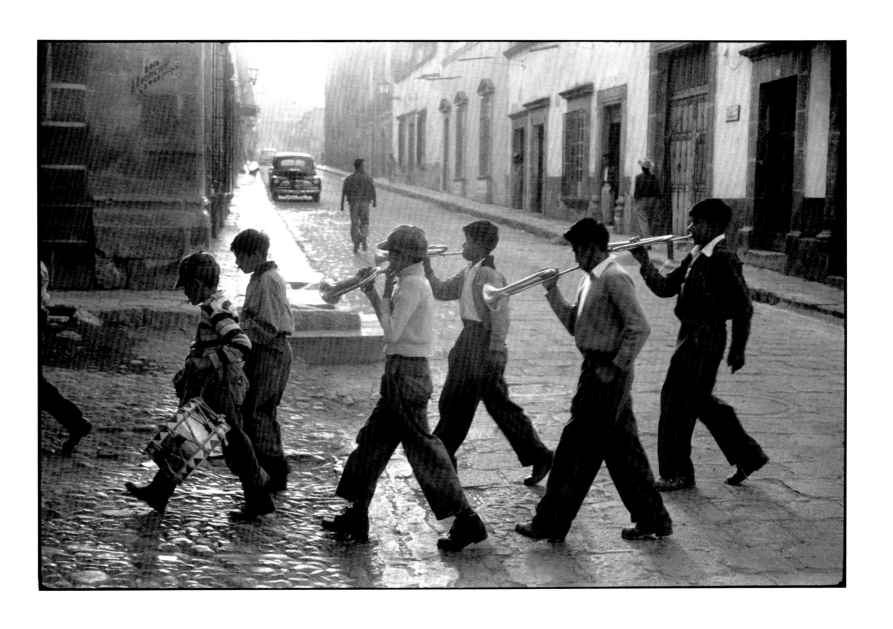

San Miguel de Allende, Mexico, 1957

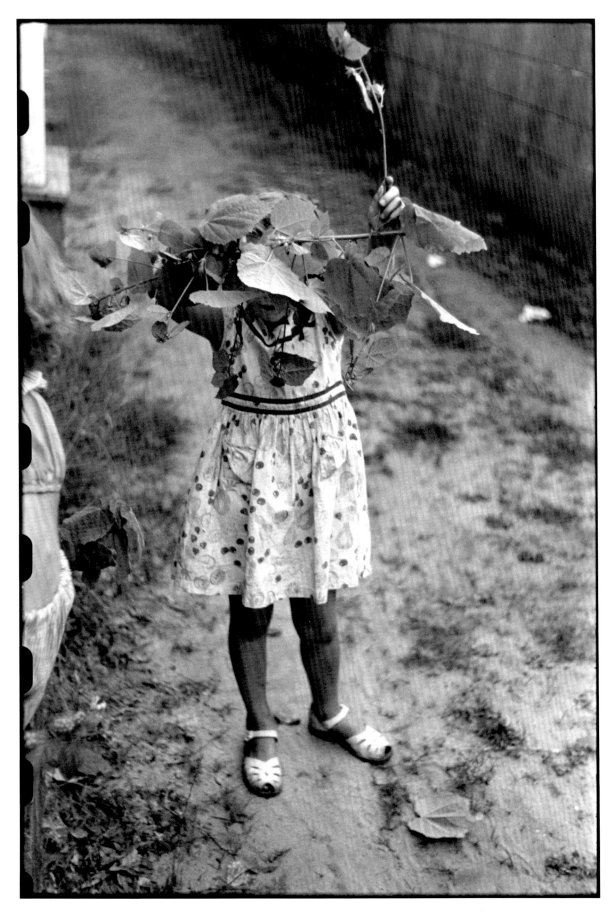

Fernandina, Florida, 1950

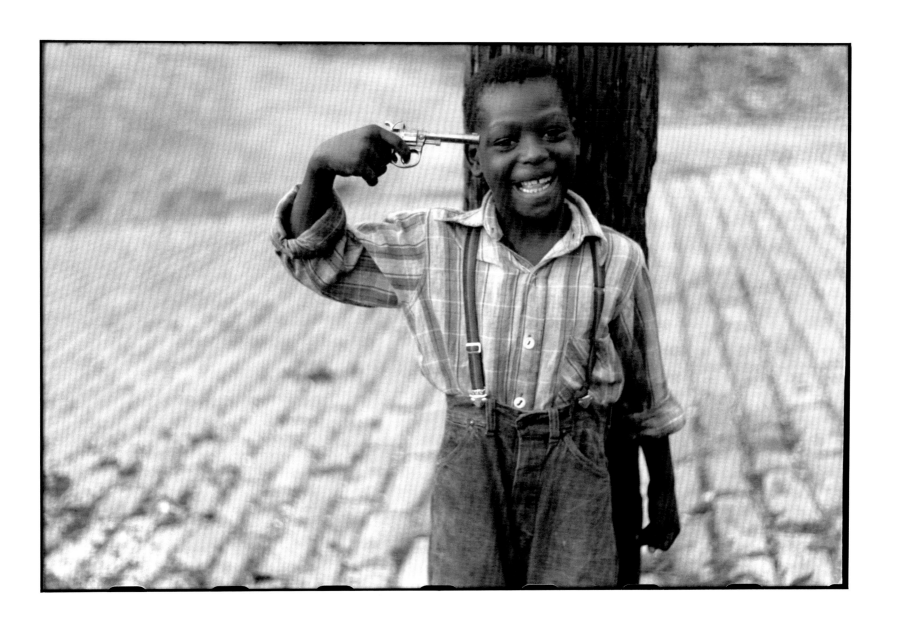

Pittsburgh, 1950

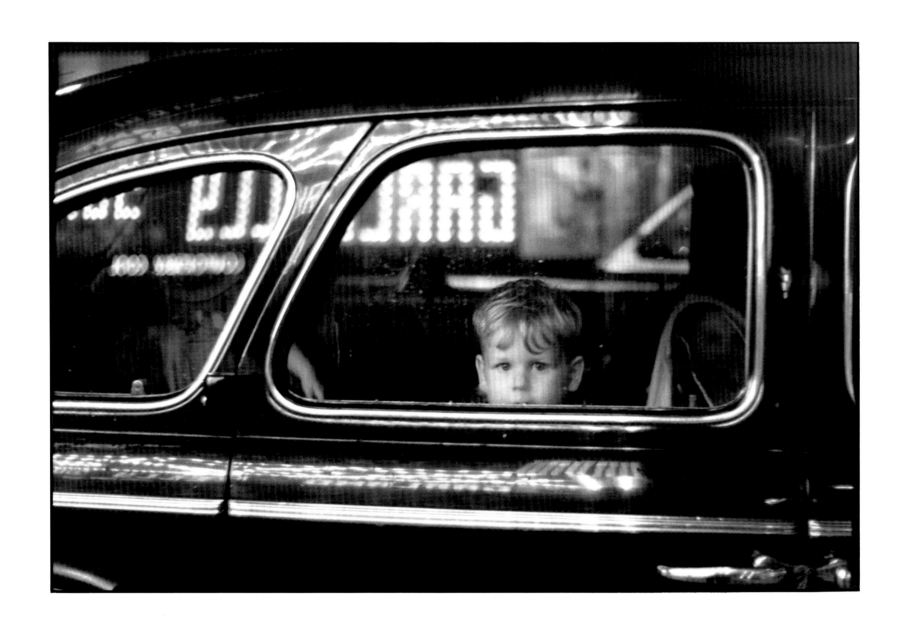

Pittsburgh, 1950

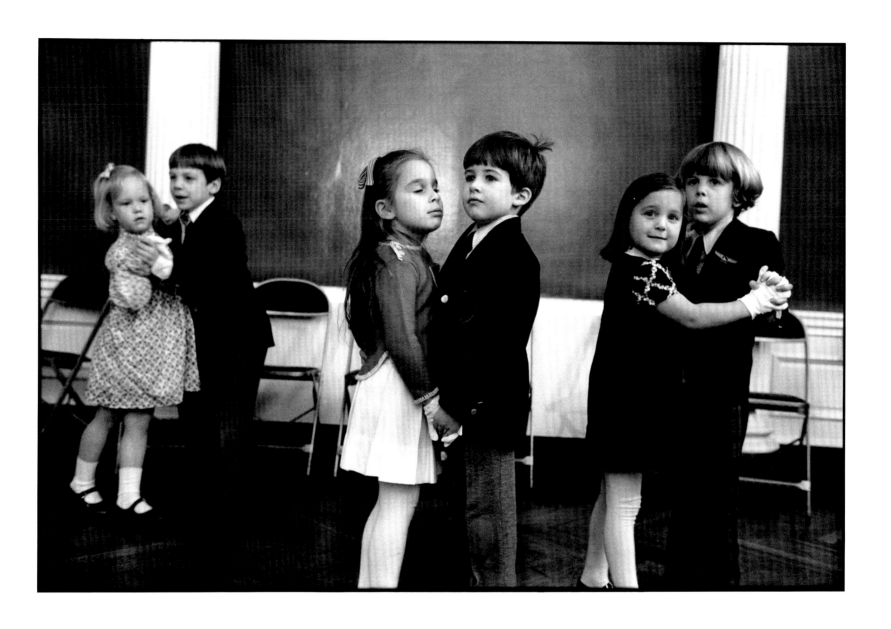

New York City, 1977

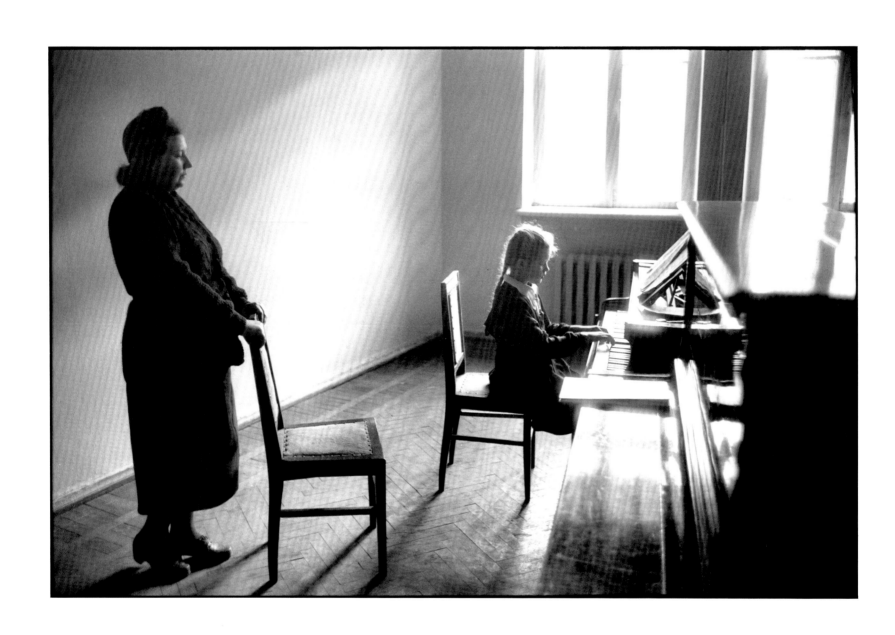

Odessa, U.S.S.R., 1957

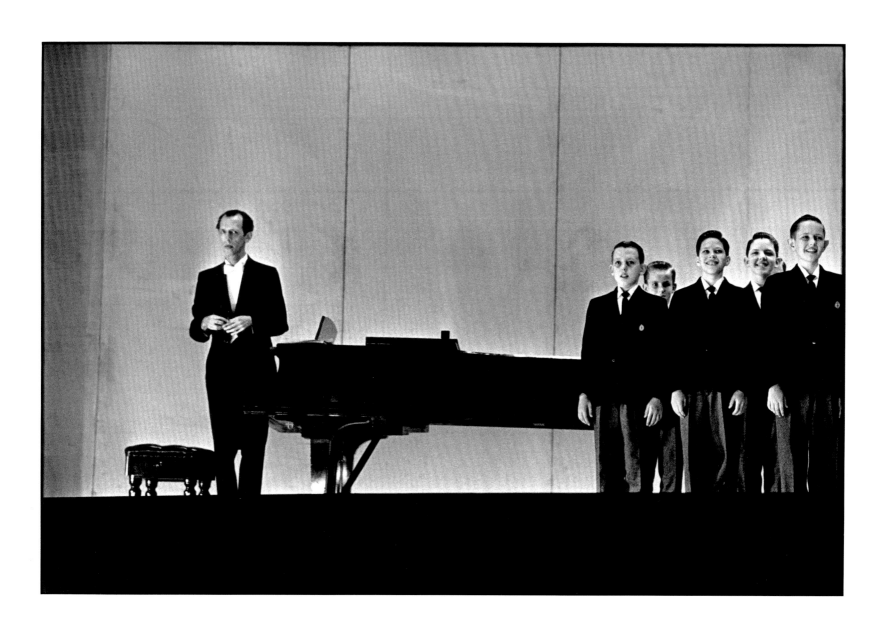

Fort Worth, Texas, 1963

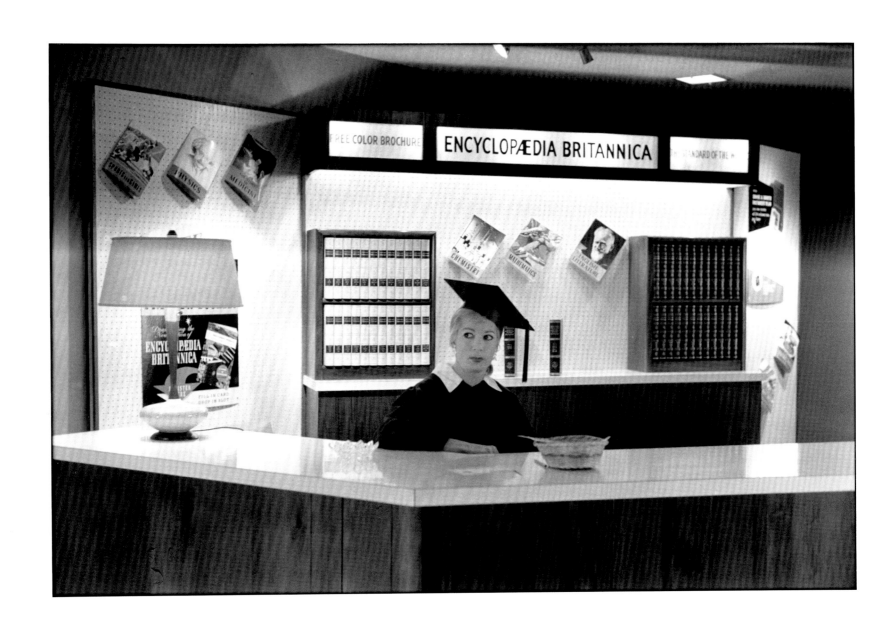

Dallas, Texas, 1962

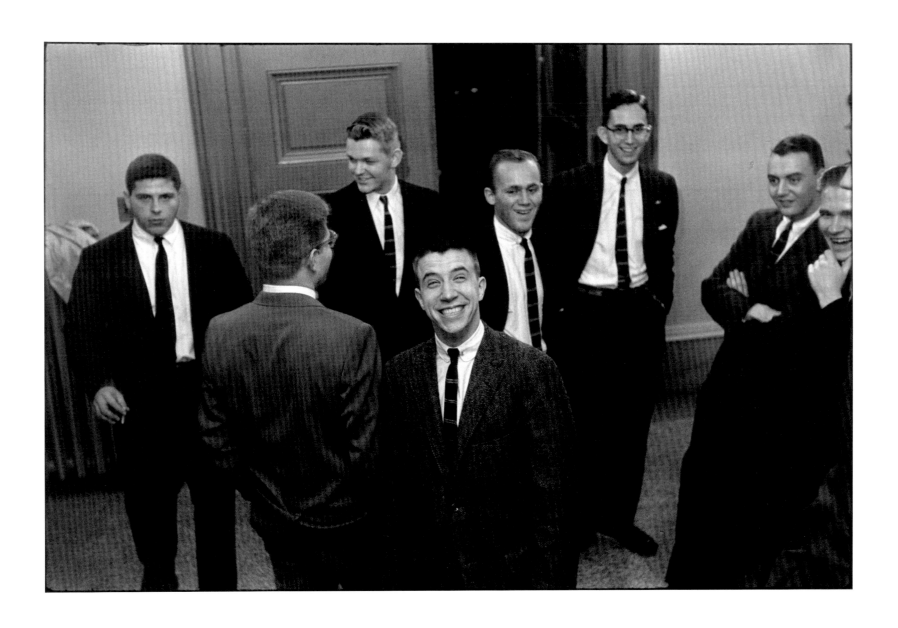

New Haven, Connecticut, 1955

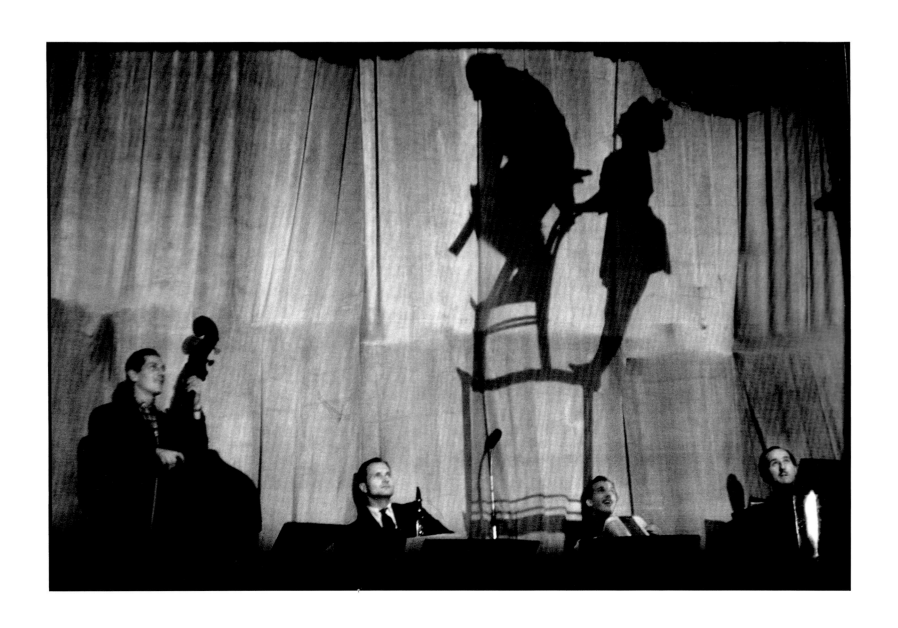

Paris, 1952

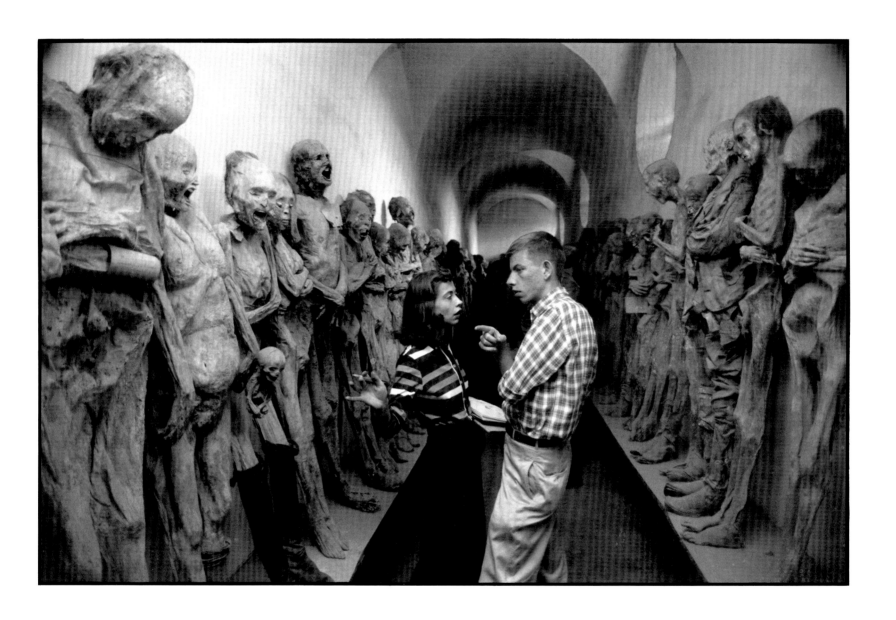

Guanajuato, Mexico, 1957

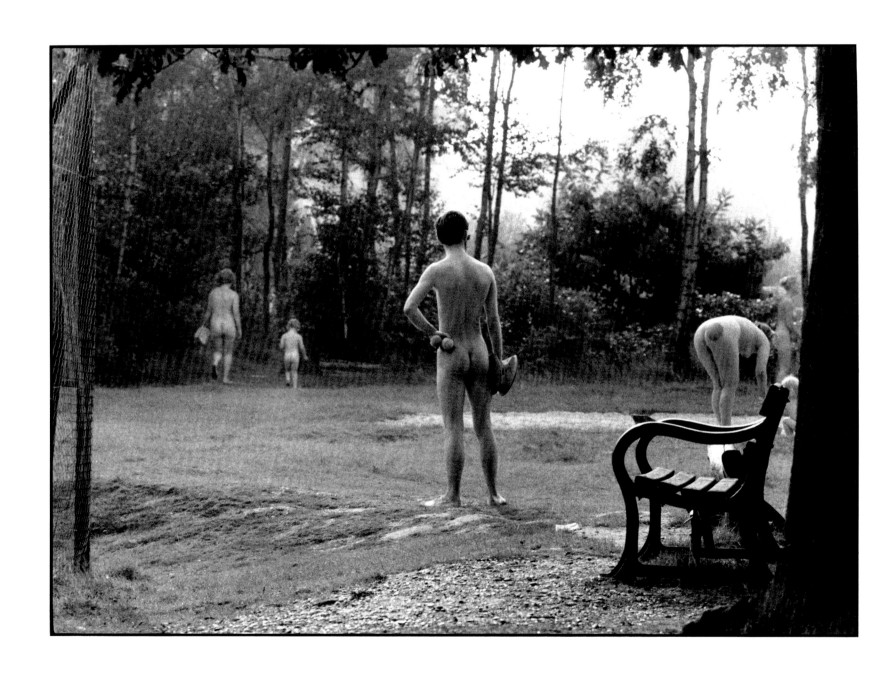

Kent, England, 1968

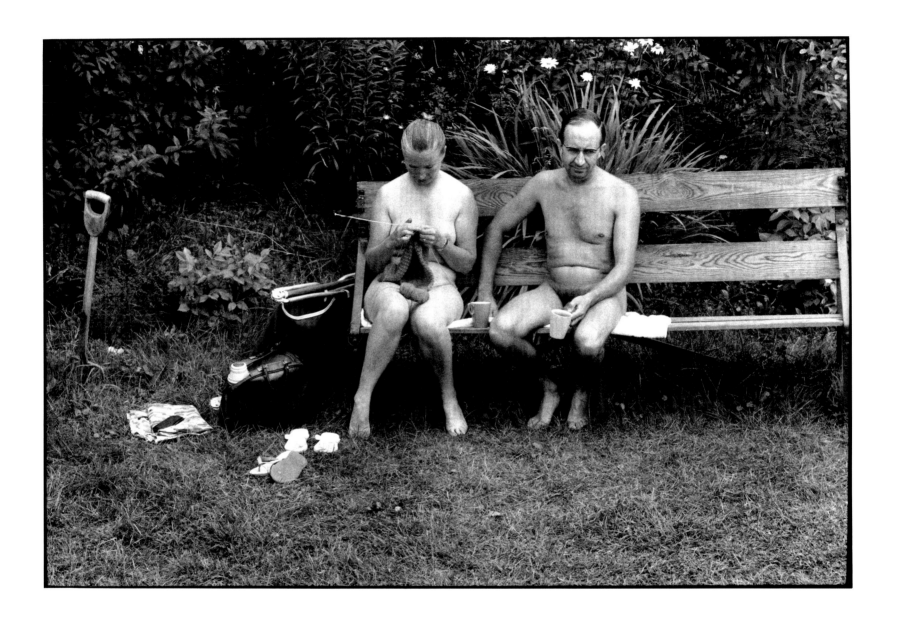

Kent, England, 1968

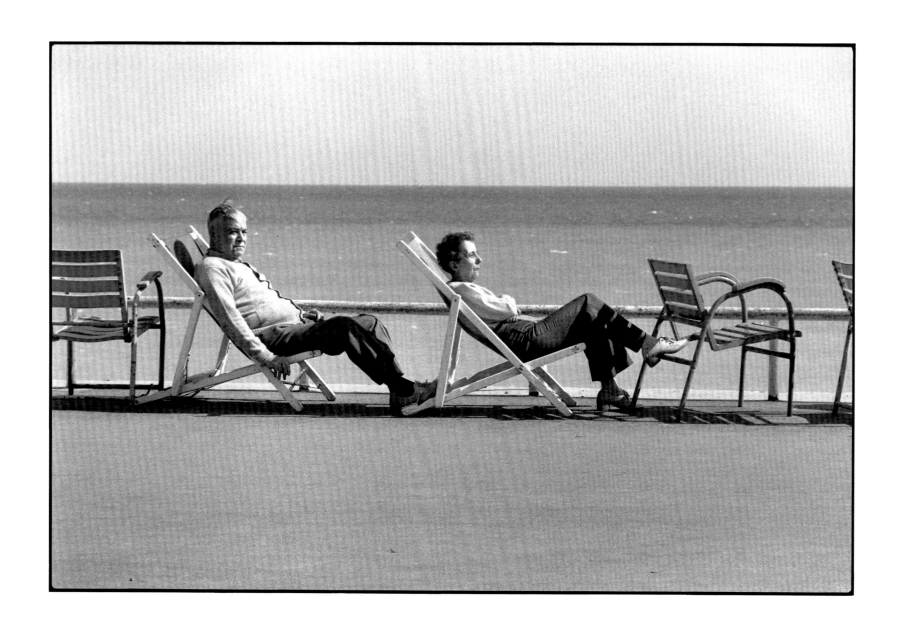

Cannes, 1975

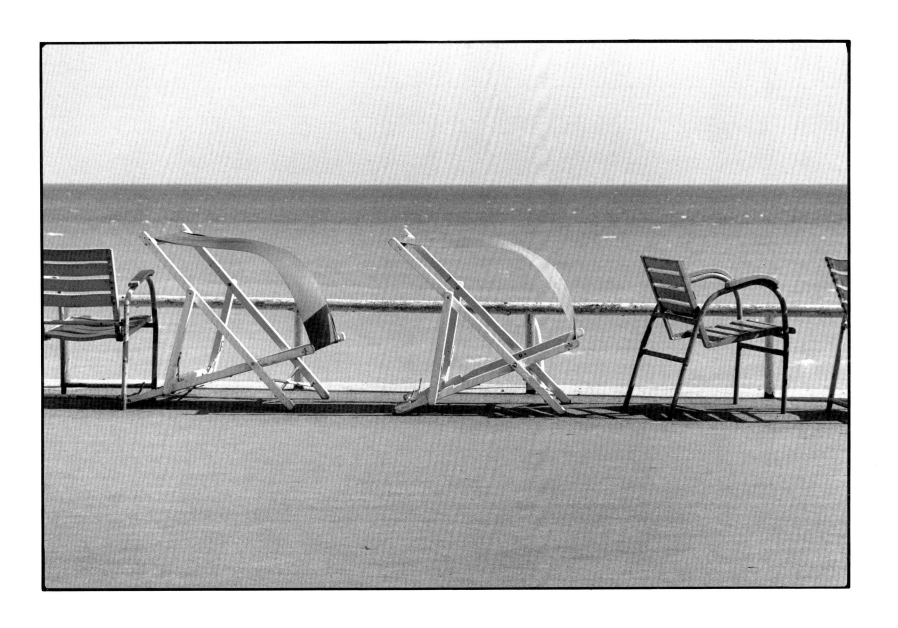

Cannes, 1975

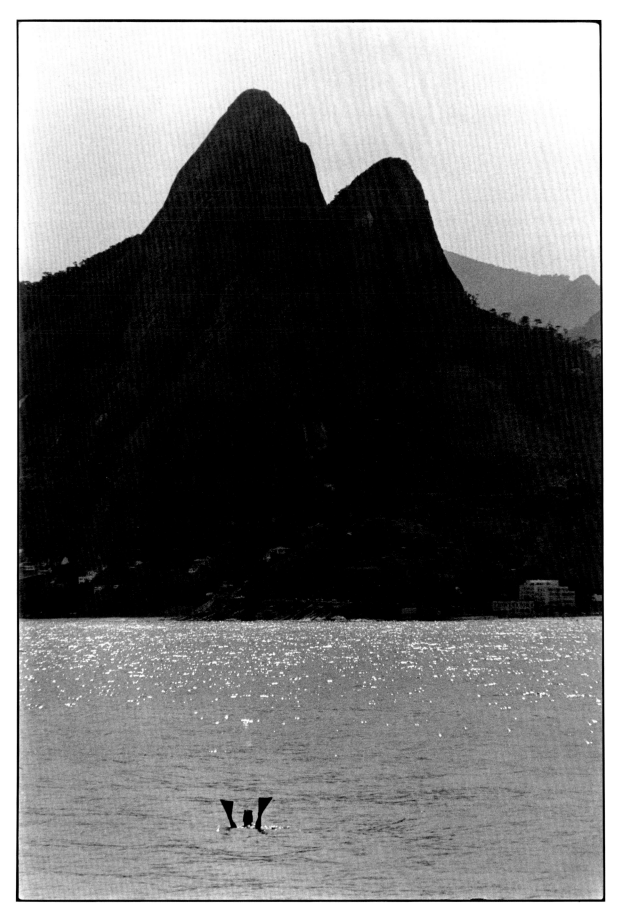

Rio de Janeiro, 1963

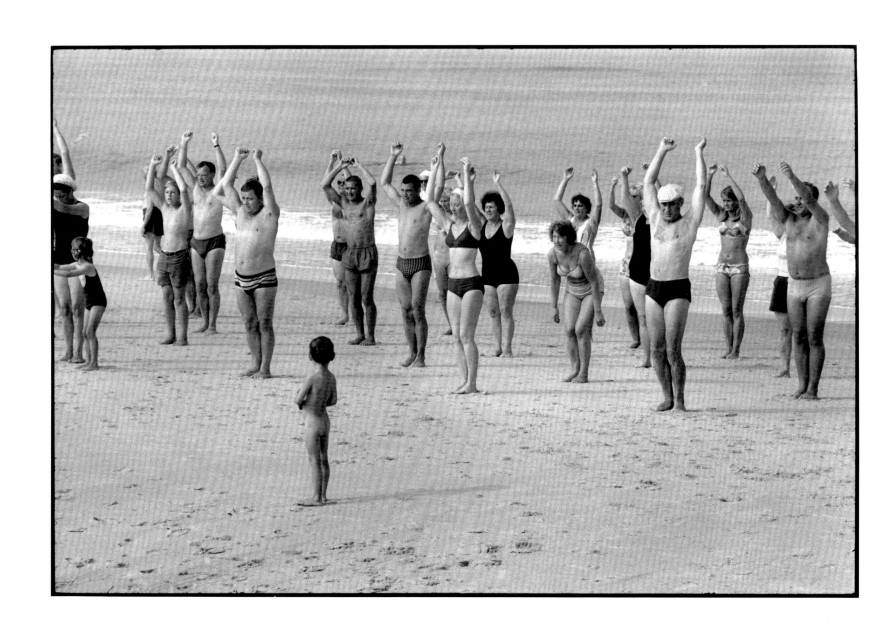

Sylt, West Germany, 1968

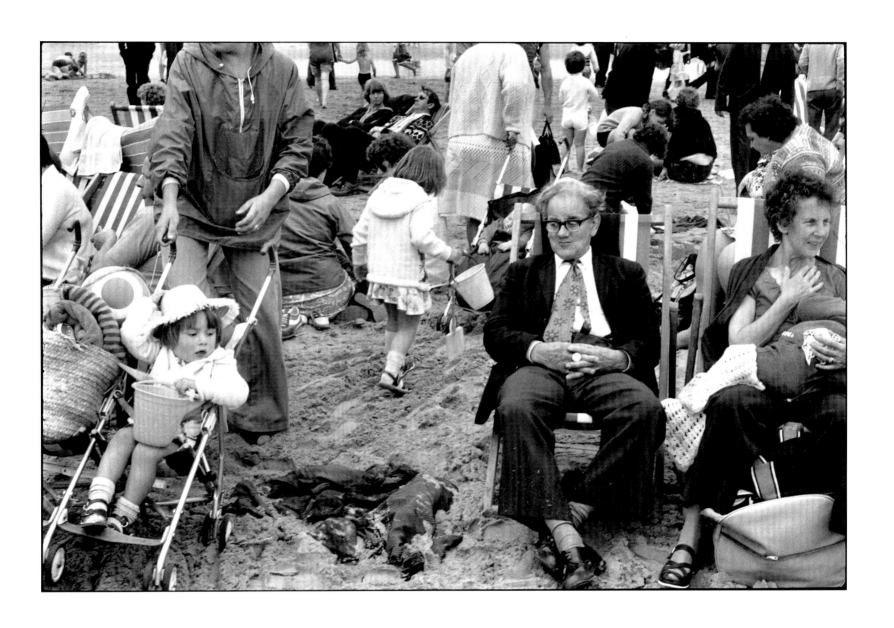

Blackpool, England, 1978

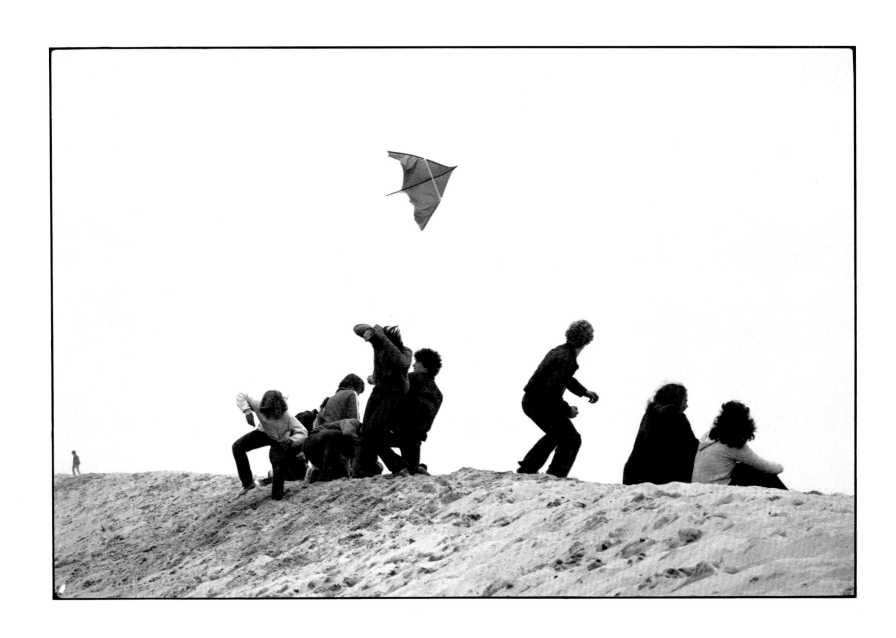

East Hampton, New York, 1976

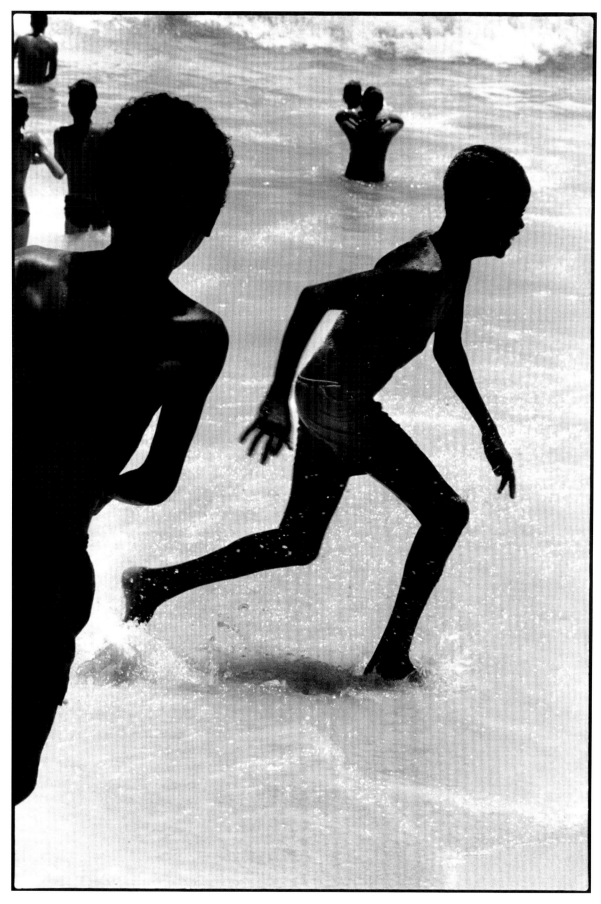

Rio de Janeiro, 1984

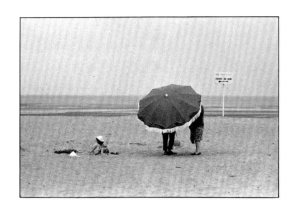 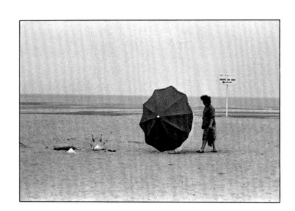 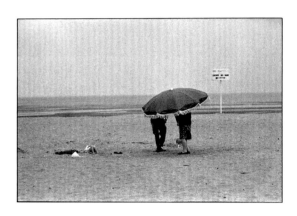

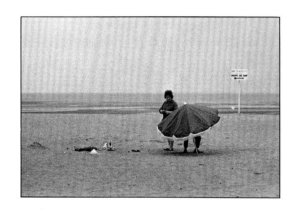 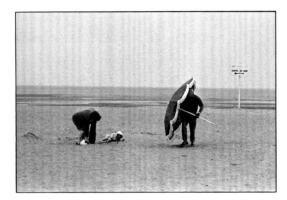 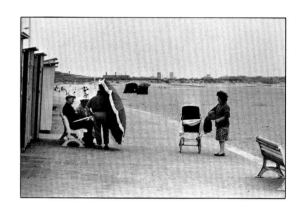

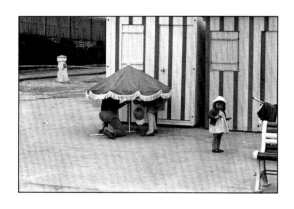 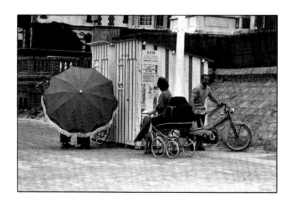 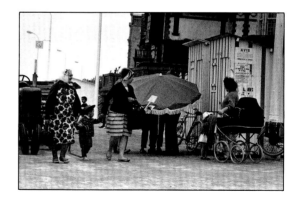

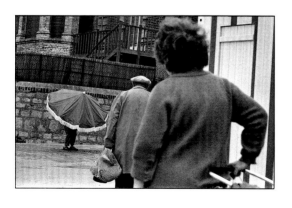 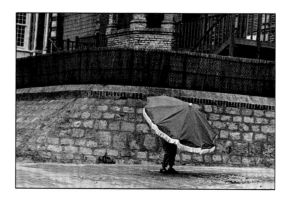 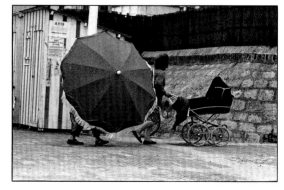

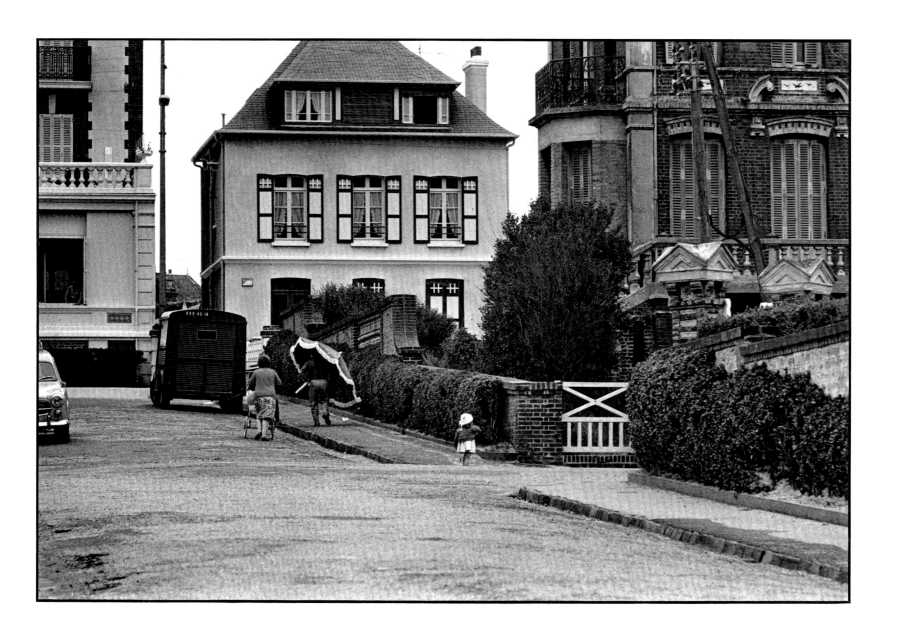

Trouville, France, 1965

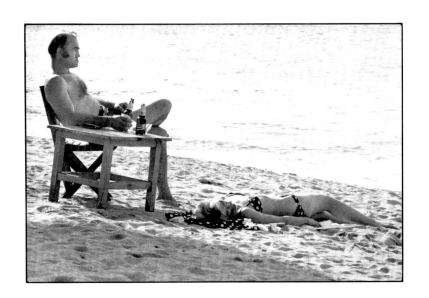 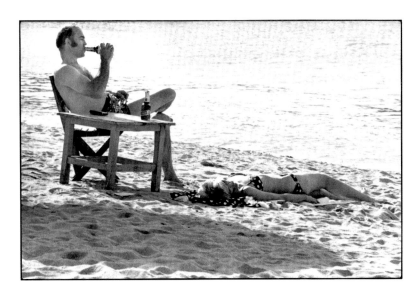

Mexico, 1973

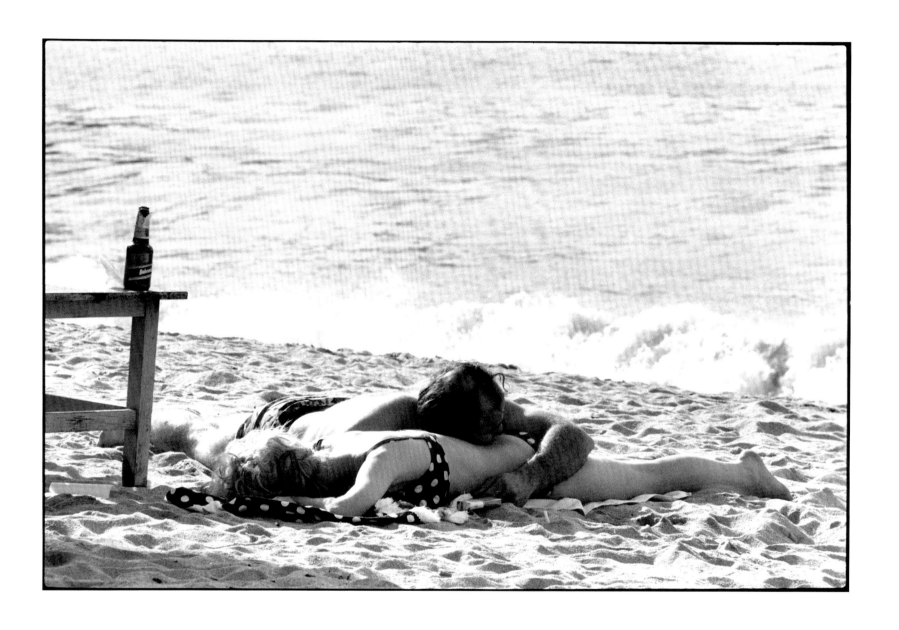

Mexico, 1973

119

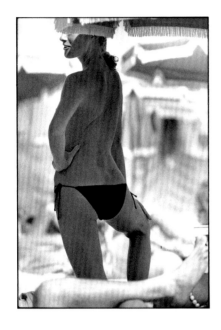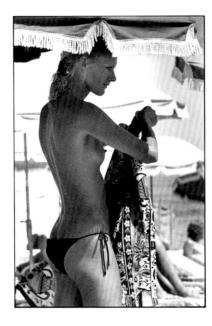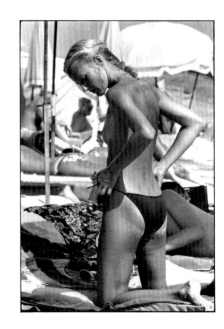
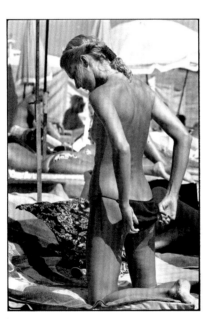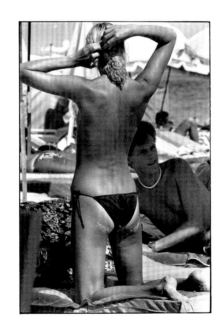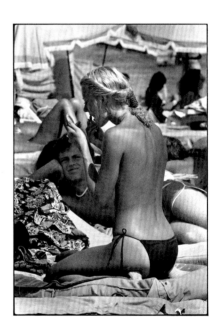
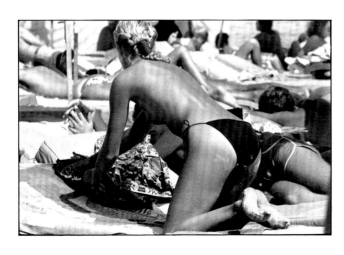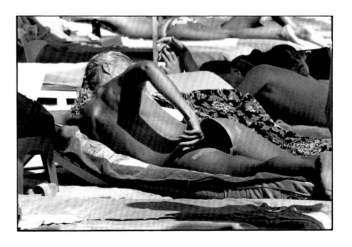

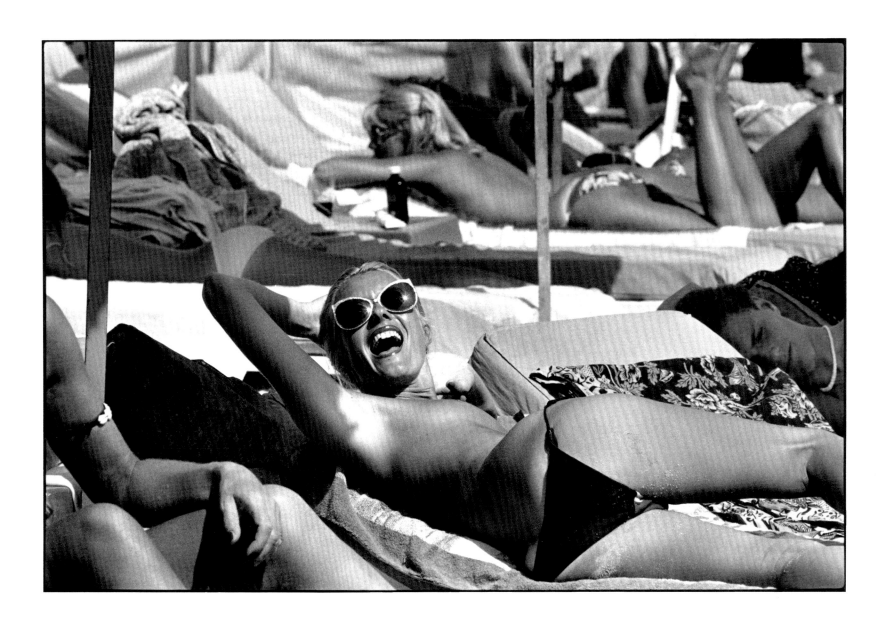

Saint Tropez, 1978

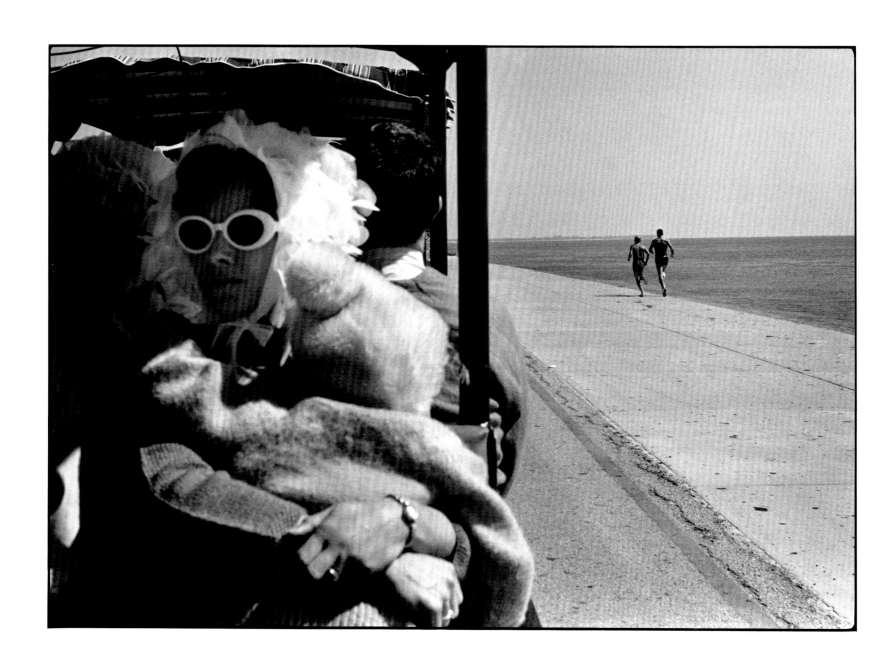

Key West, Florida, 1968

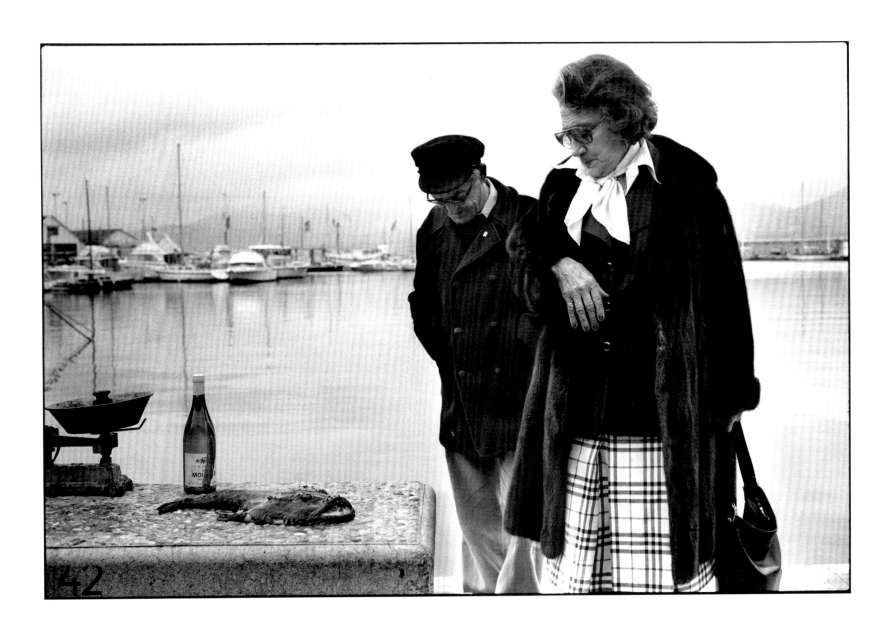

Saint Tropez, 1979

123

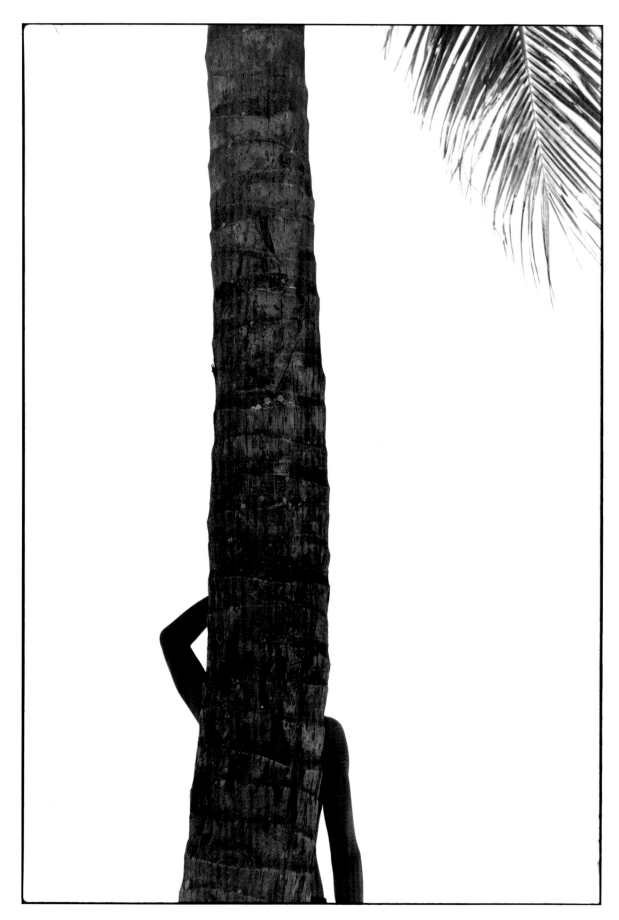

Tahiti, 1980

124

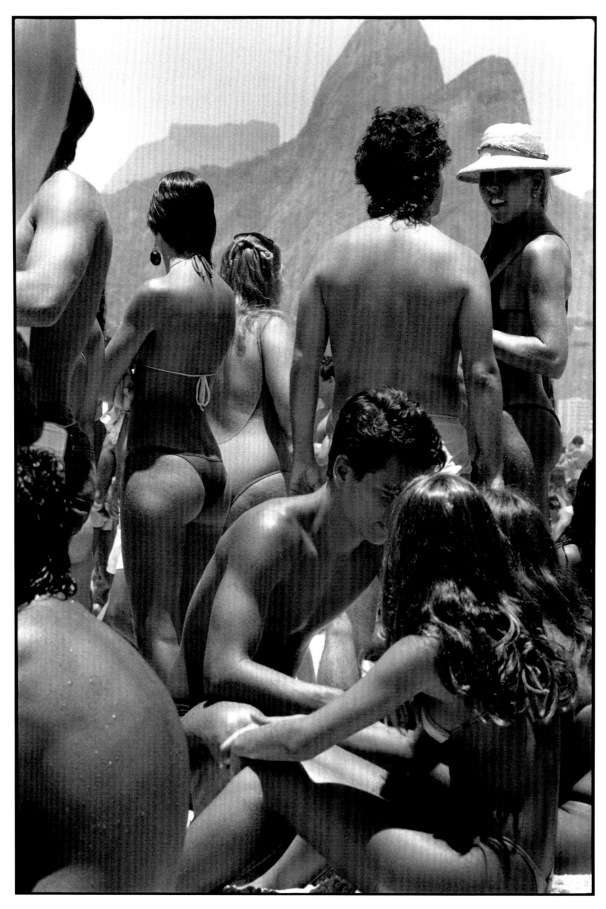

Rio de Janeiro, 1984

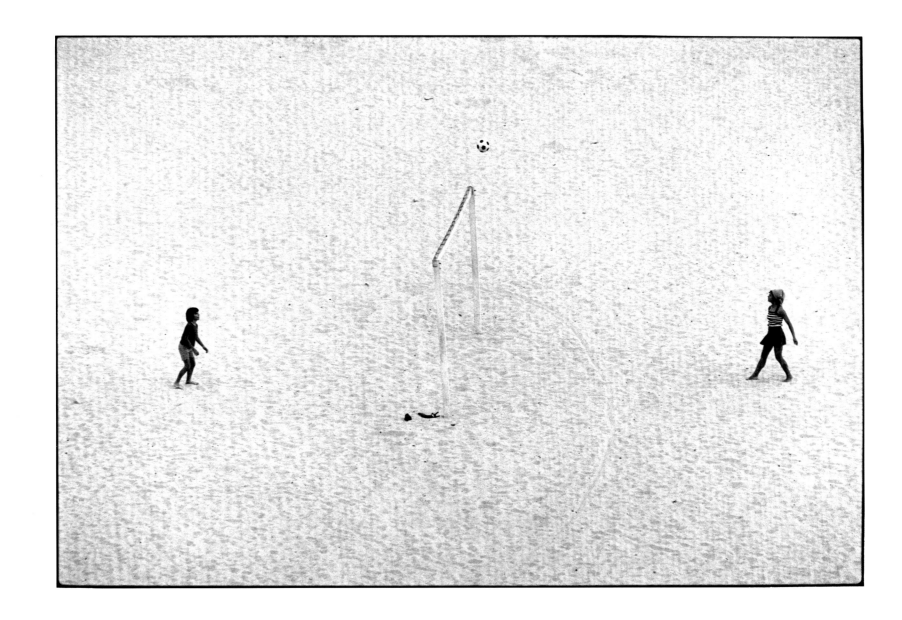

Rio de Janeiro, 1973

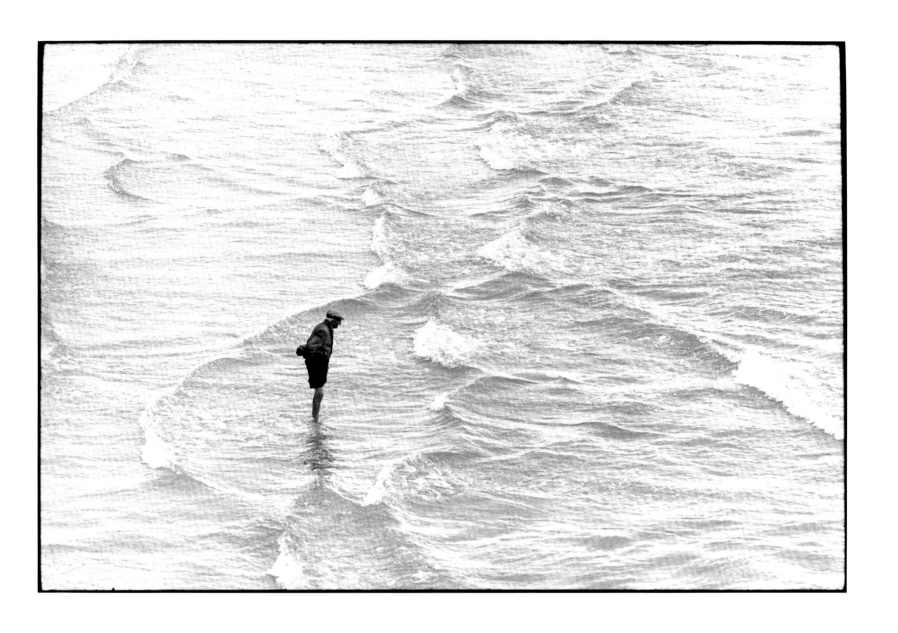

Brighton, England, 1966

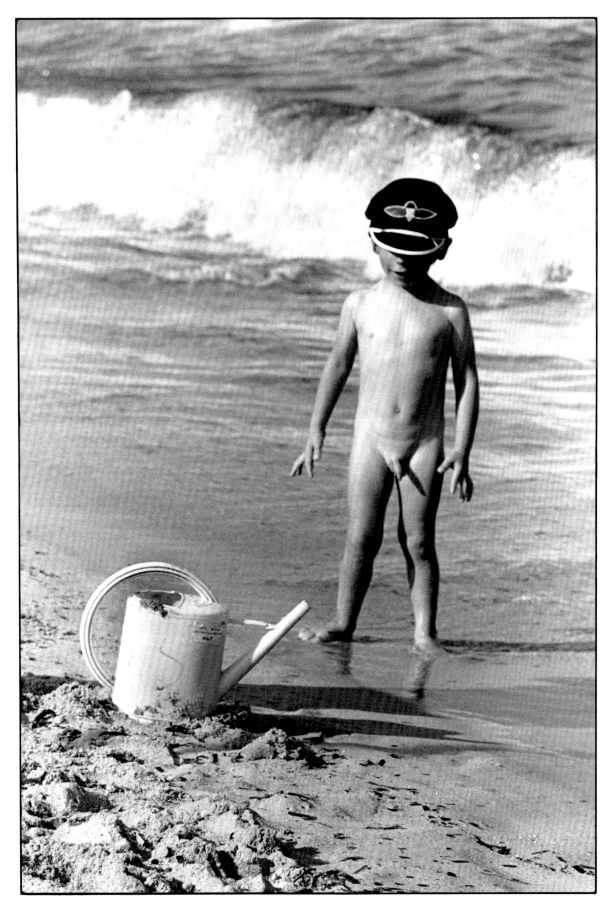

Saint Tropez, 1978

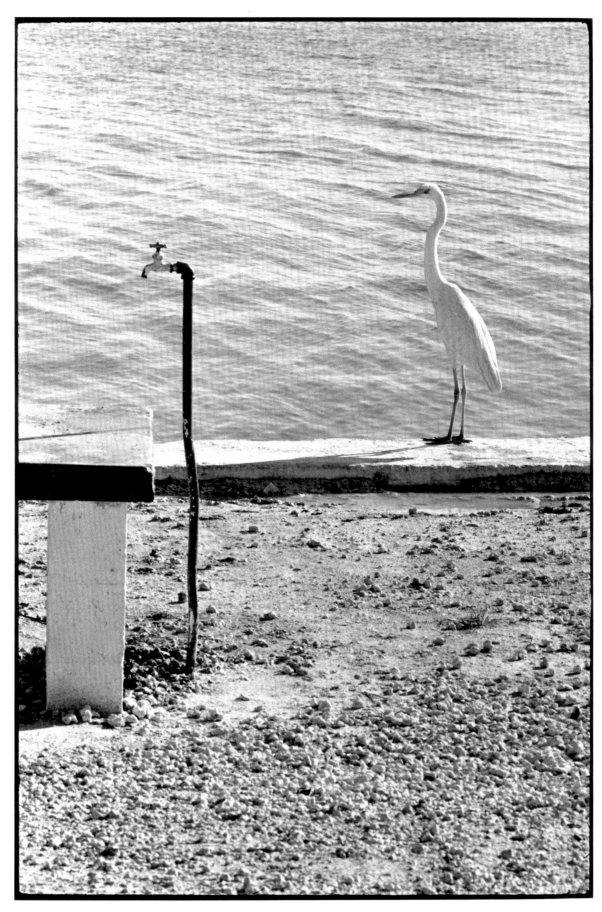

Florida Keys, 1968

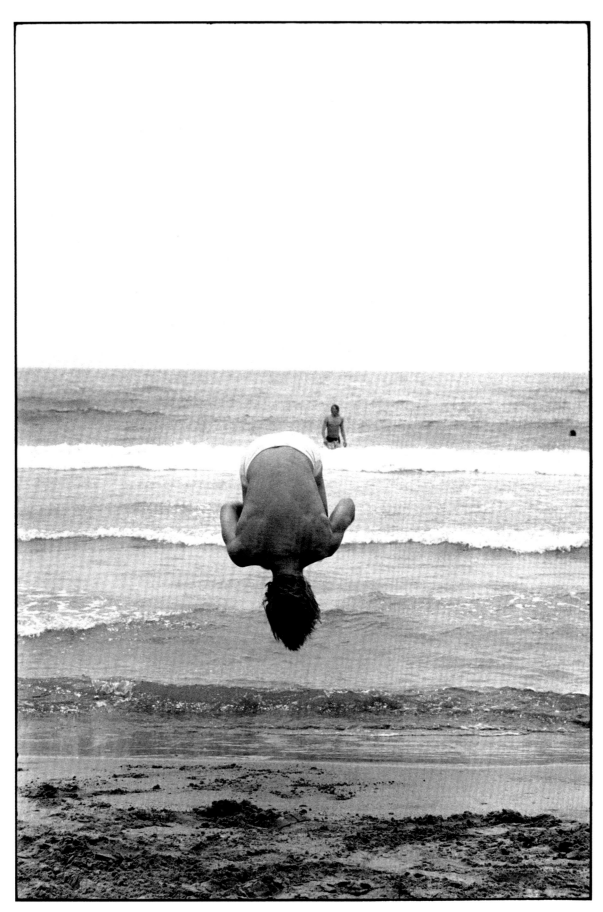

Saintes Maries de la Mer, France, 1977

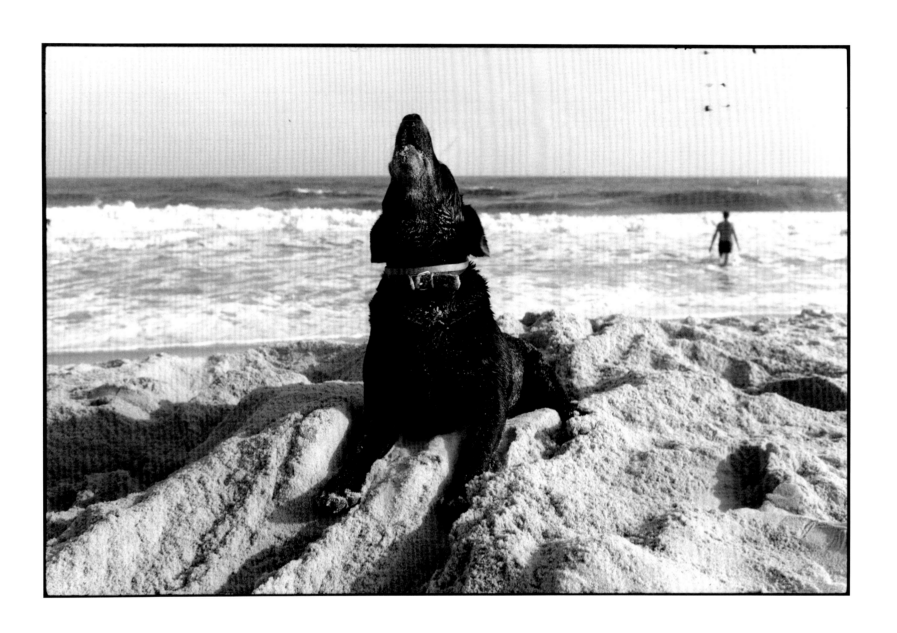

East Hampton, New York, 1981

131

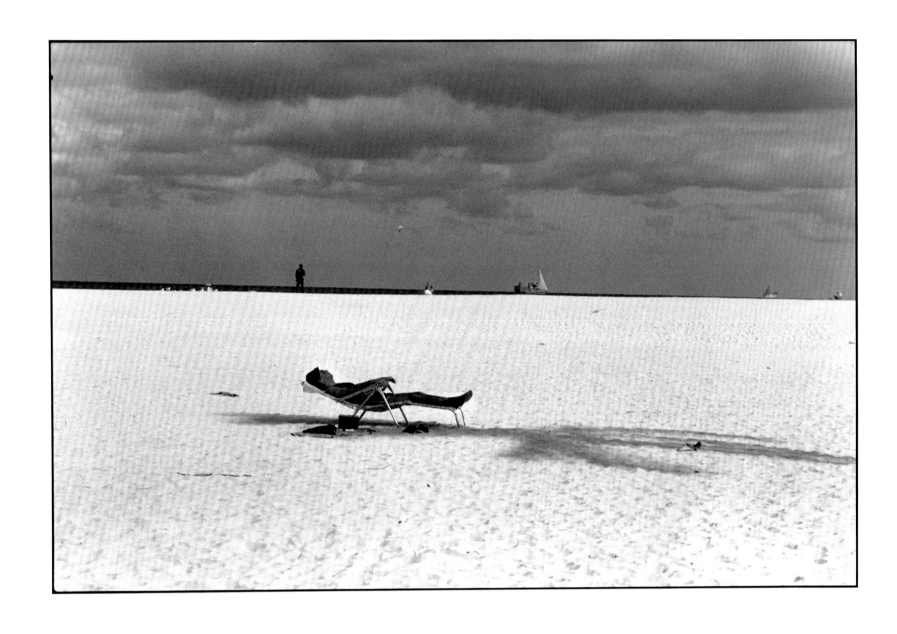

Miami Beach, Florida, 1984

Daytona Beach, Florida, 1975

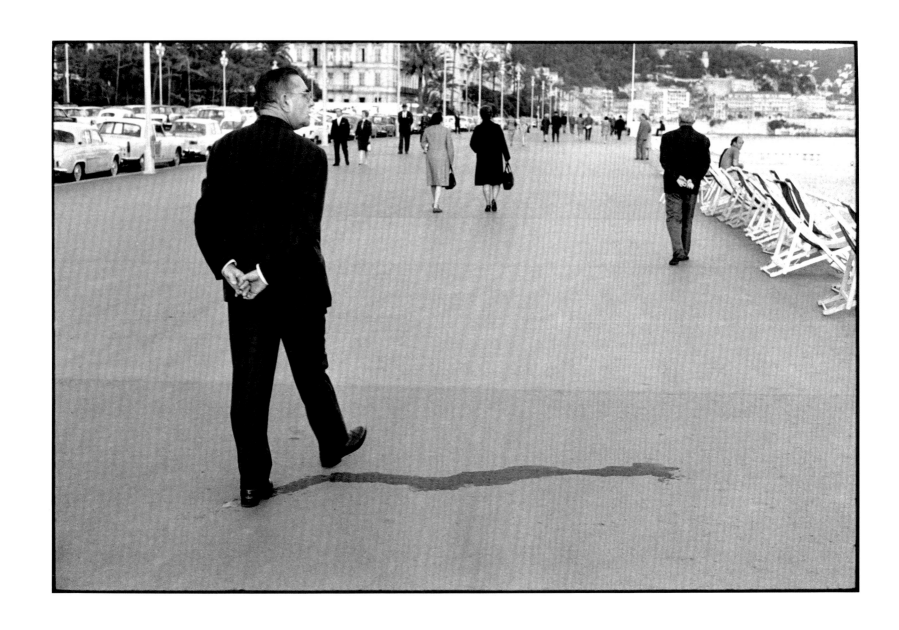

Nice, 1968

134

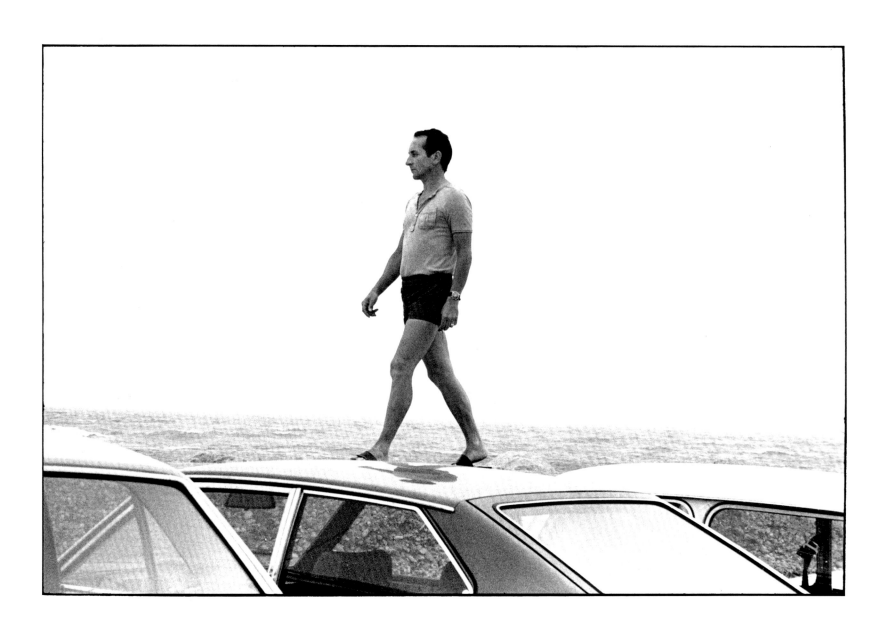

Saintes Maries de la Mer, France, 1977

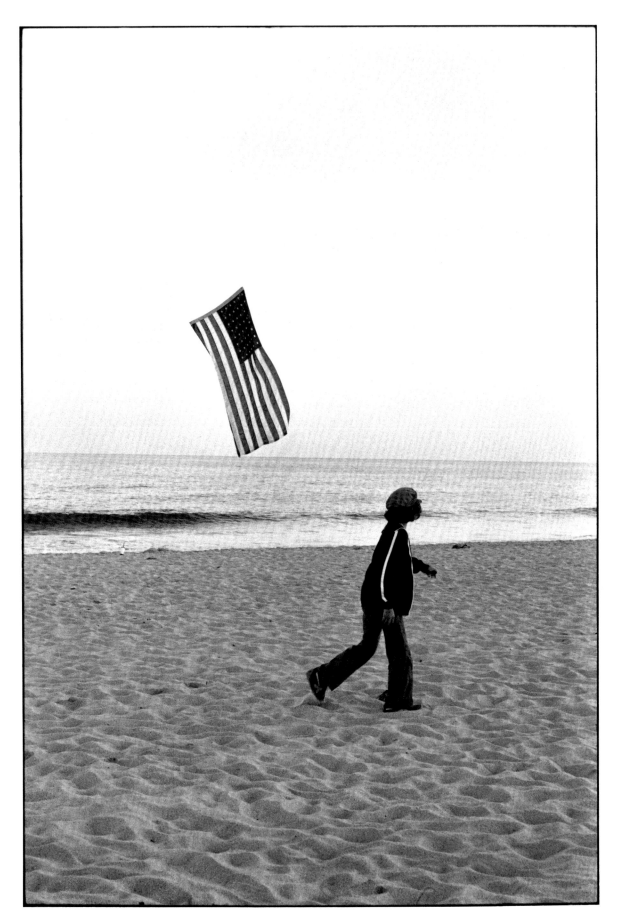

East Hampton, New York, 1977

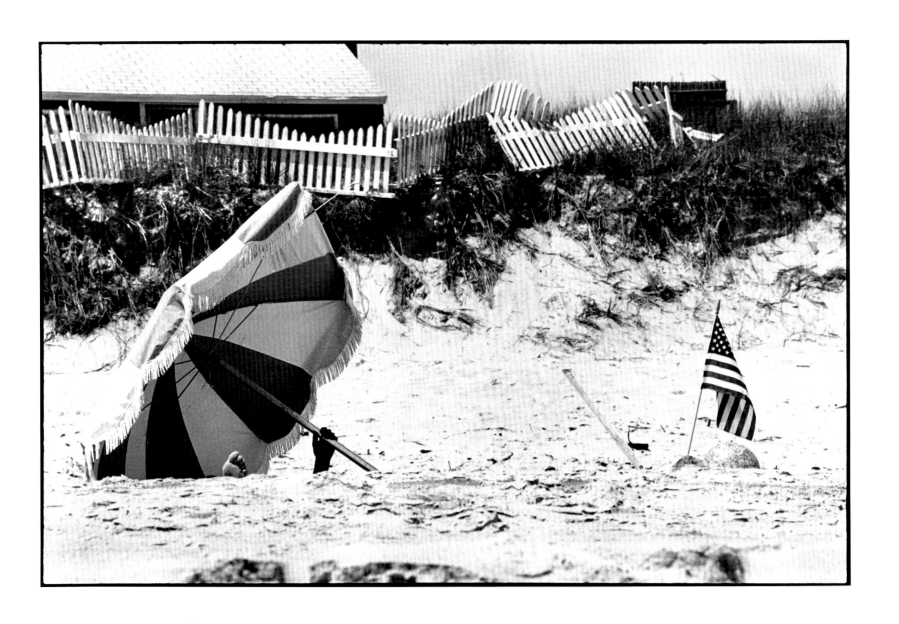

Amagansett, New York, 1969

137

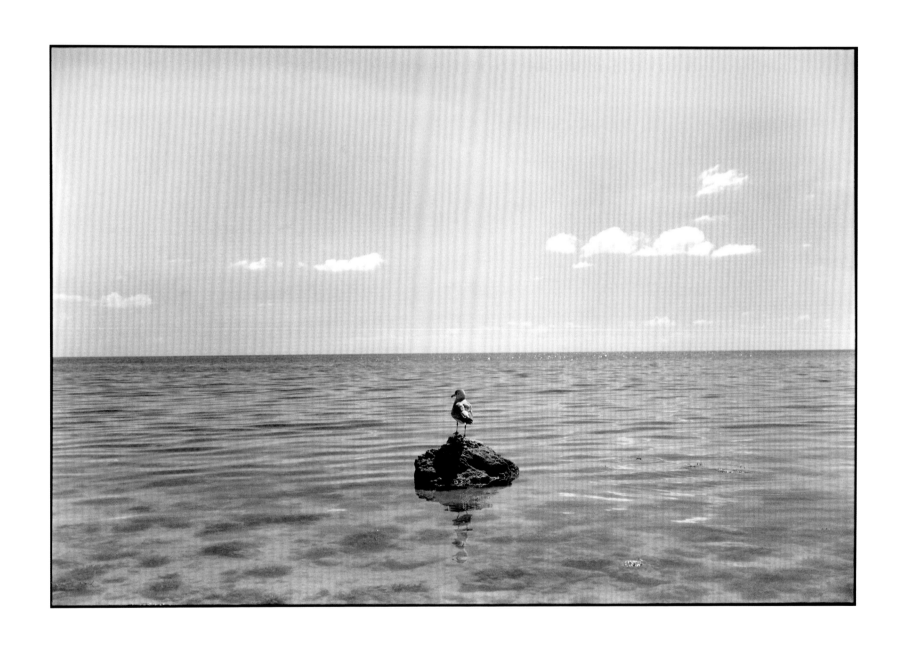

Key West, Florida, 1982

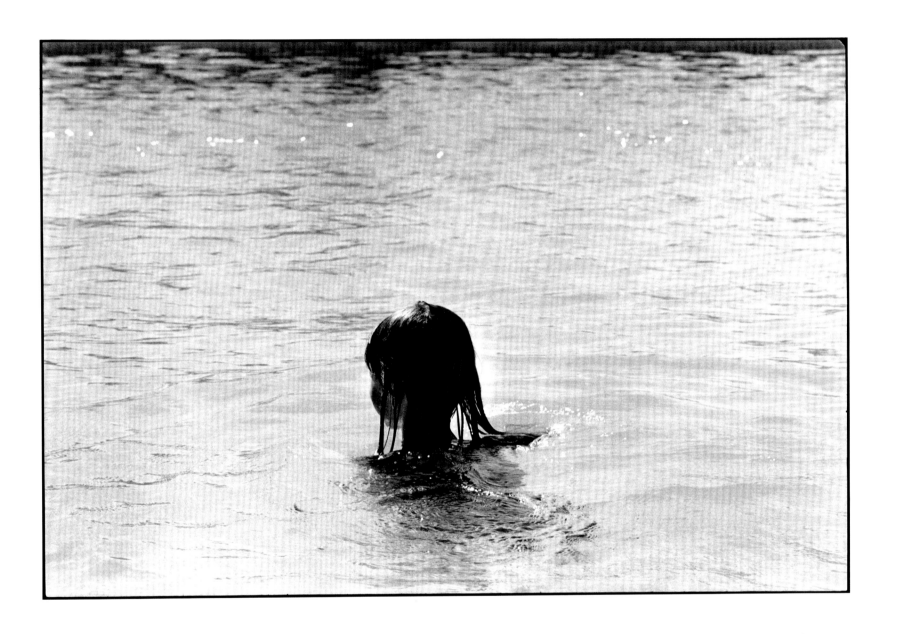

Acapulco, Mexico, 1988

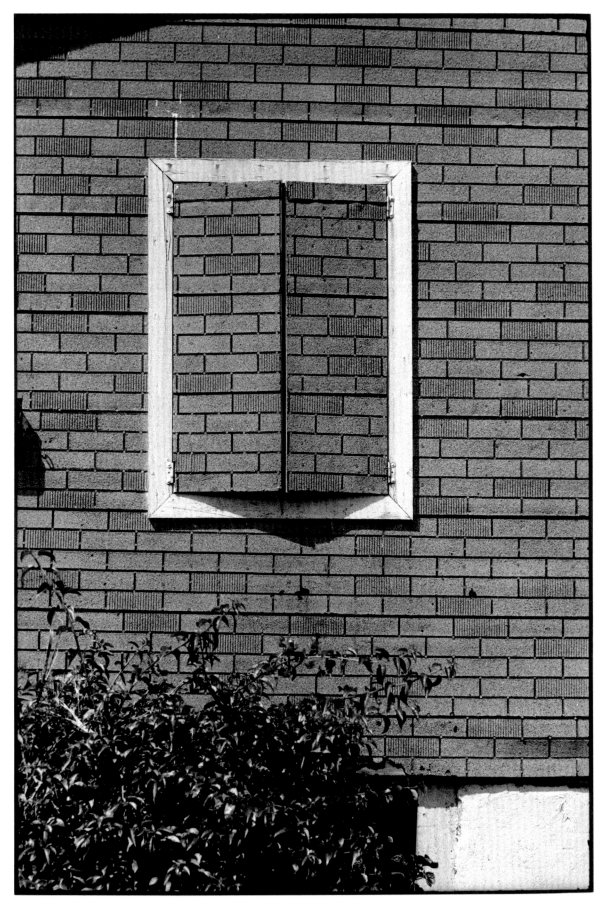

Puerto Rico, 1969

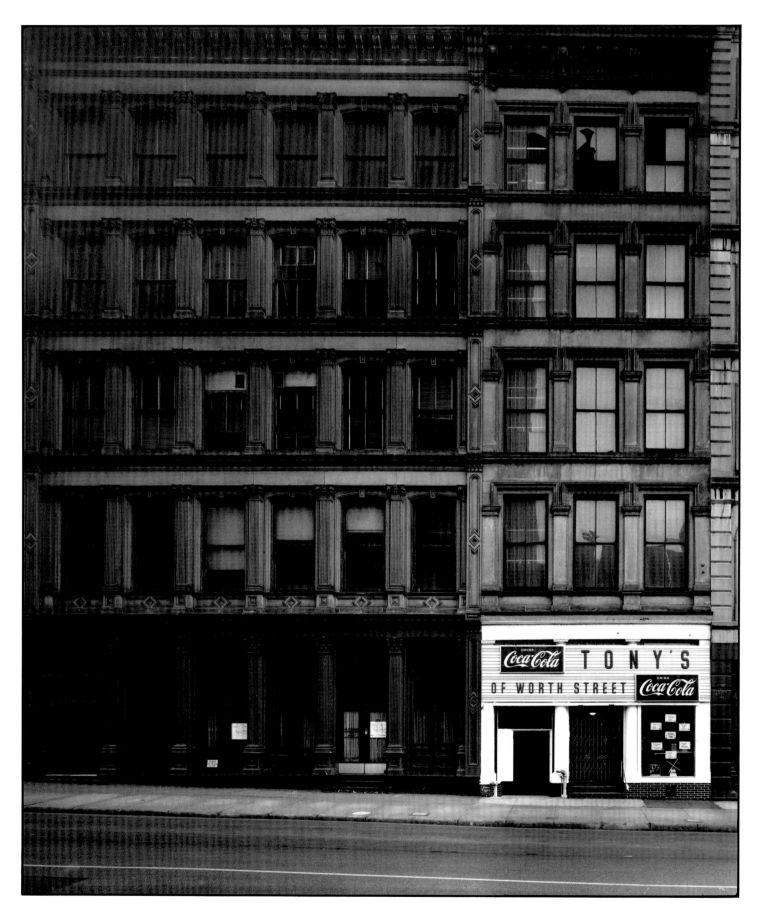

New York City, 1969

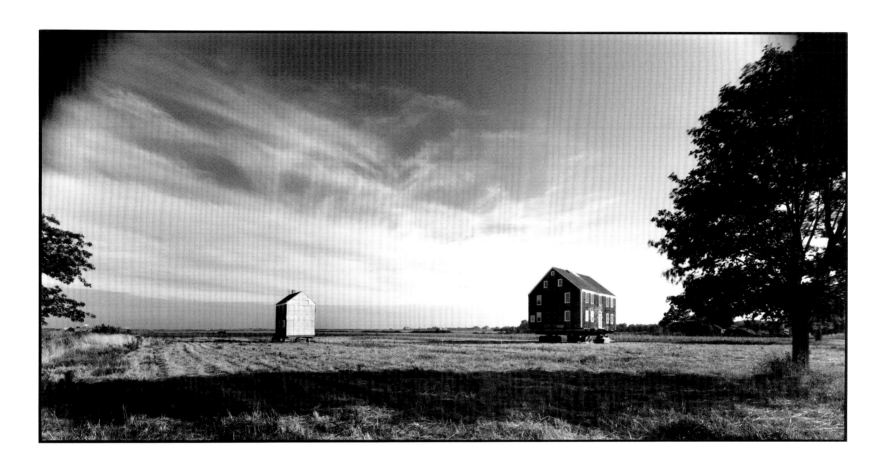

Bridgehampton, New York, 1982

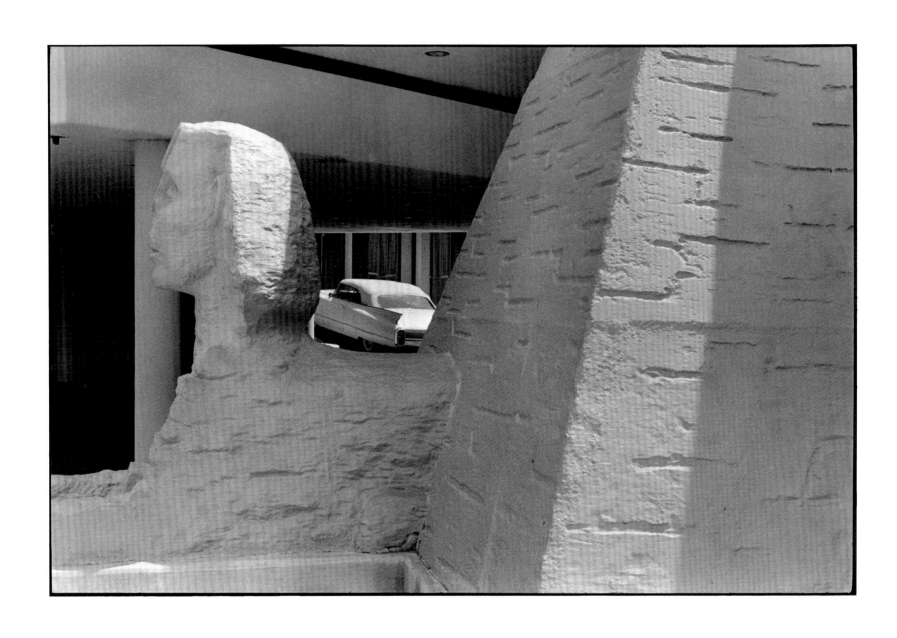

Hollywood, Florida, 1962

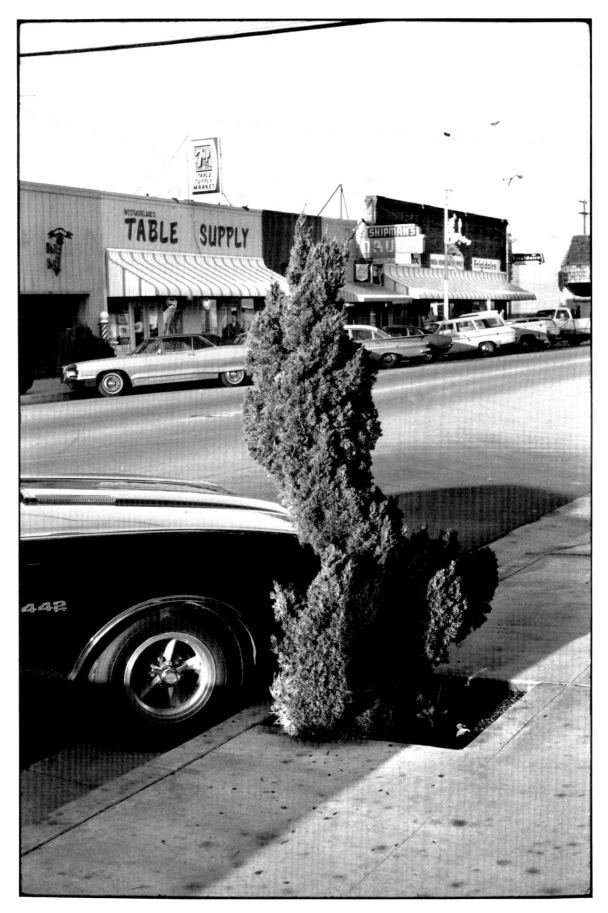

Dinuba, California, 1975

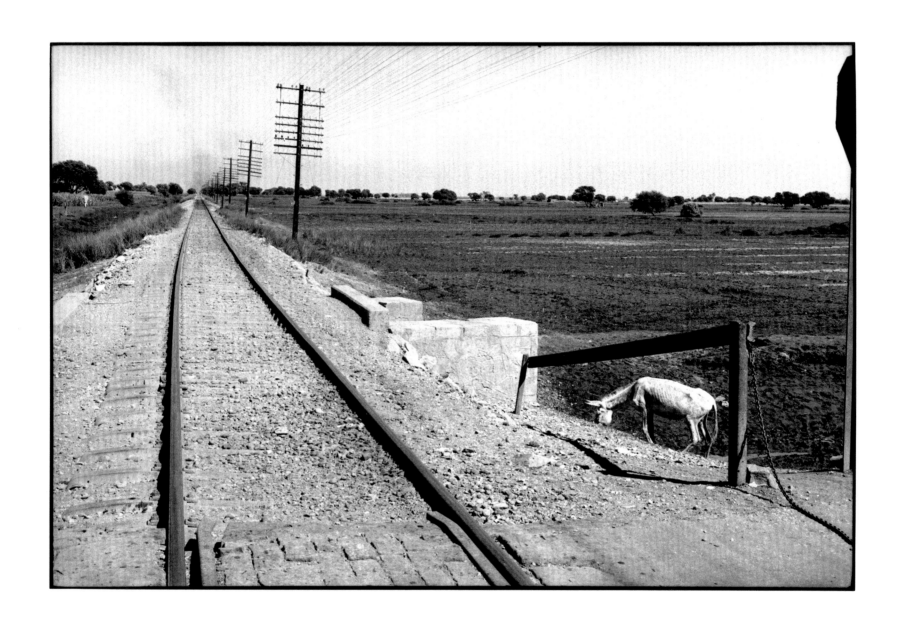

Luxor, Egypt, 1958

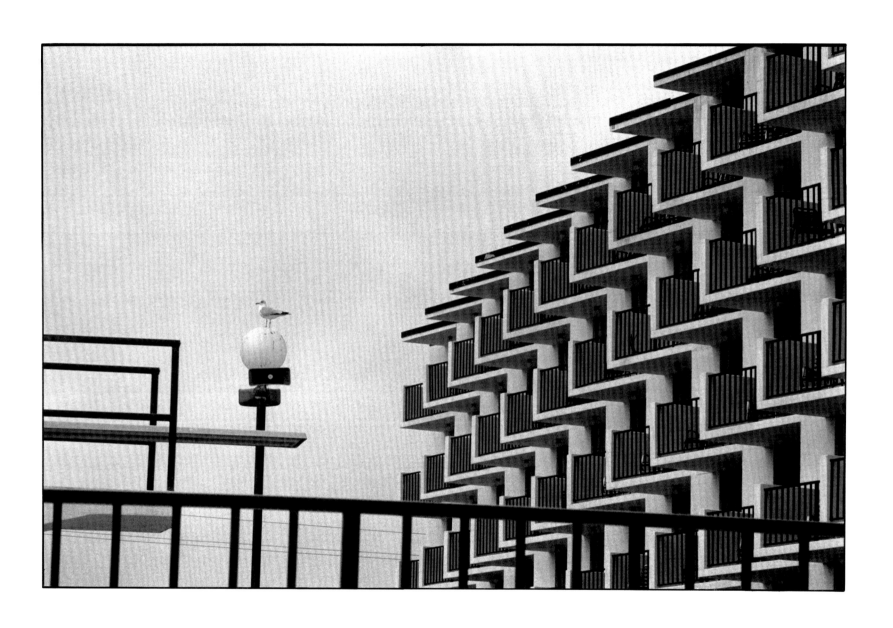

Daytona Beach, Florida, 1975

147

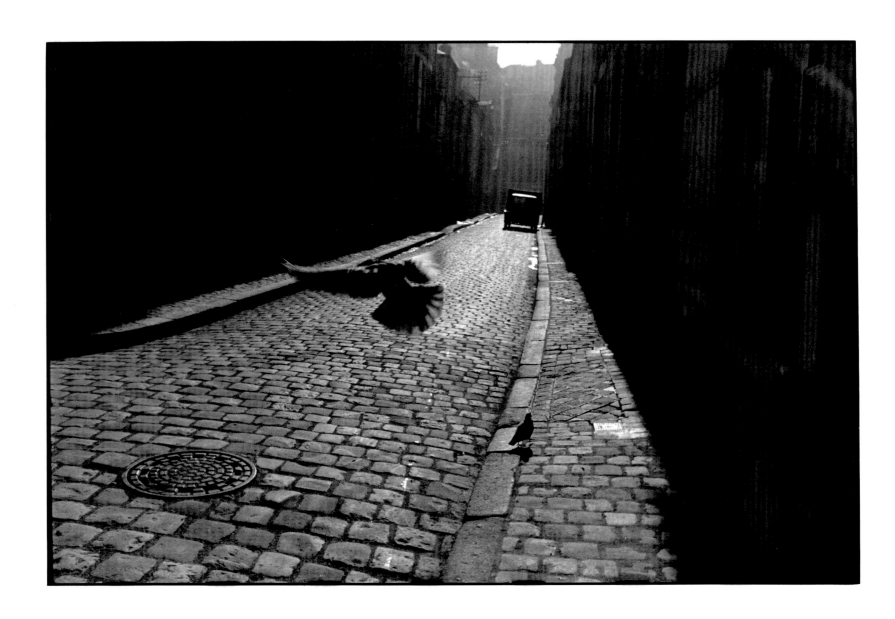

Orléans, France, 1952

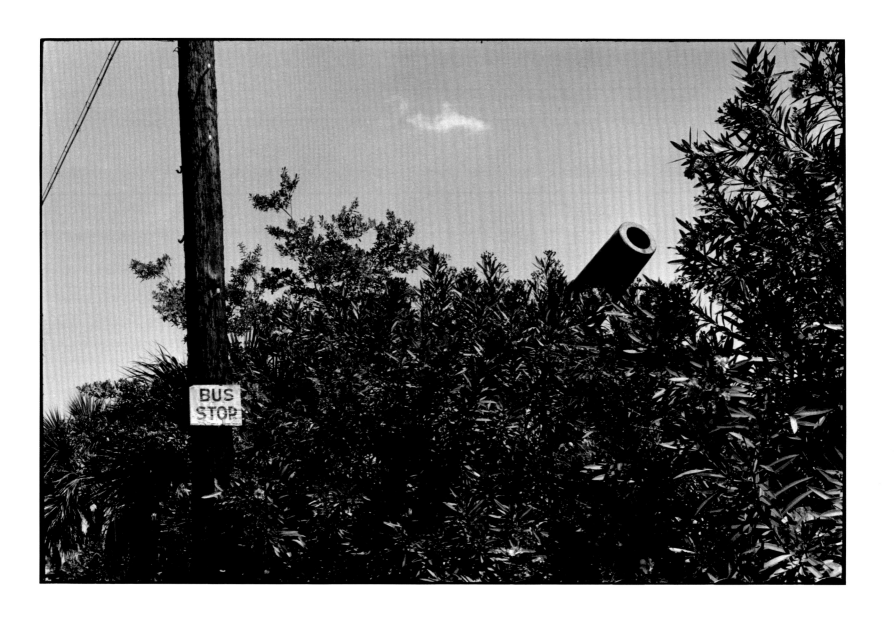

New Jersey, 1951

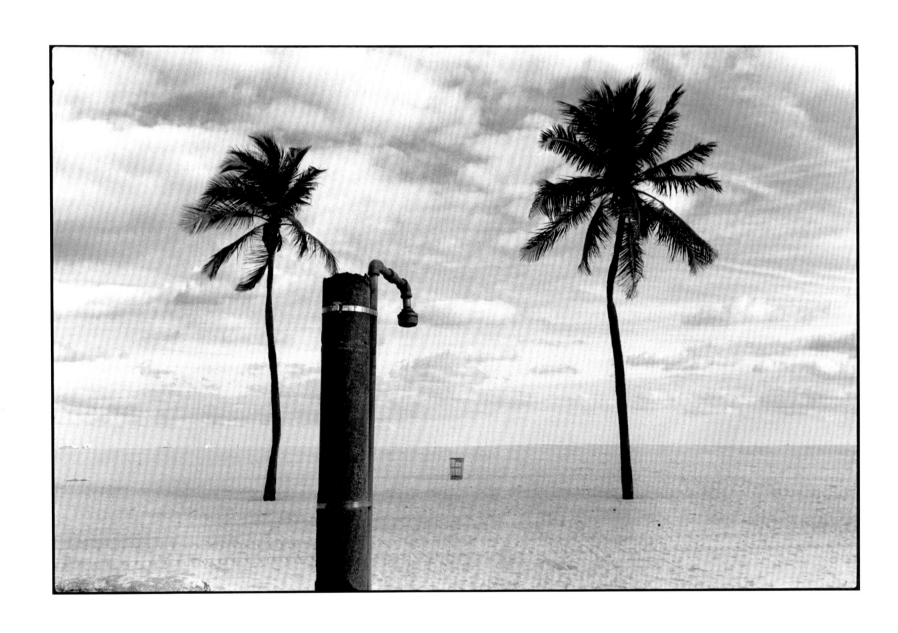

Miami Beach, Florida, 1984

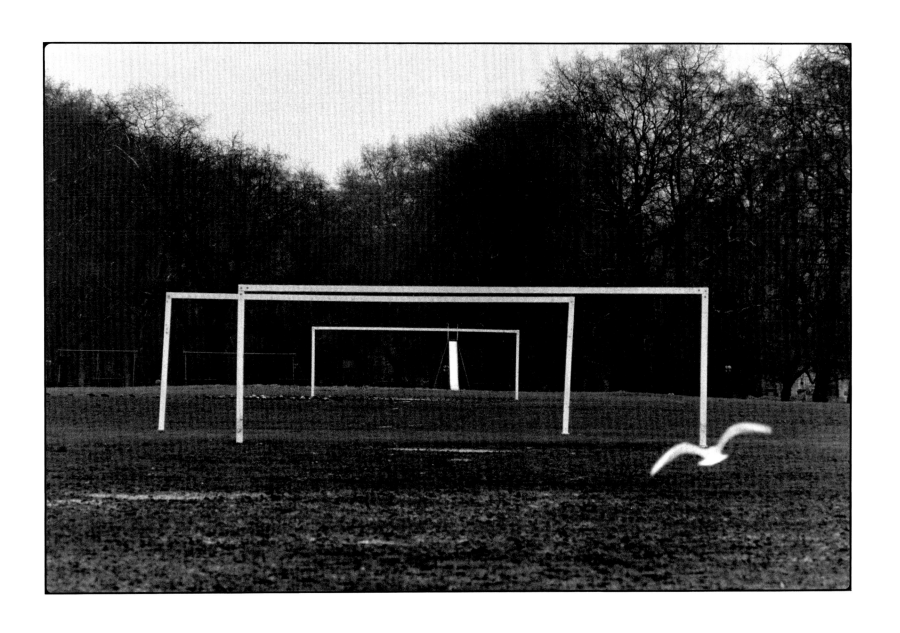

Hyde Park, London, 1978

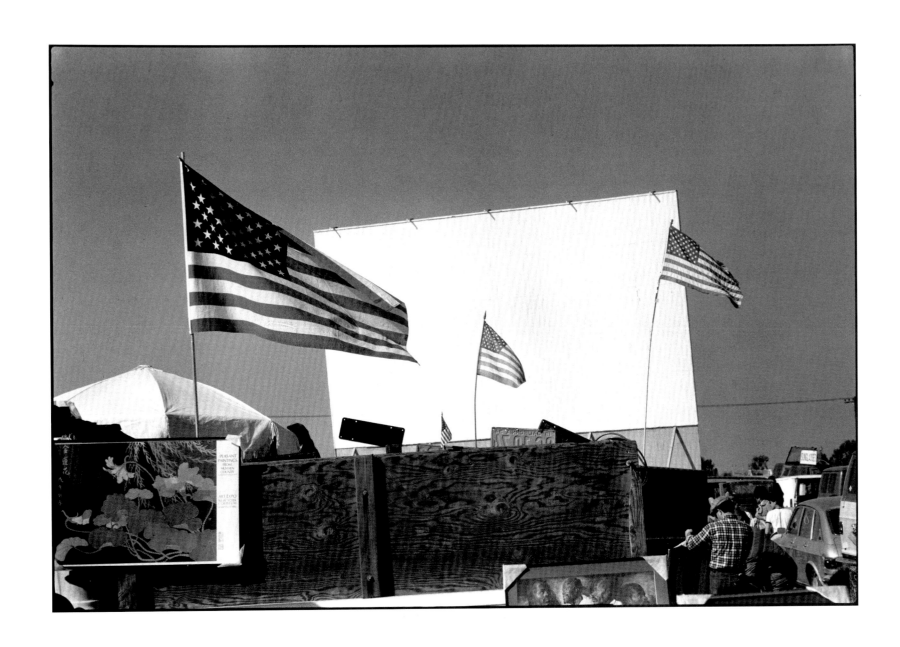

Alameda, California, 1982

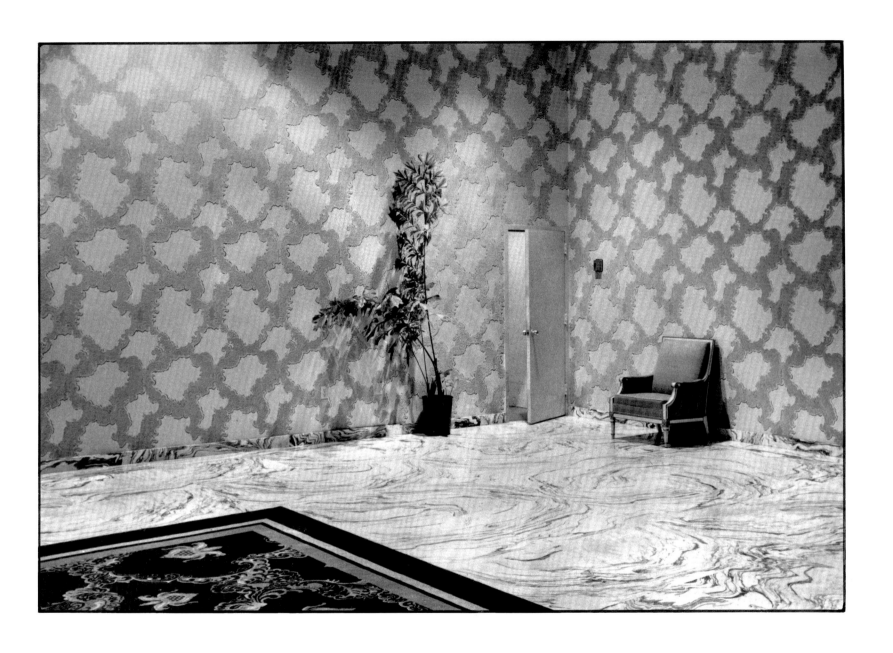

Miami Beach, Florida, 1962

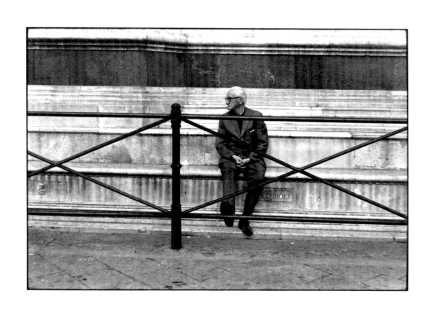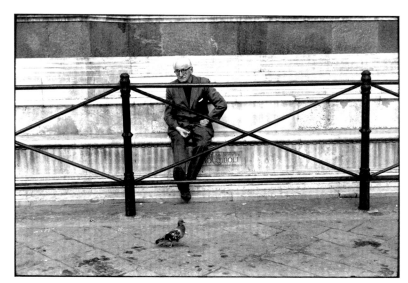

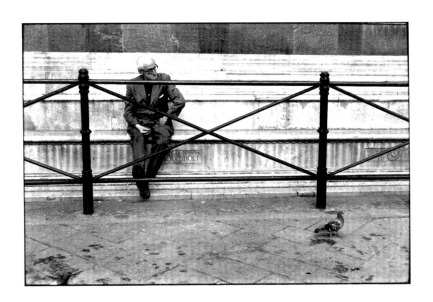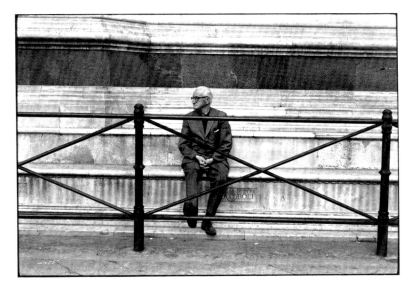

Florence, Italy, 1965

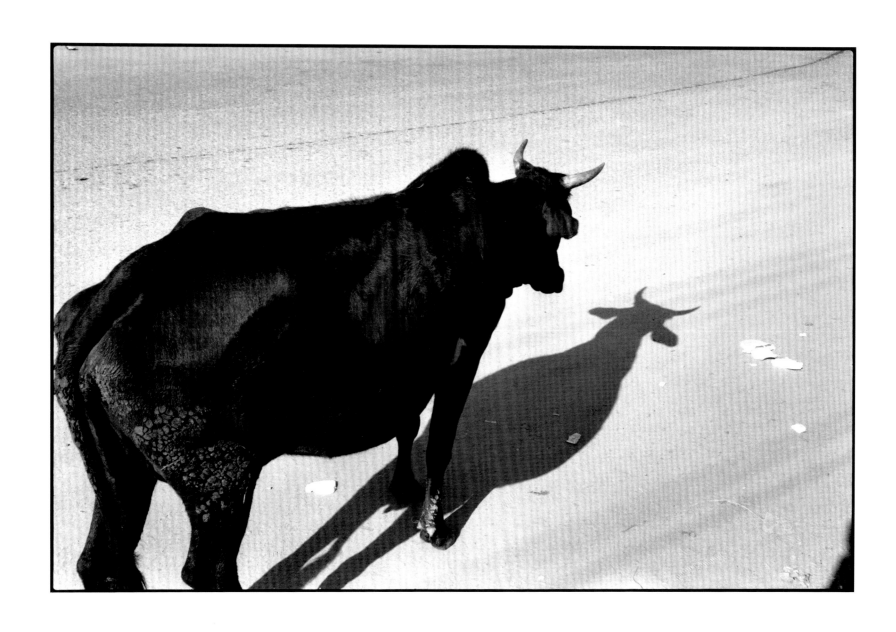

Katmandu, Nepal, 1983

156

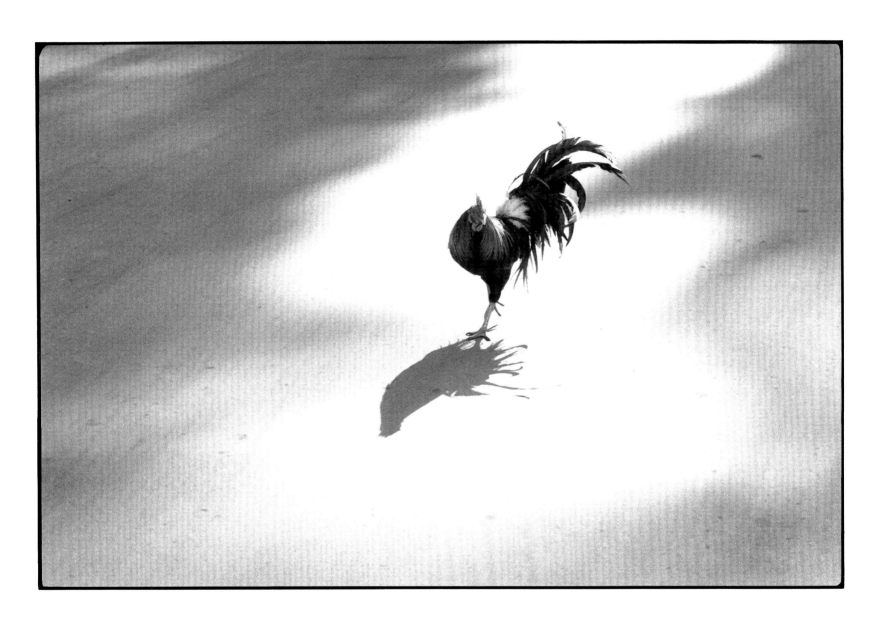

San Diego, California, 1973

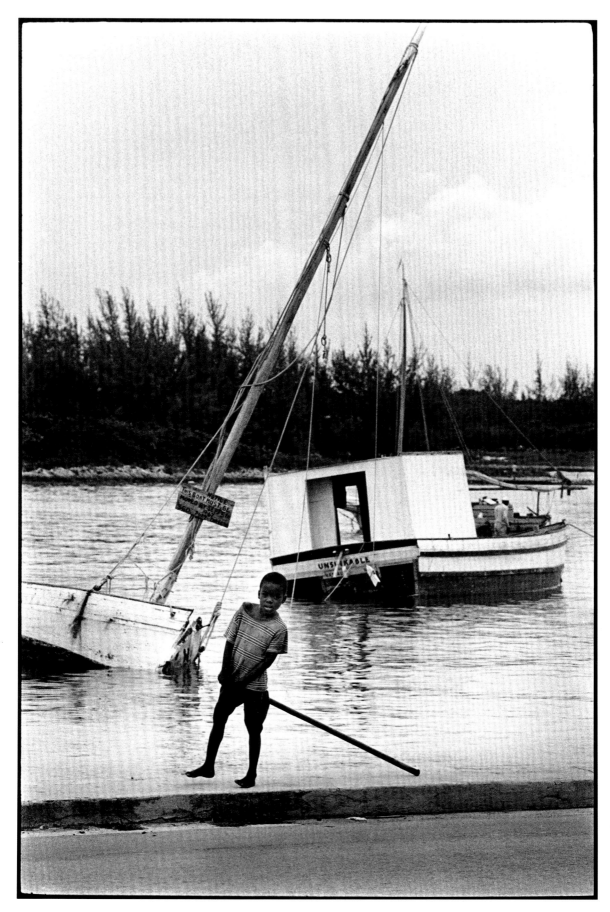

Nassau, Bahamas, 1967

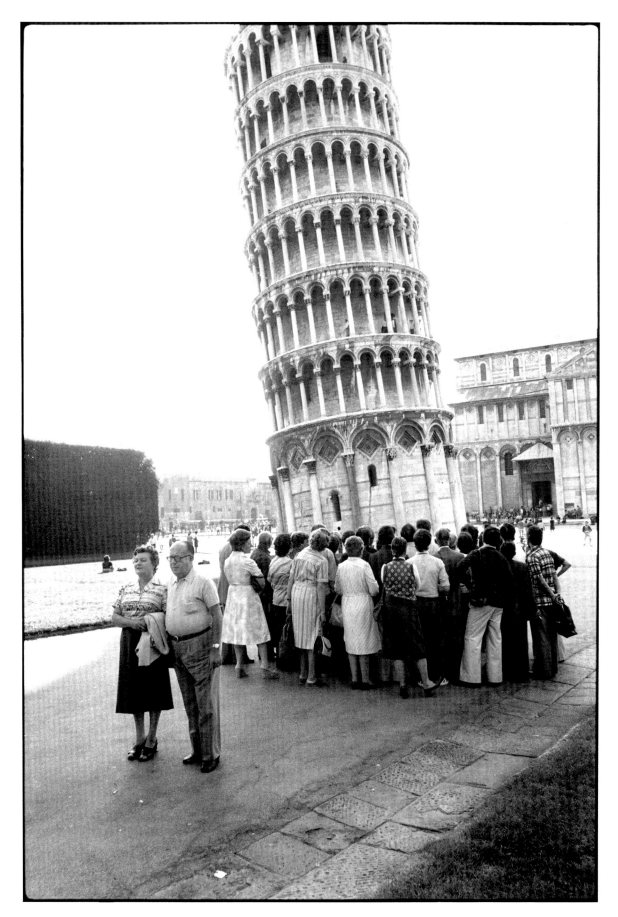

Pisa, Italy, 1976

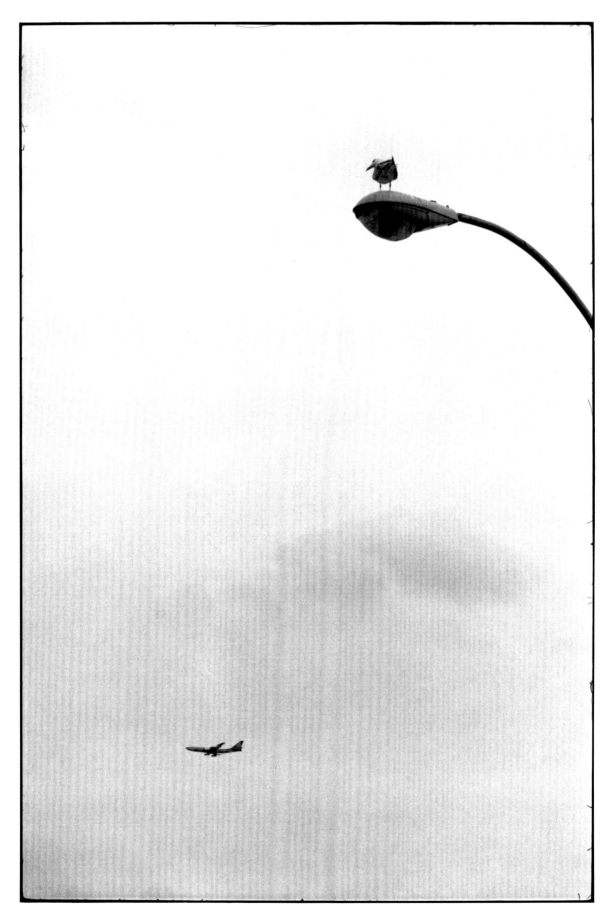

New York City, 1975

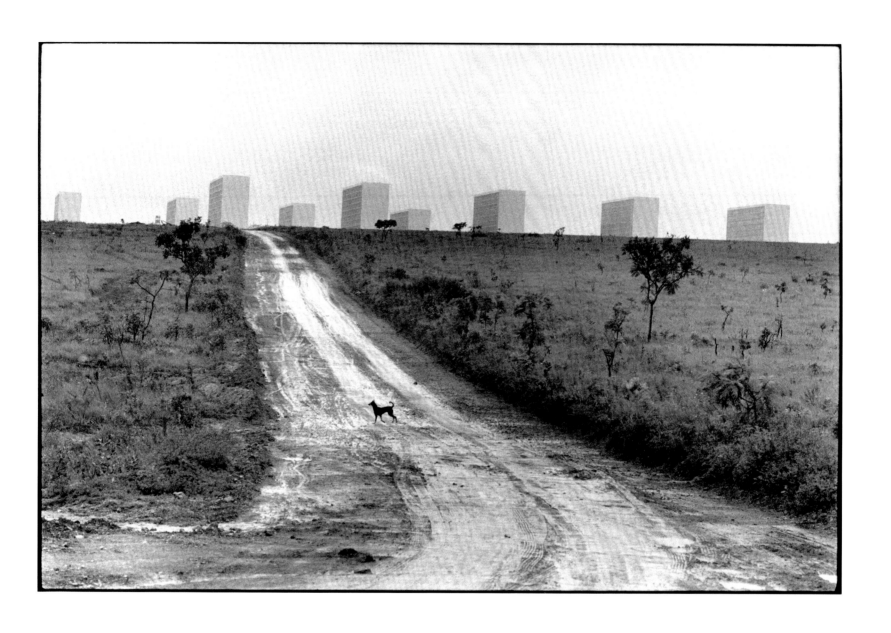

Brasília, 1961

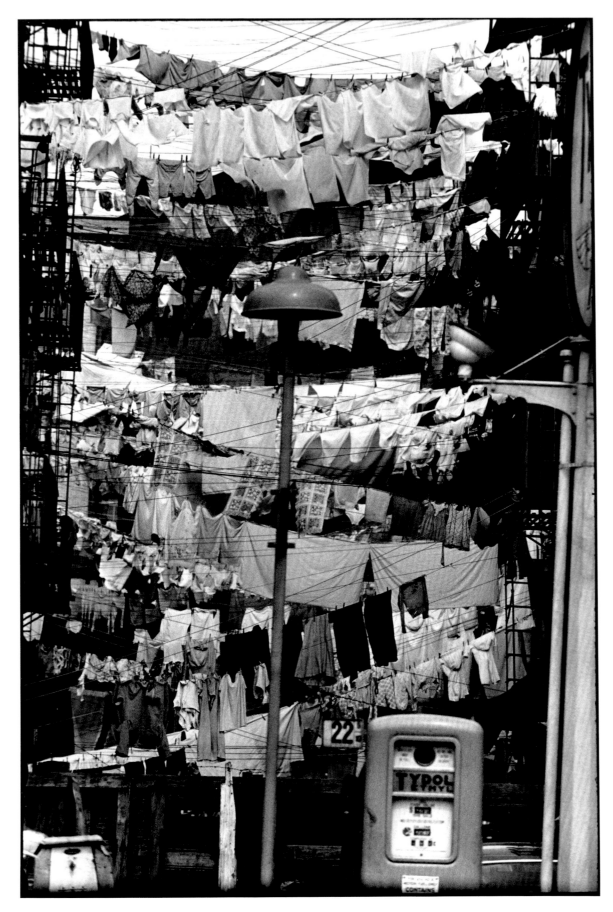

Hoboken, New Jersey, 1954

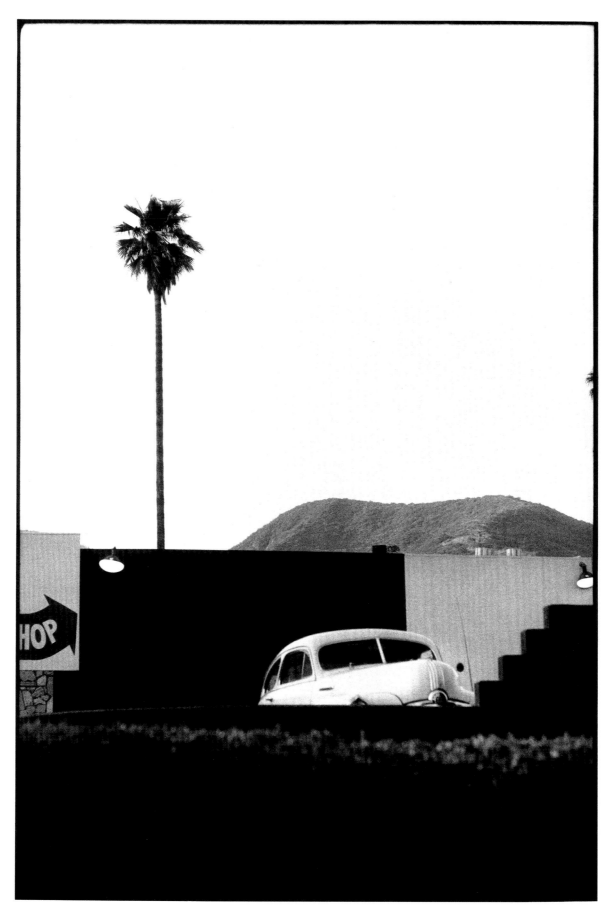

Hollywood, California, 1956

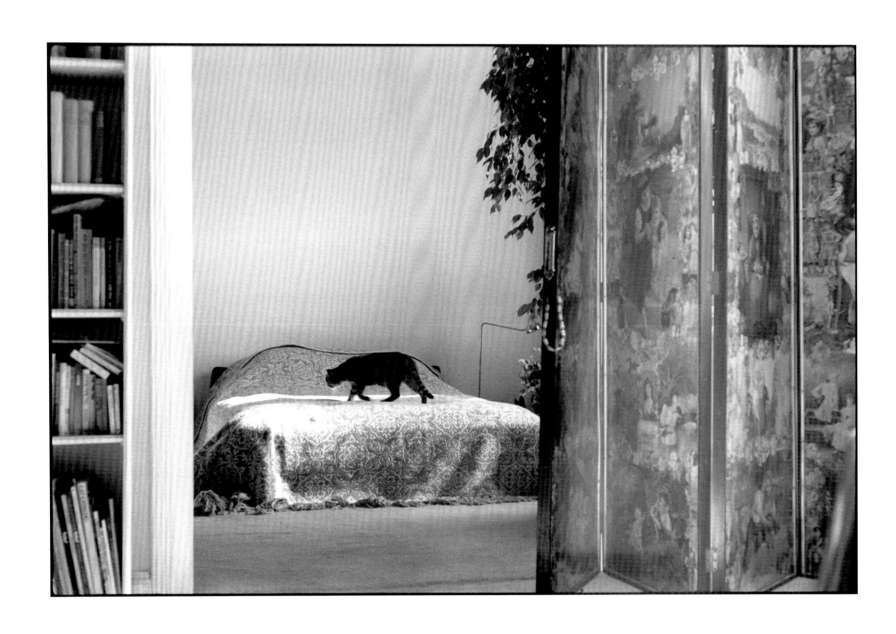

Hamburg, West Germany, 1987

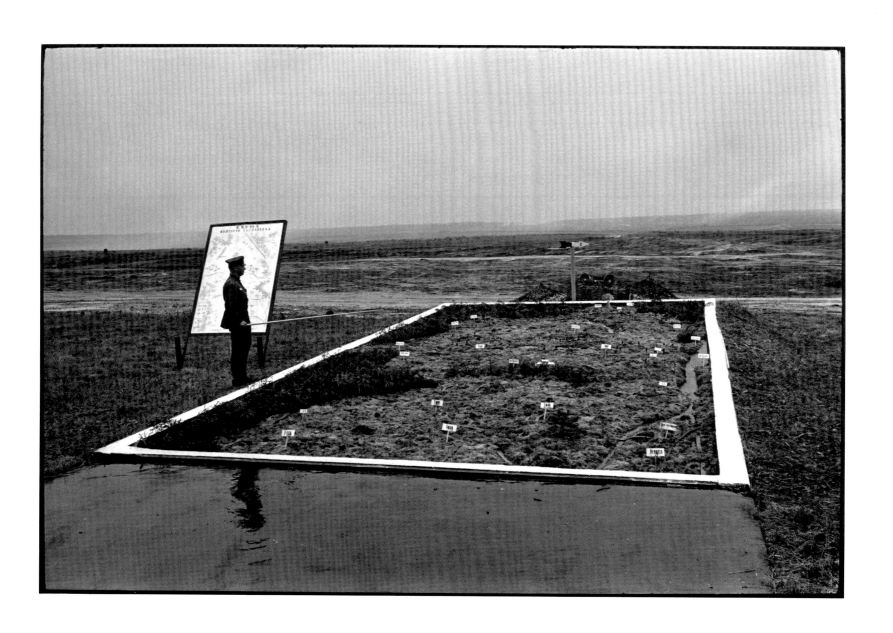

Moscow, U.S.S.R., 1966

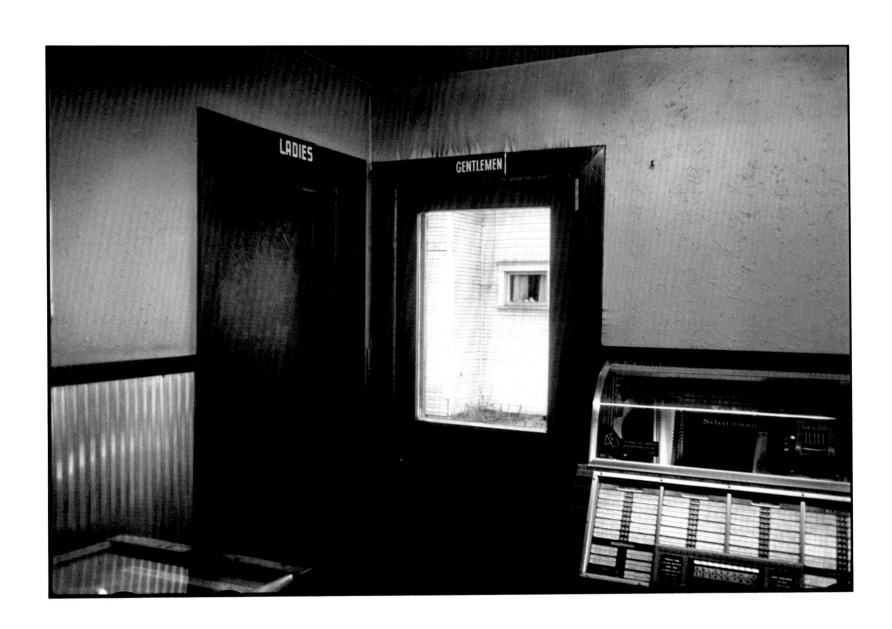

Western United States, 1954

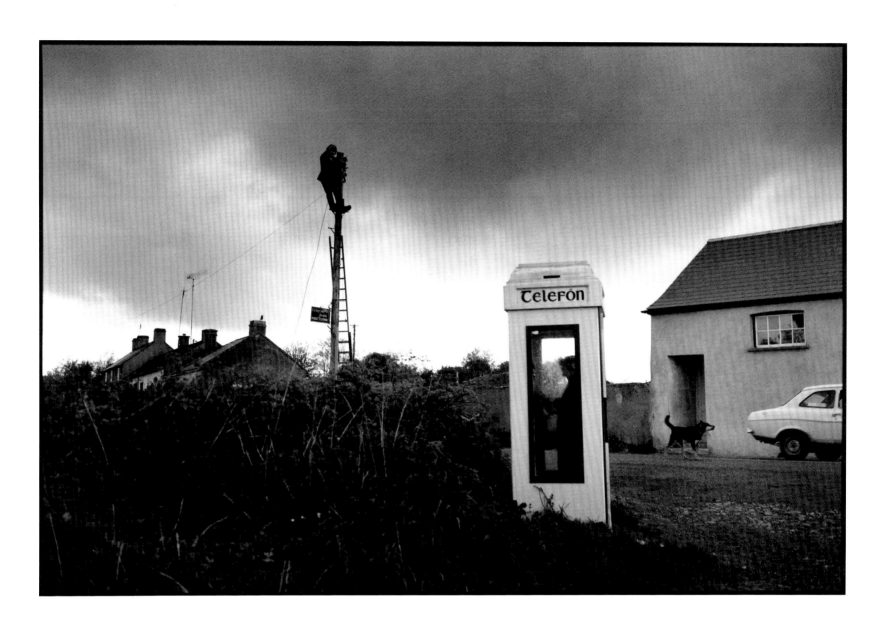

Shanagarry, Eire, 1982

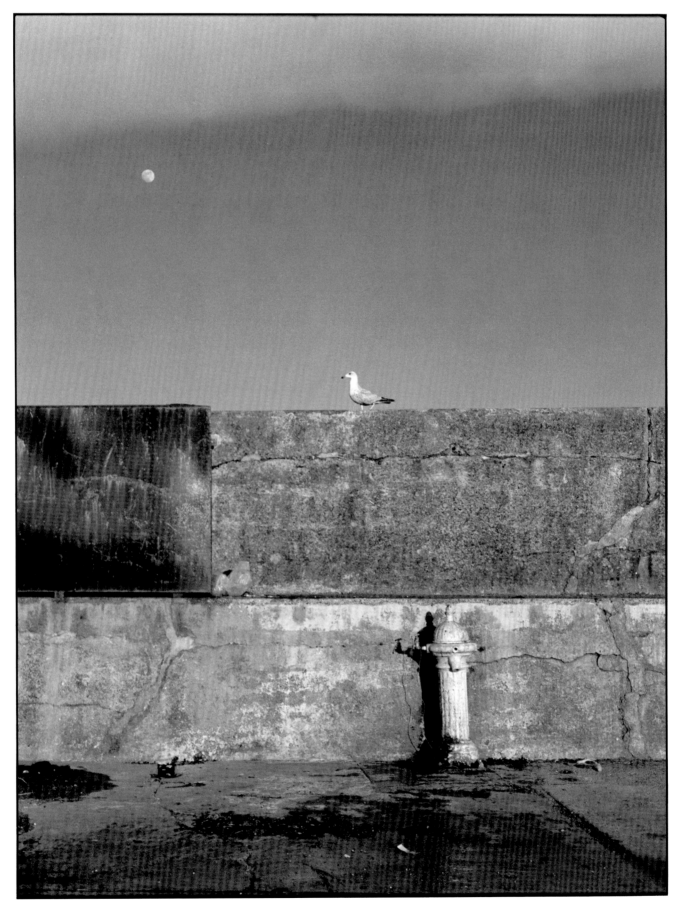

Ballycotton, Eire, 1982

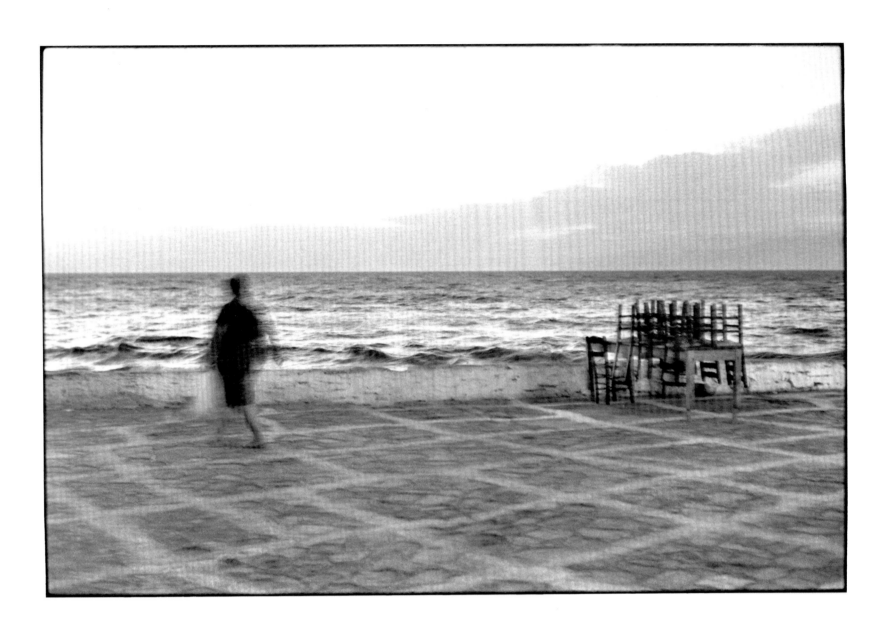

Mikonos, Greece, 1976

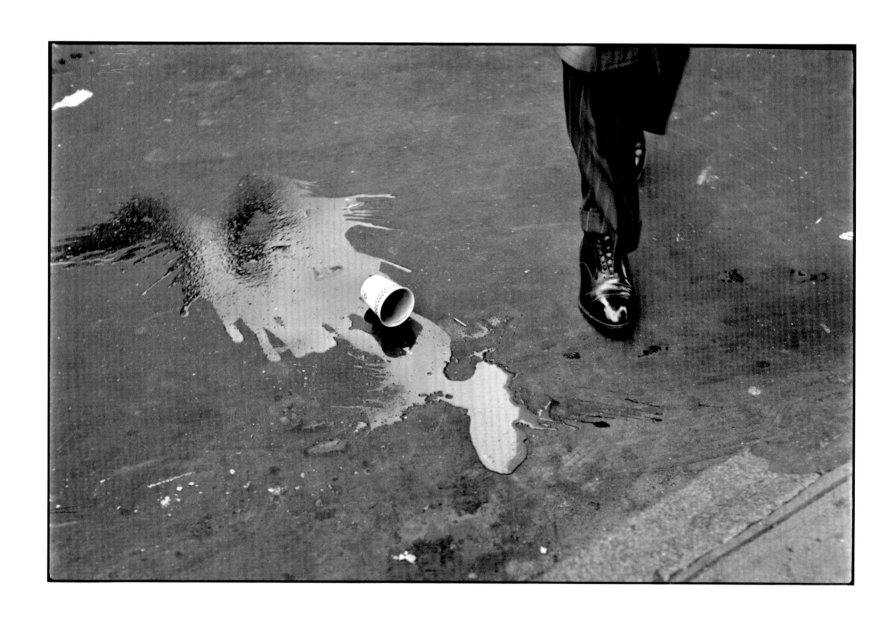

New York City, circa 1950

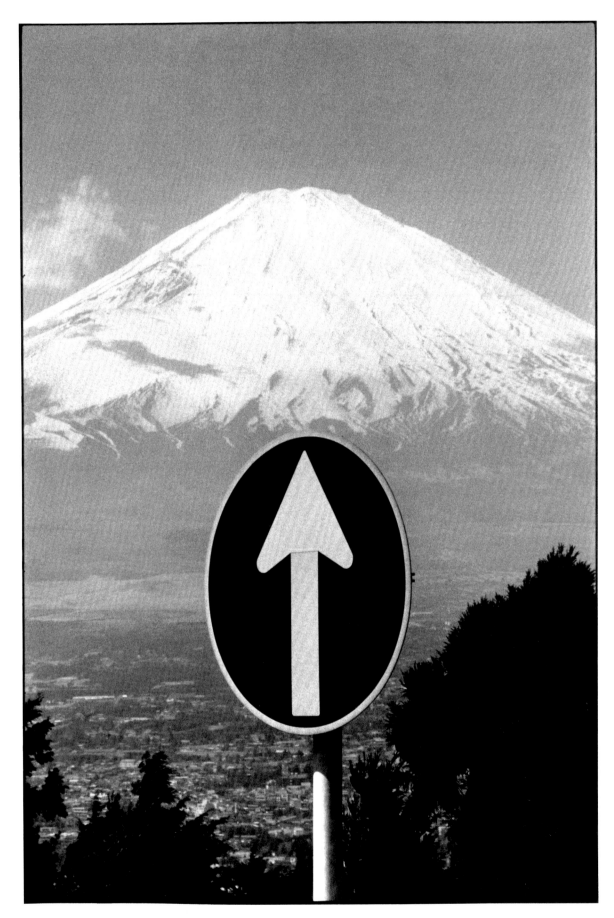

Mount Fuji, Japan, 1977

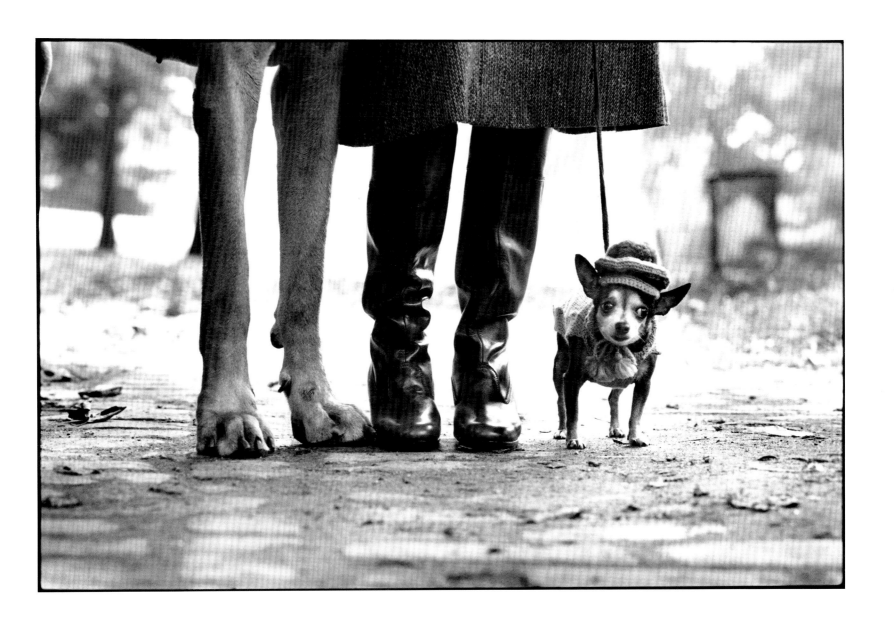

New York City, 1974

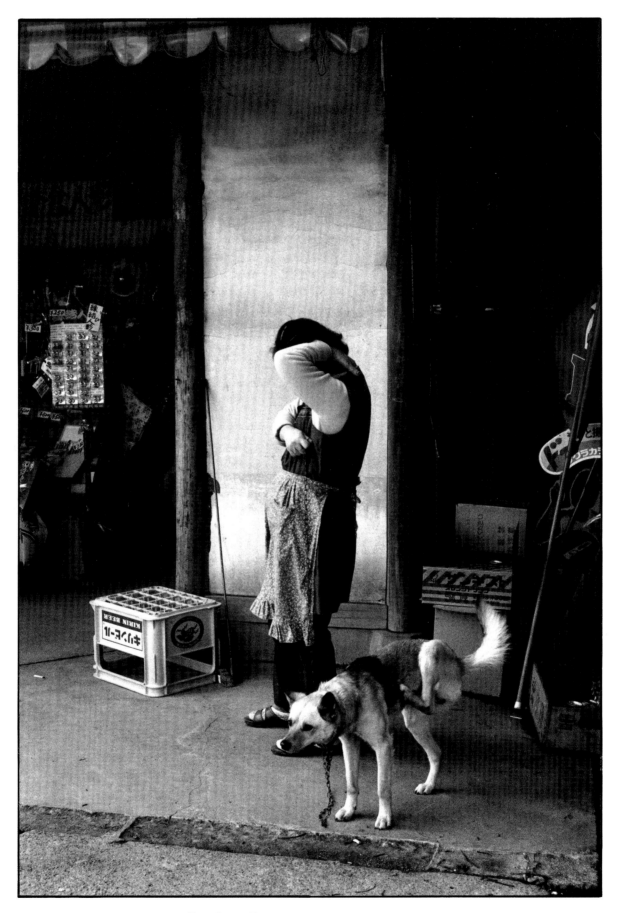

Kyoto, Japan, 1977

174

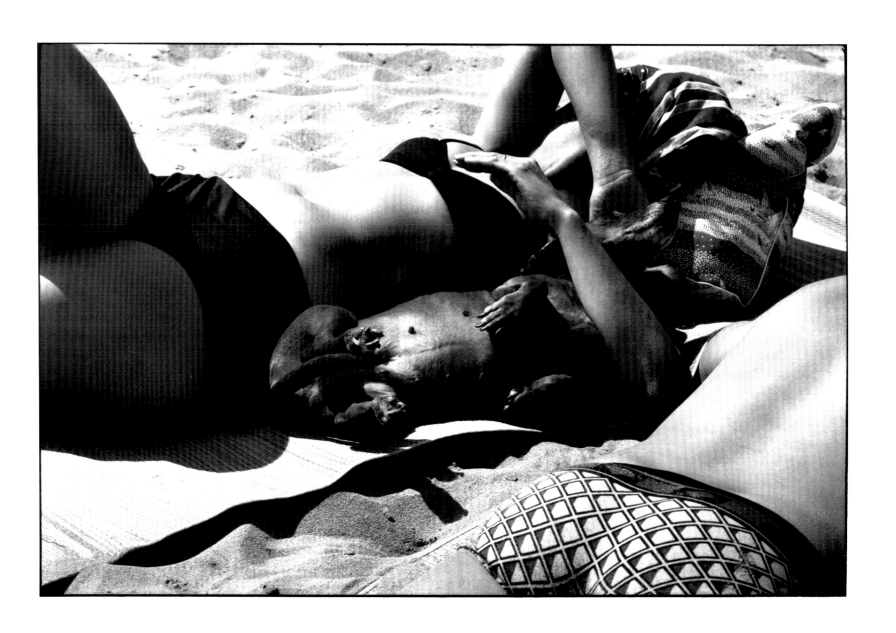

Saintes Maries de la Mer, France, 1977

175

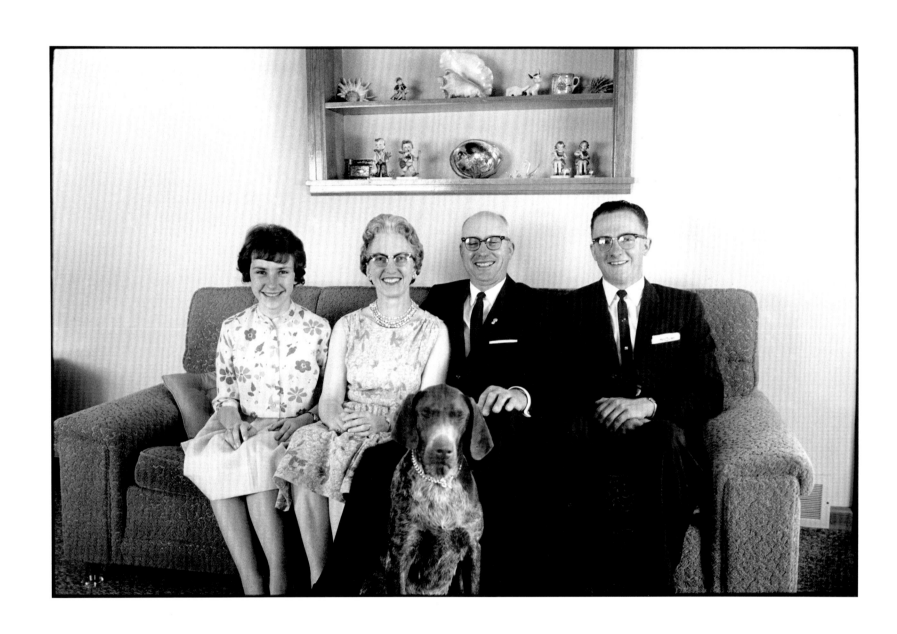

U.S.A., 1964

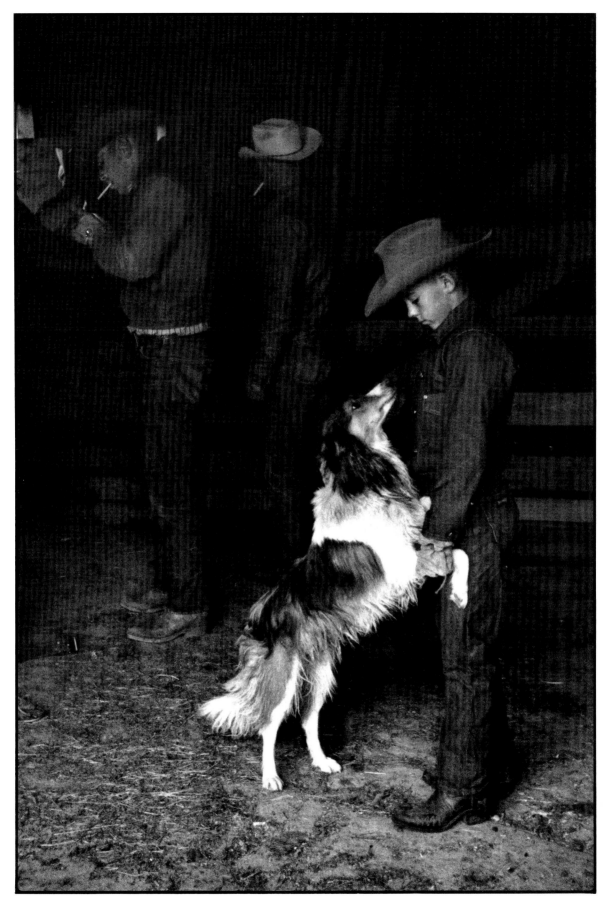

Wyoming, 1953

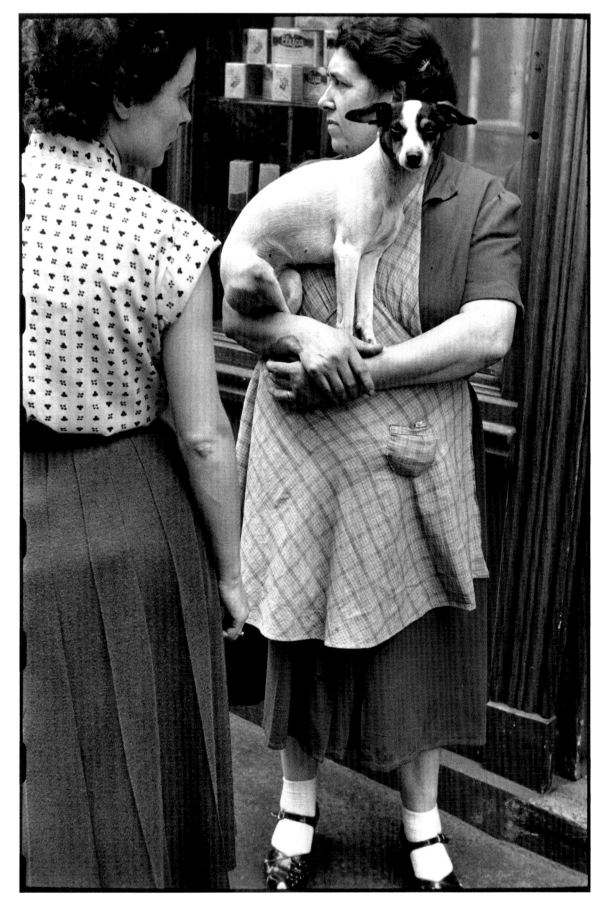

Paris, 1952

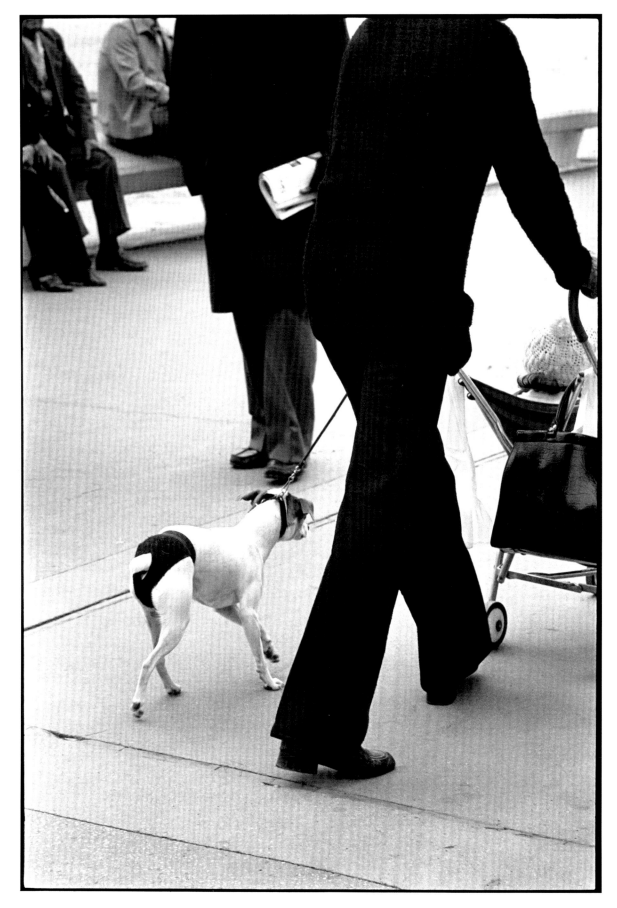

Cannes, 1980

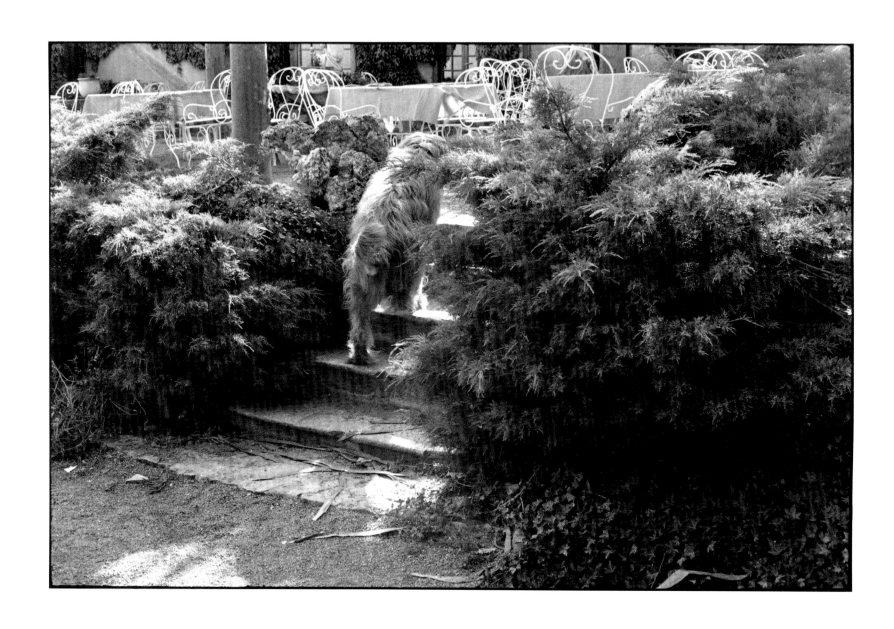

Fleury, France, 1974

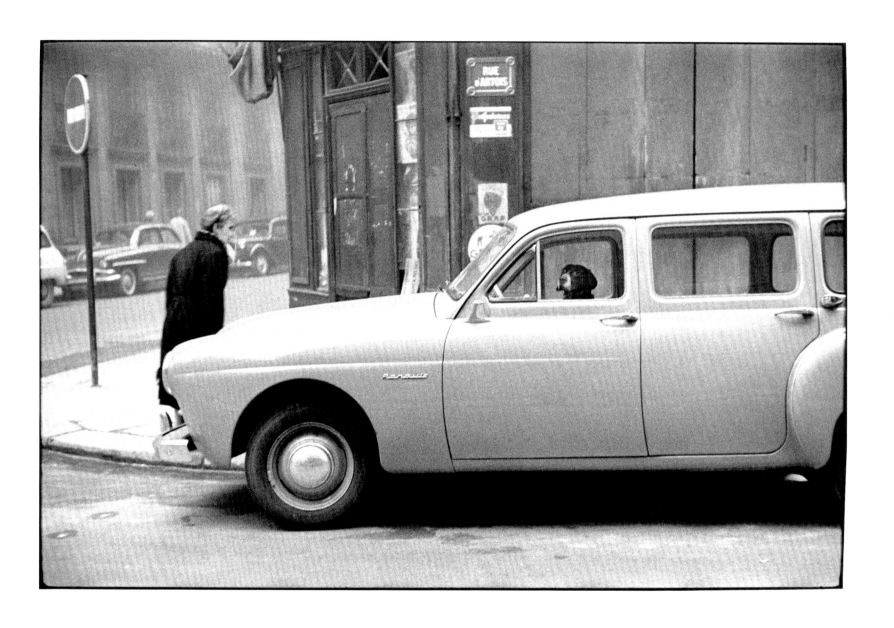

Paris, 1957

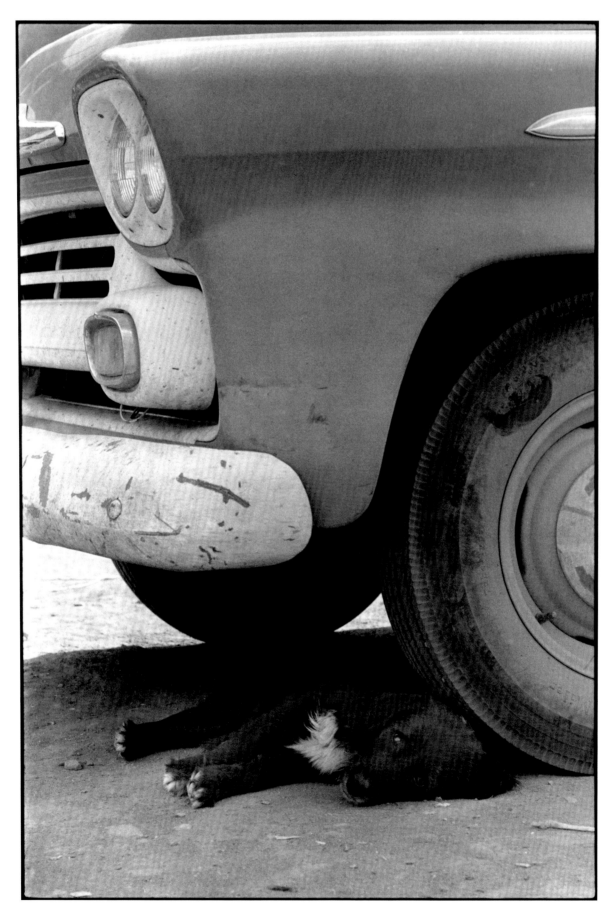

New Mexico, 1962

182

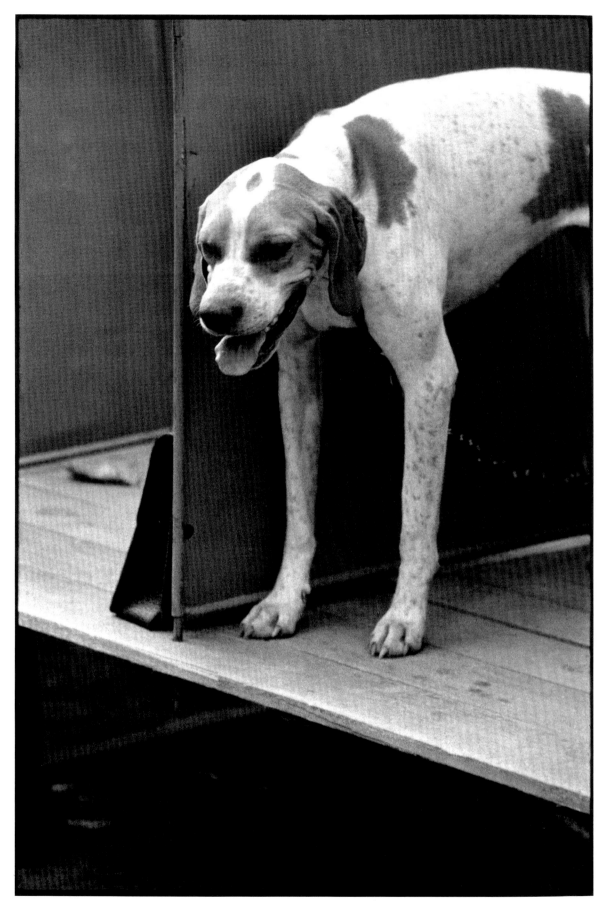

Saint Tropez, 1968

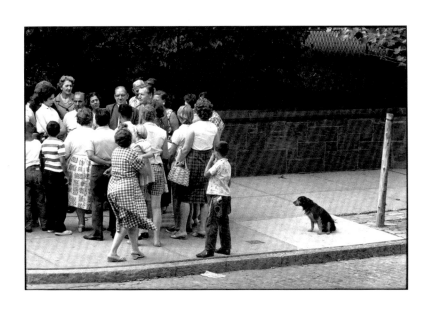 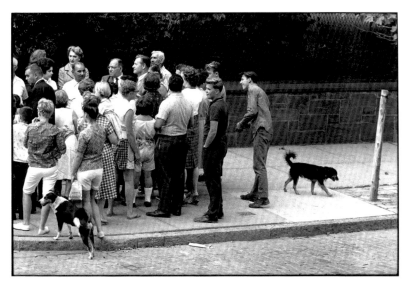

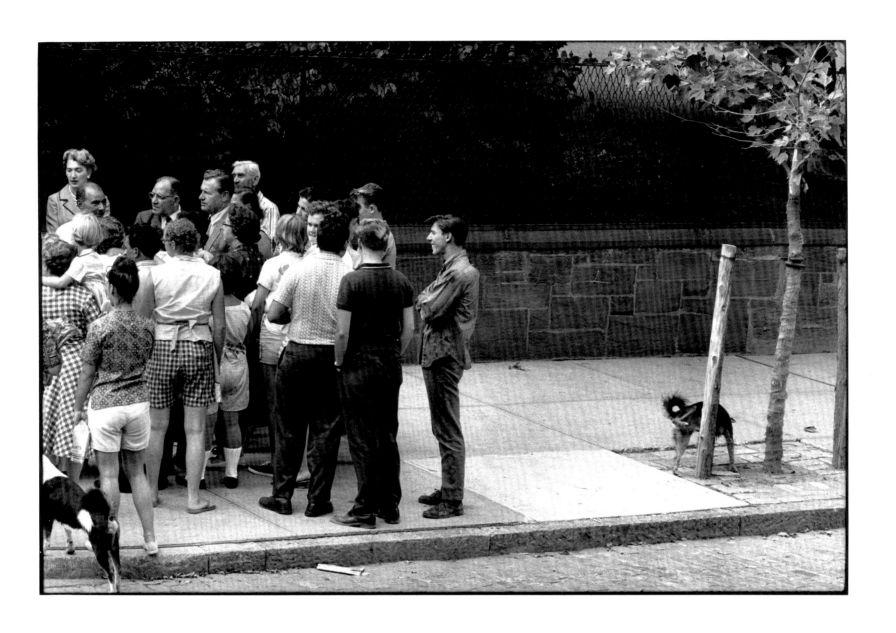

Albany, New York, 1962

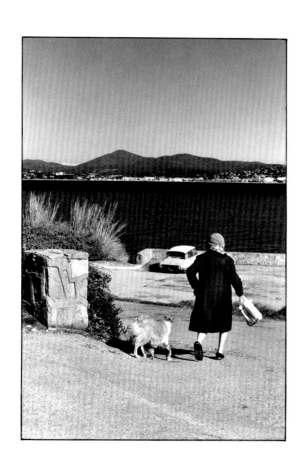

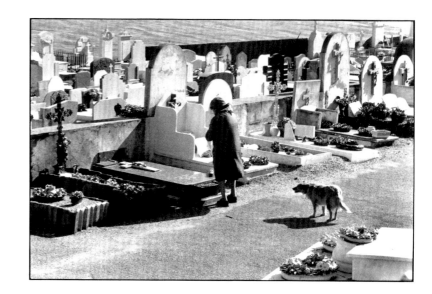

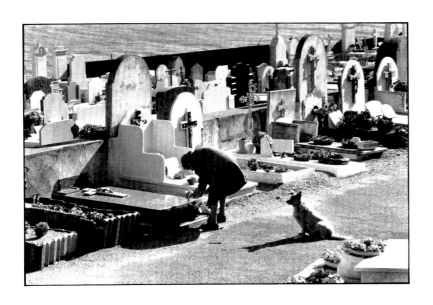 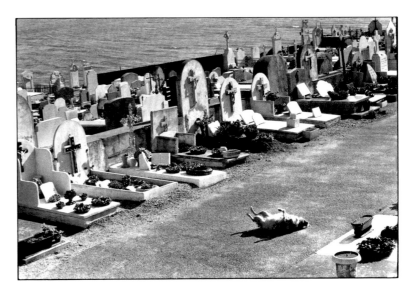

Saint Tropez, 1979

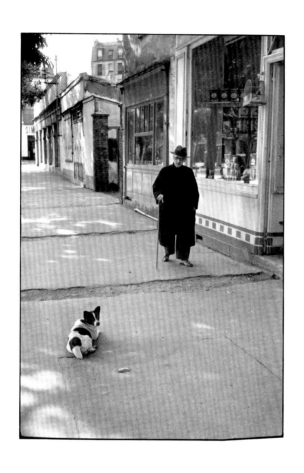 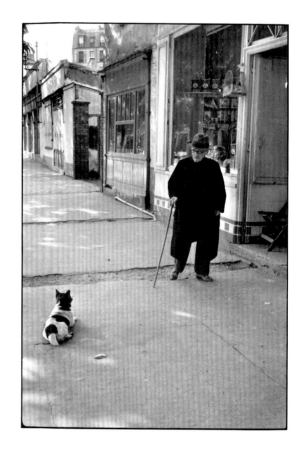

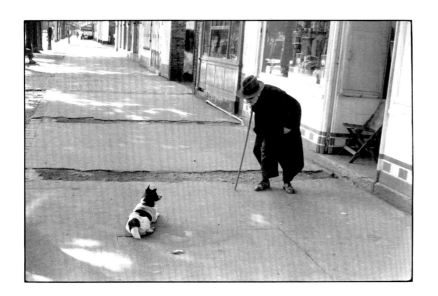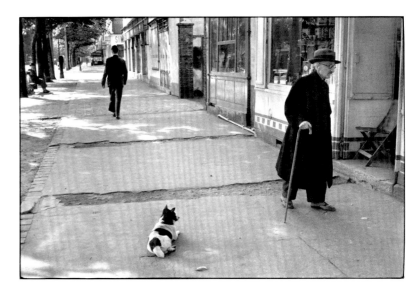

Neuilly, France, 1952

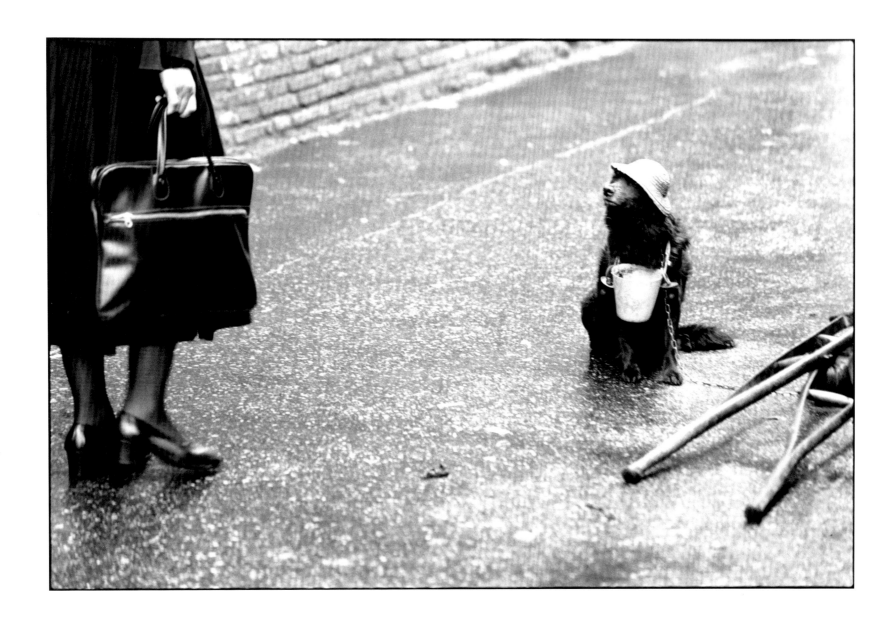

Rome, 1978

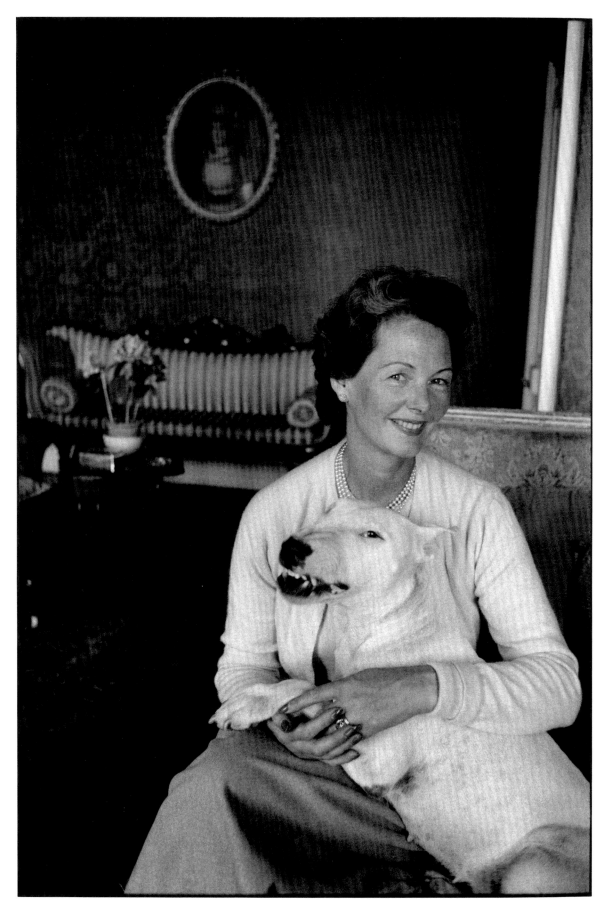

Brighton, England, 1956

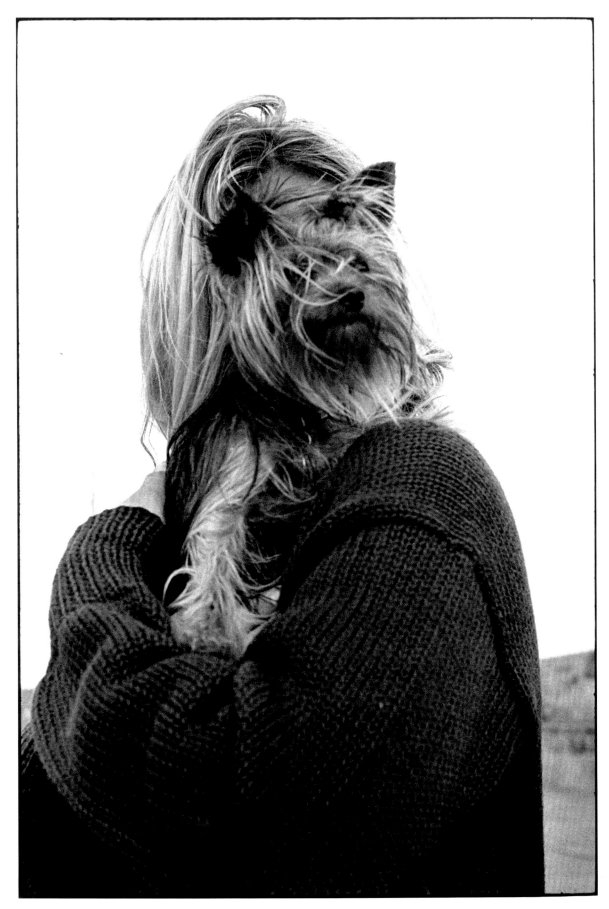

Eire, 1968

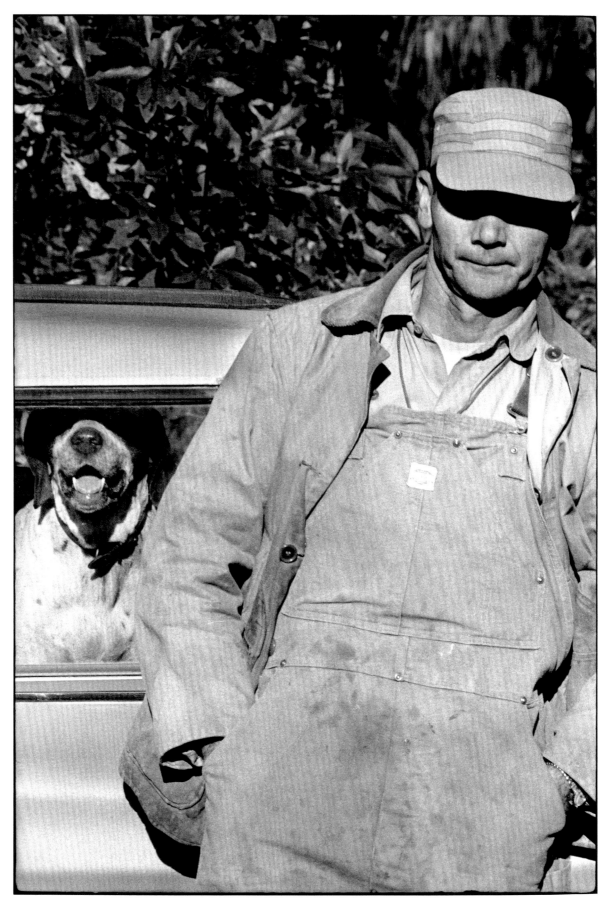

South Carolina, 1962

193

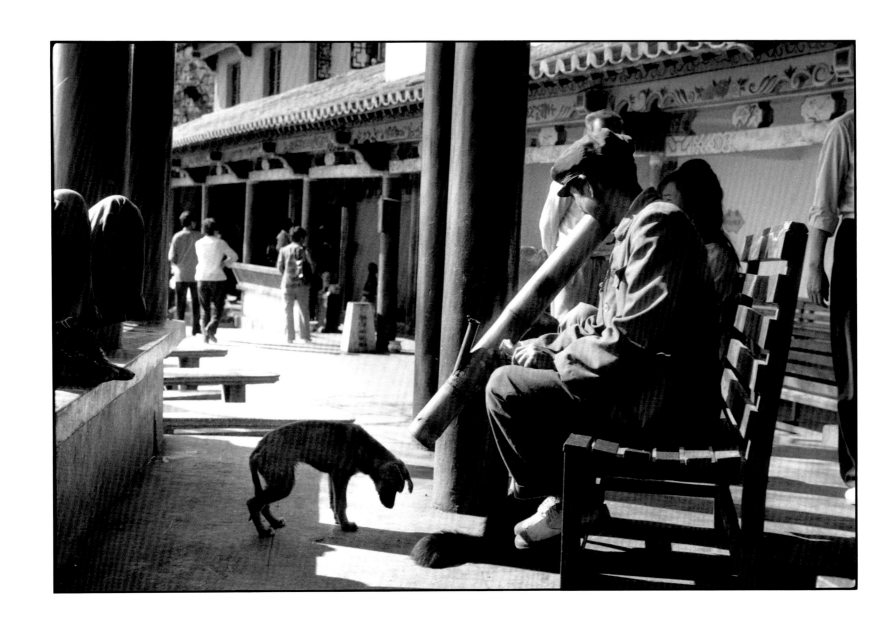

Kunming, China, 1986

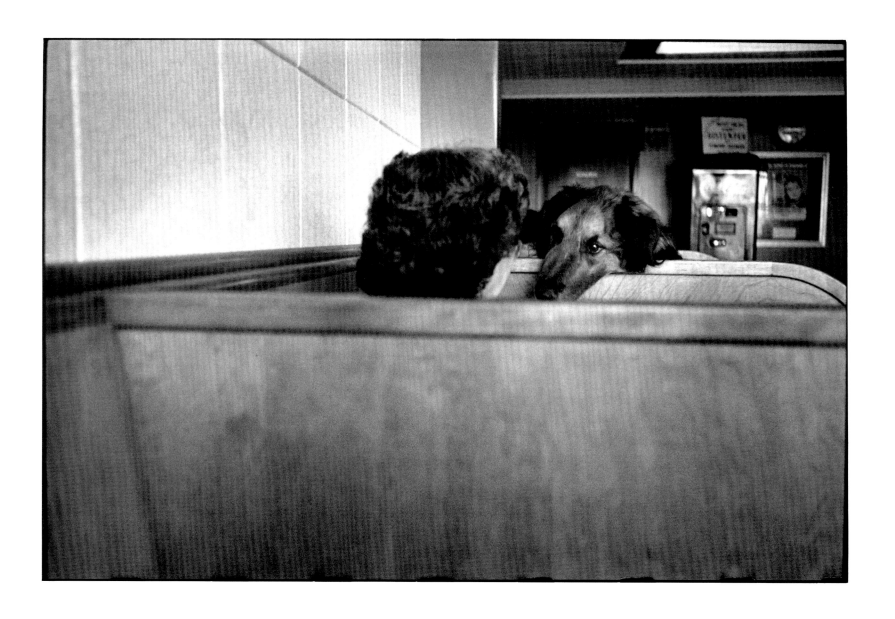

New York City, 1953

195

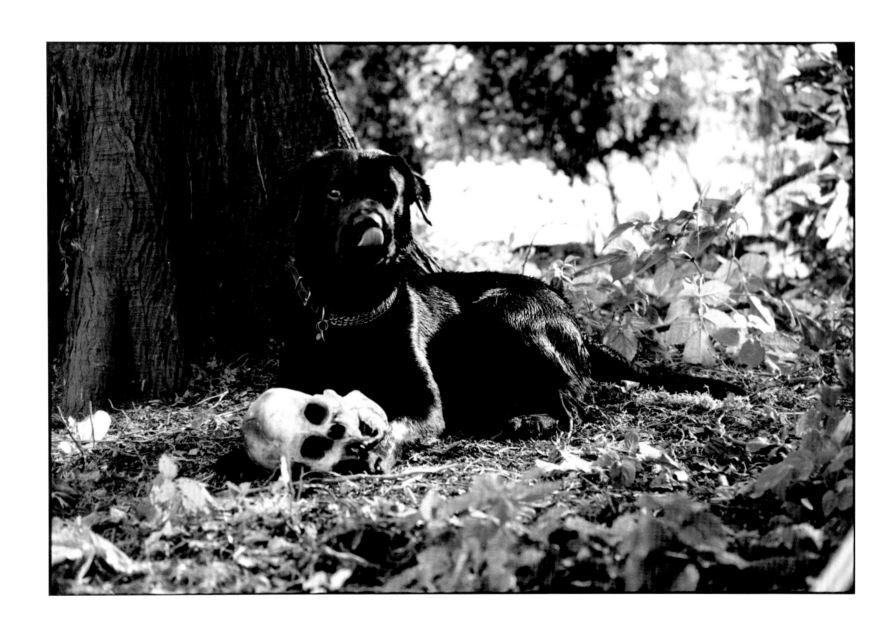

Cotswolds, England, 1985

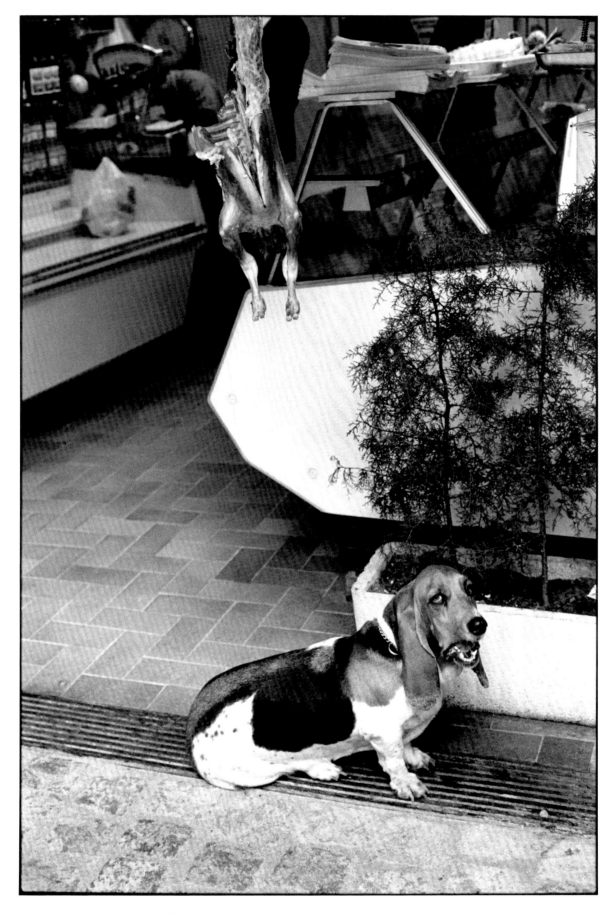

Saint Tropez, 1979

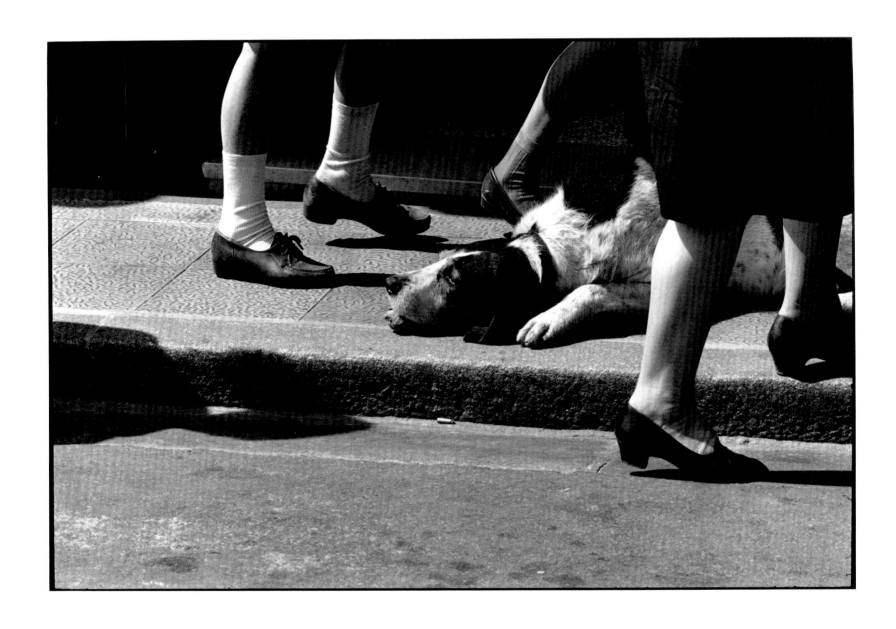

Honfleur, France, 1968

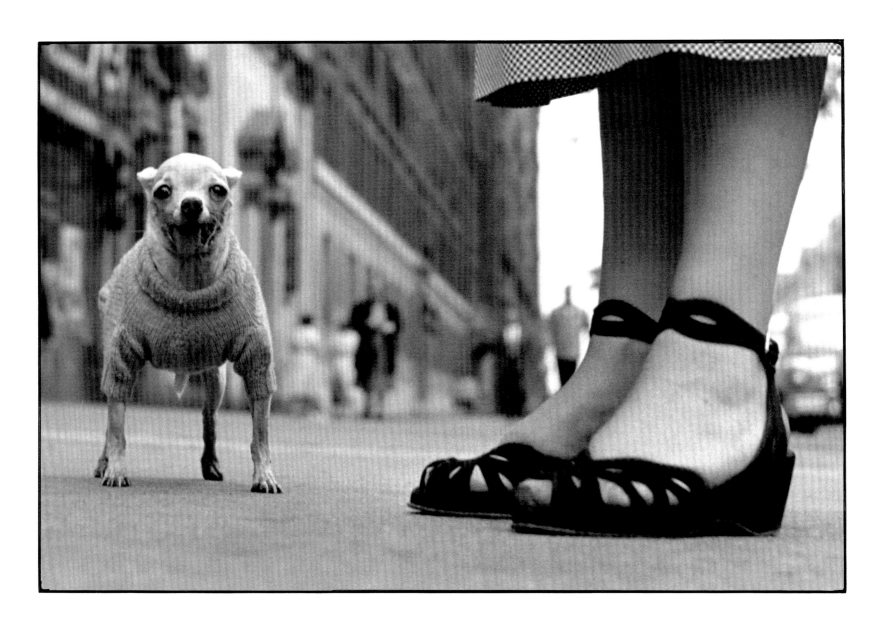

New York City, 1946

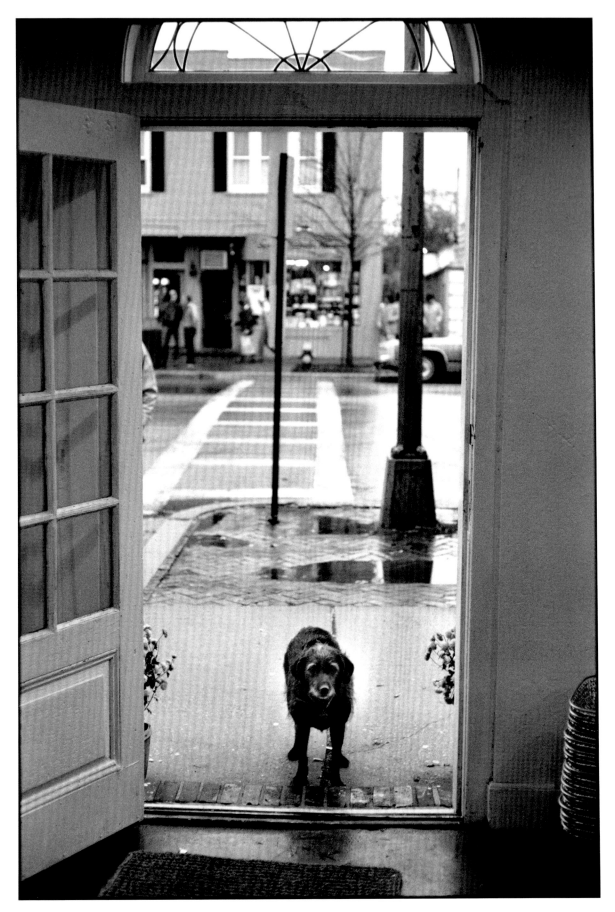

Stockbridge, Massachusetts, 1979

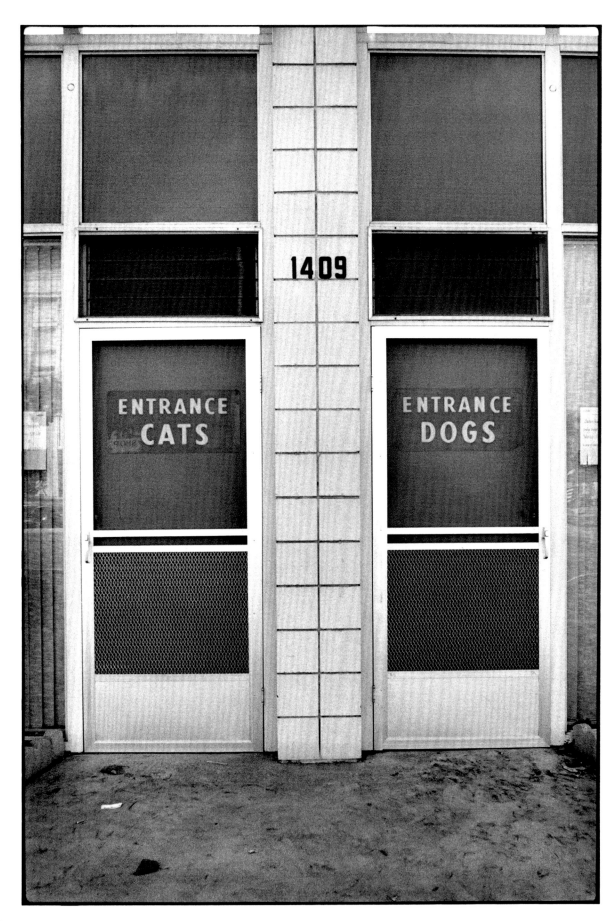

Alameda, California, 1975

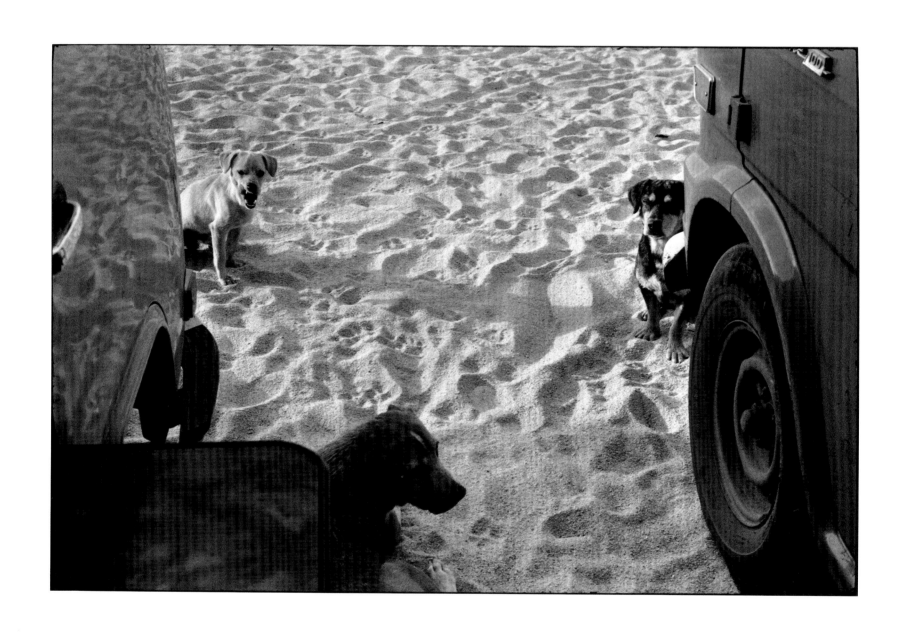

Puerto Vallarta, Mexico, 1973

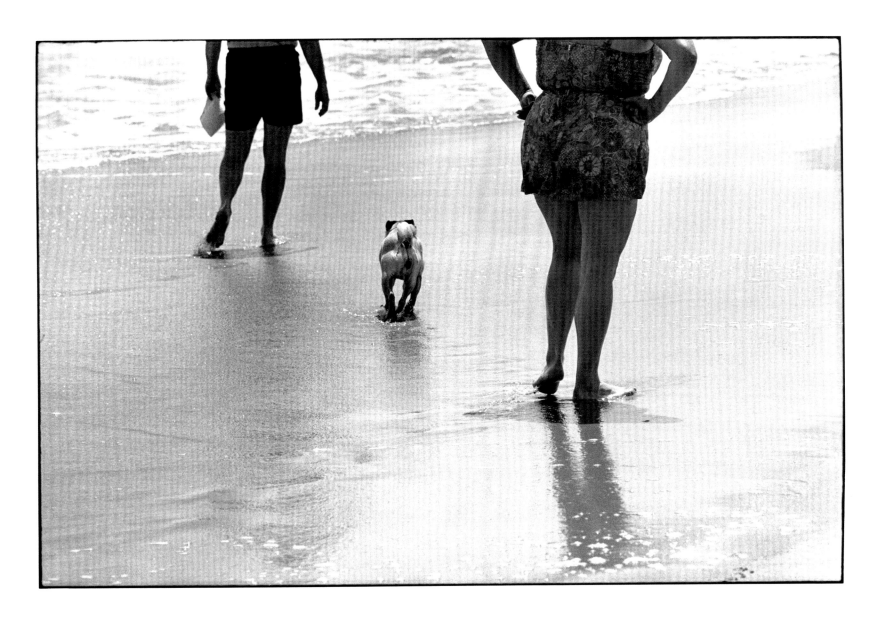

Southampton, New York, 1969

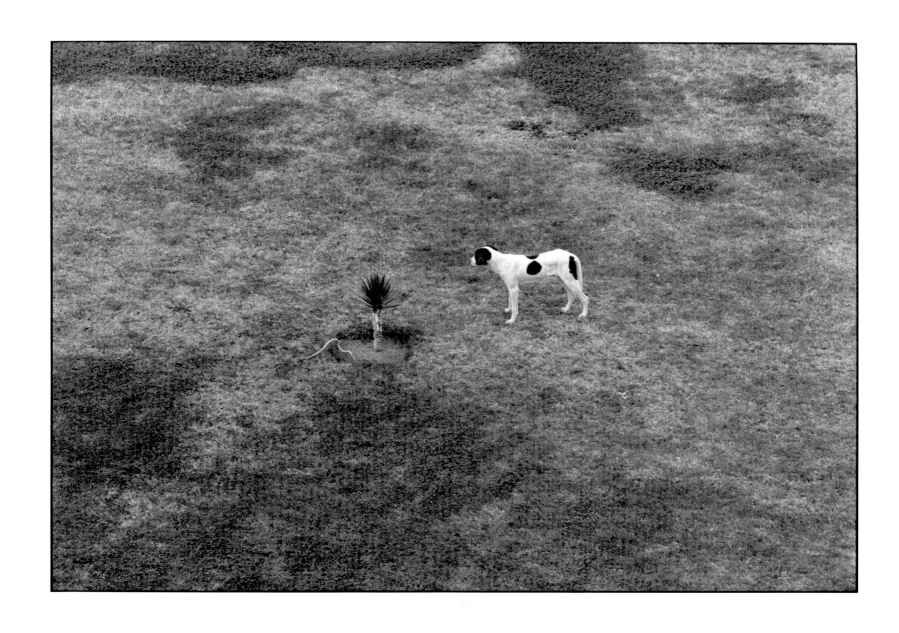

Teheran, Iran, 1967

204

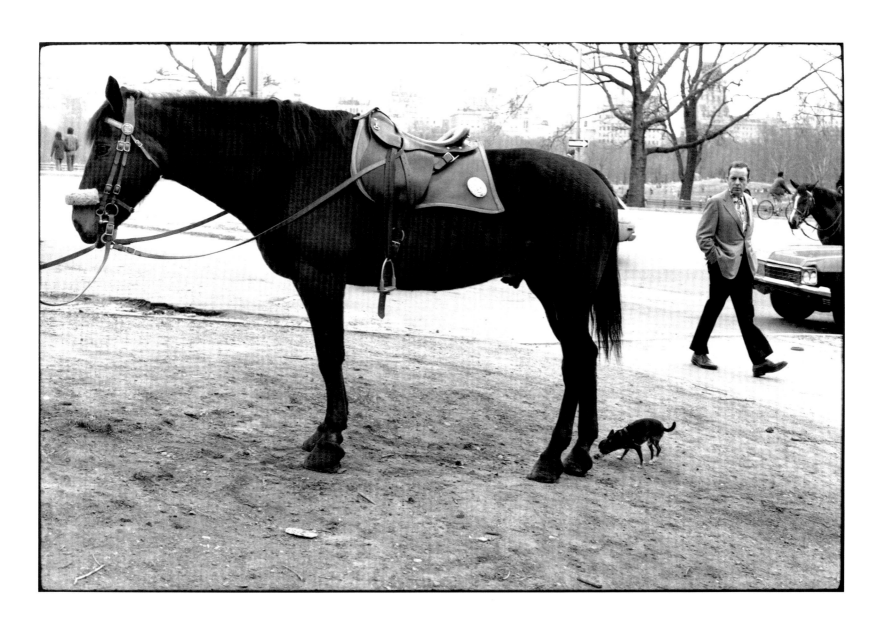

New York City, 1973

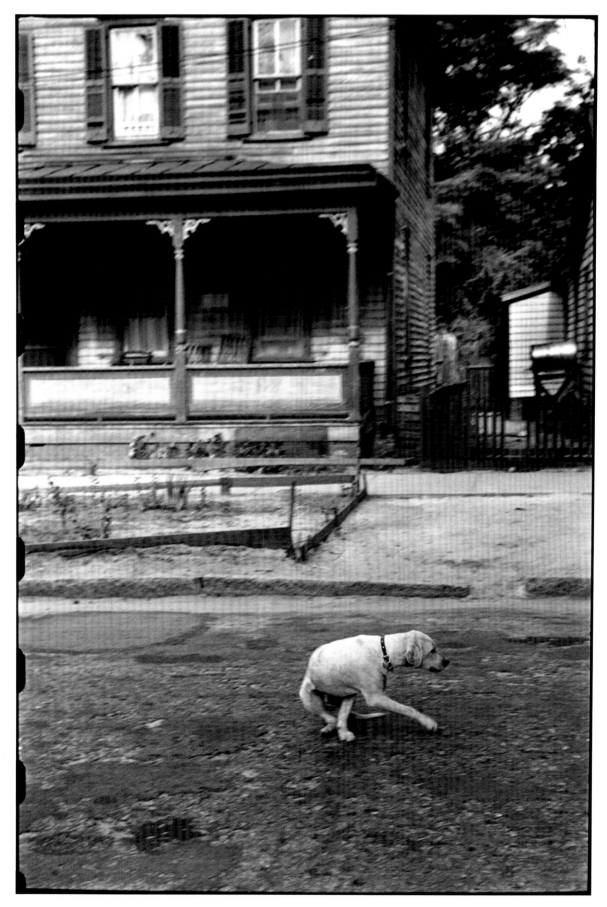

Wilmington, North Carolina, 1950

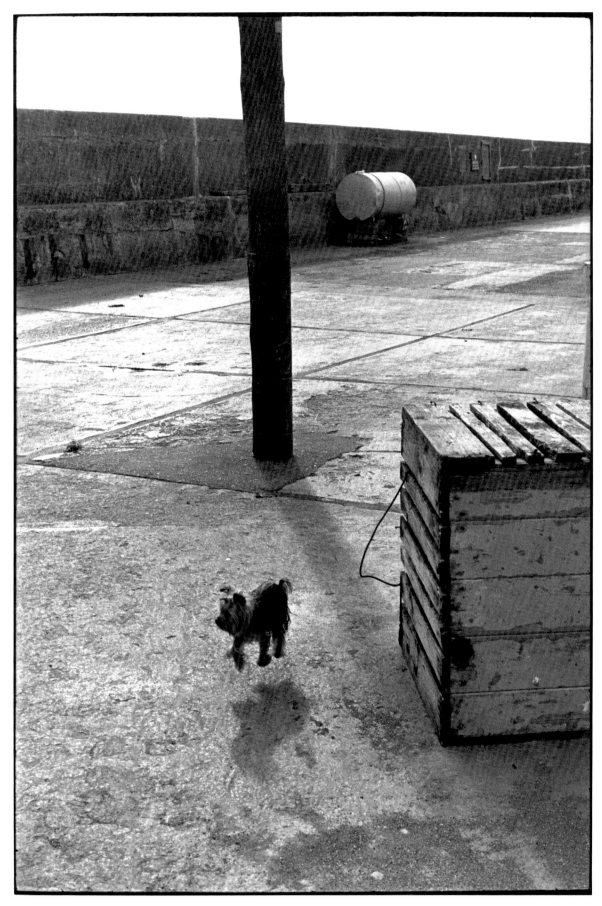

Ballycotton, Eire, 1968

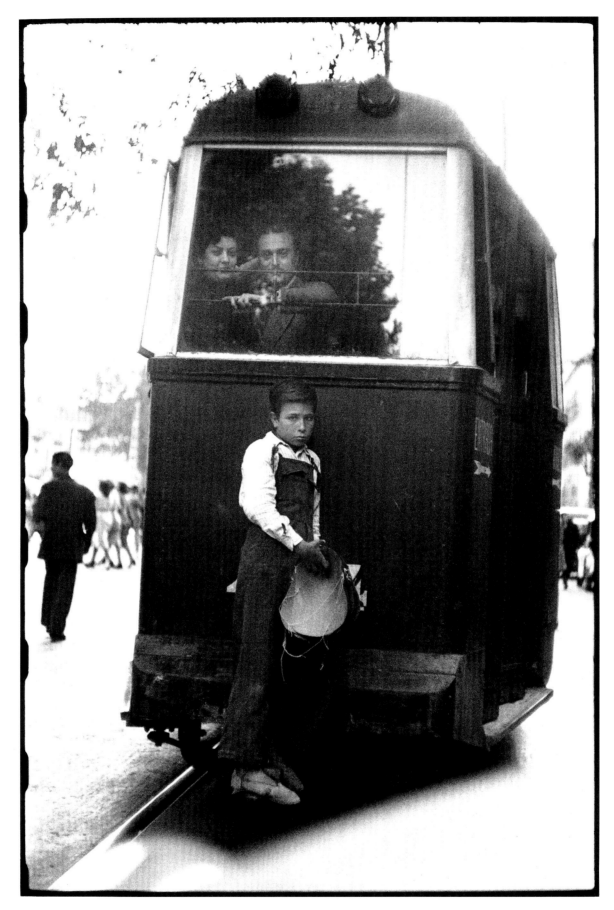

Barcelona, Spain, 1951

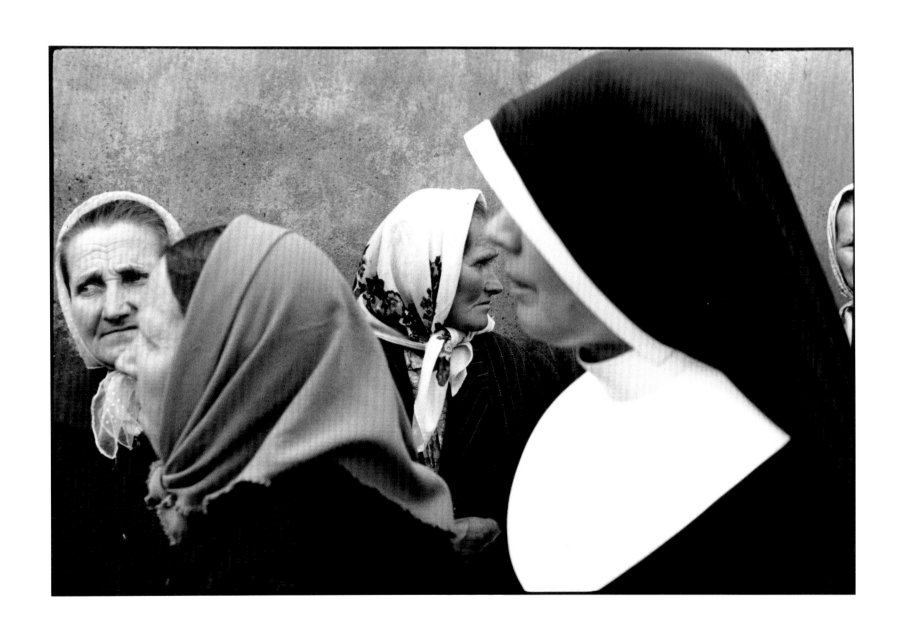

Czestochowa, Poland, 1964

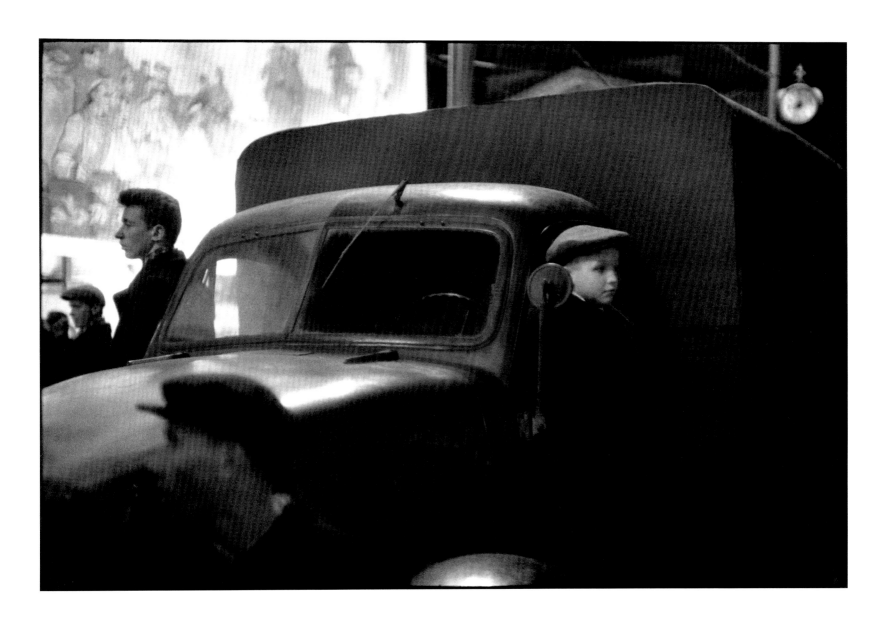

Moscow, 1957

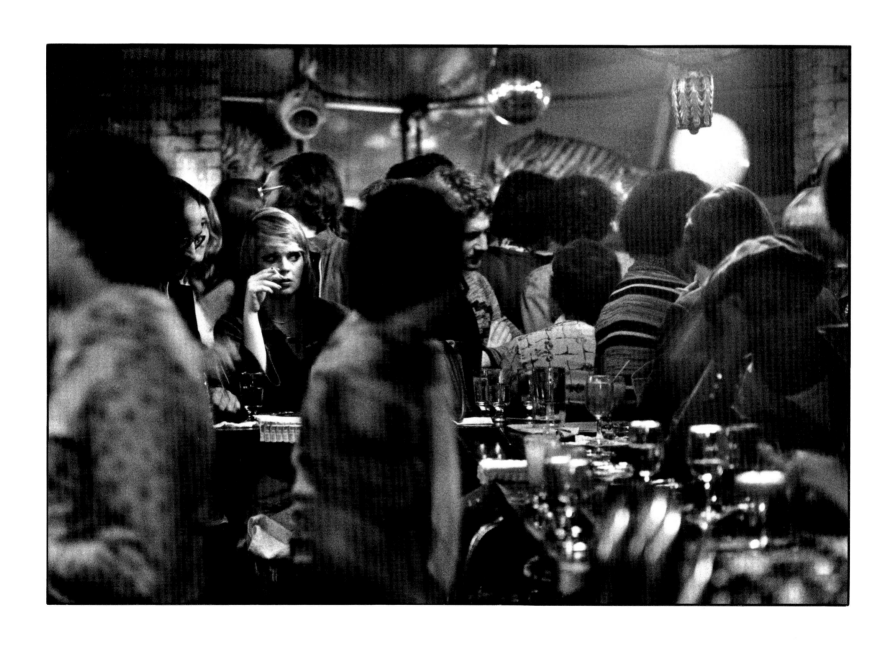

New York City, 1976

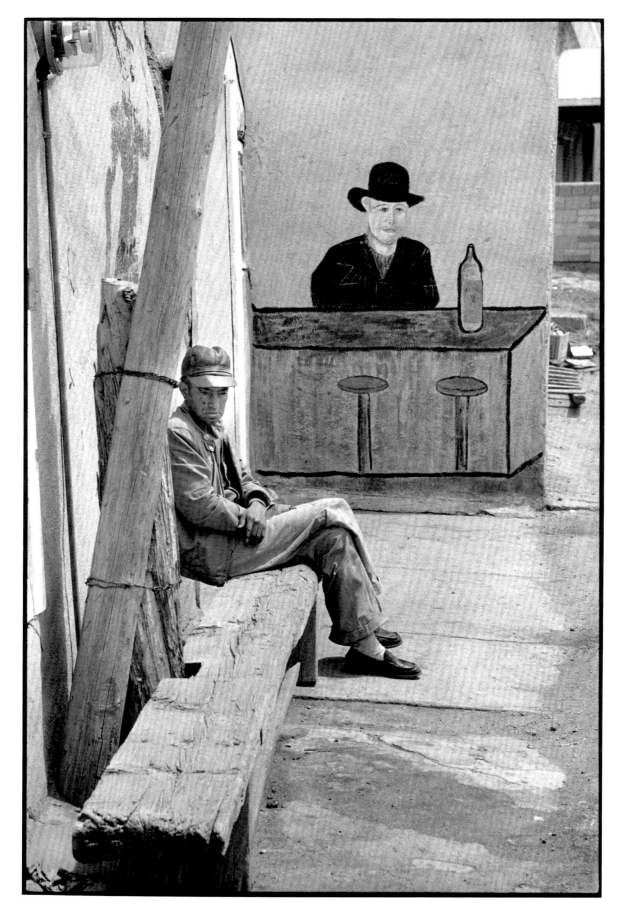

New Mexico, 1962

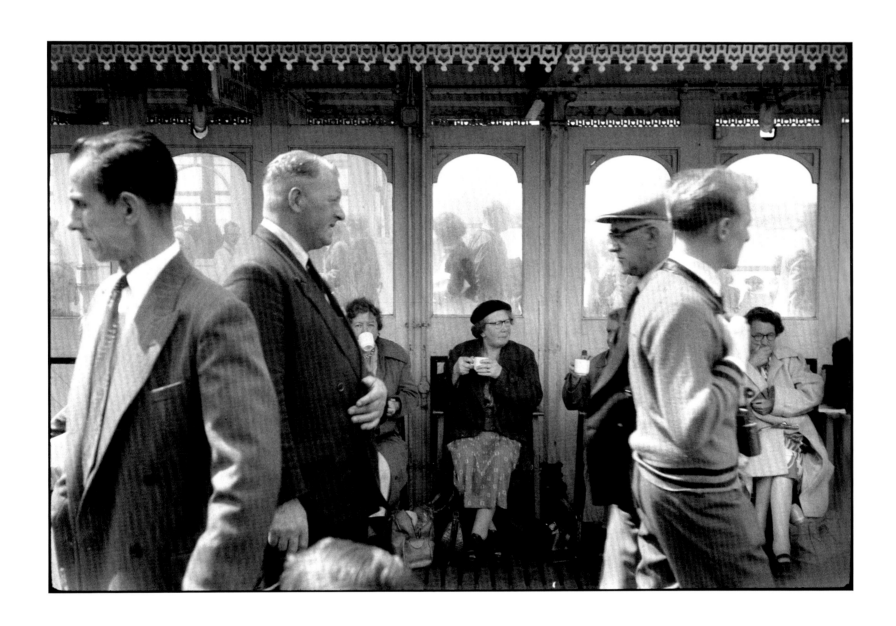

Brighton, England, 1956

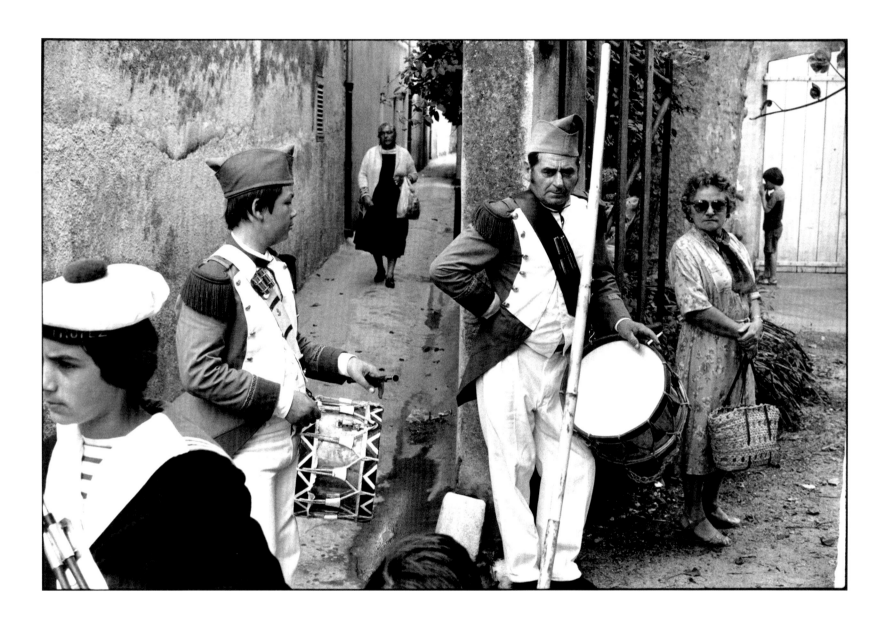

Saint Tropez, 1979

215

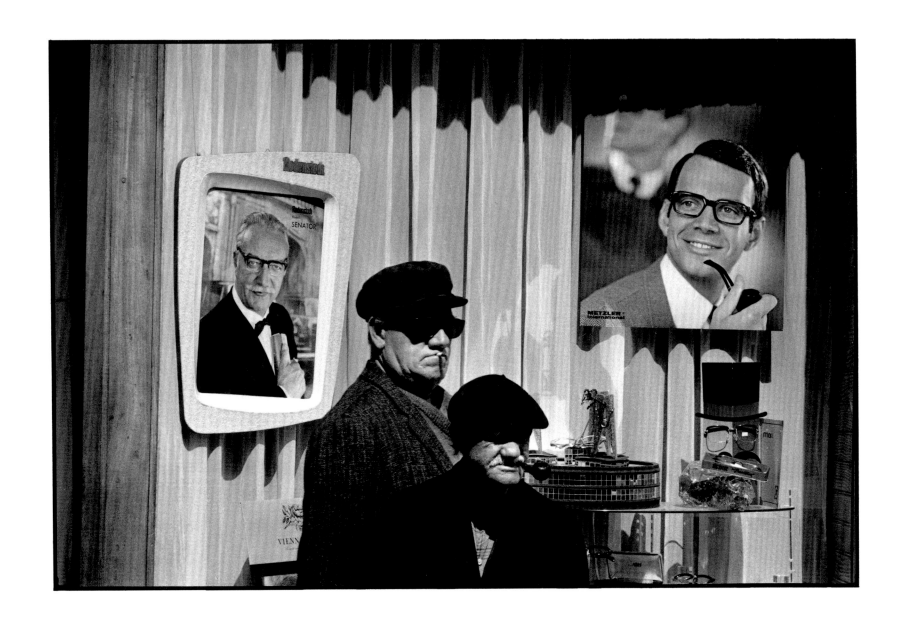

Amsterdam, 1968

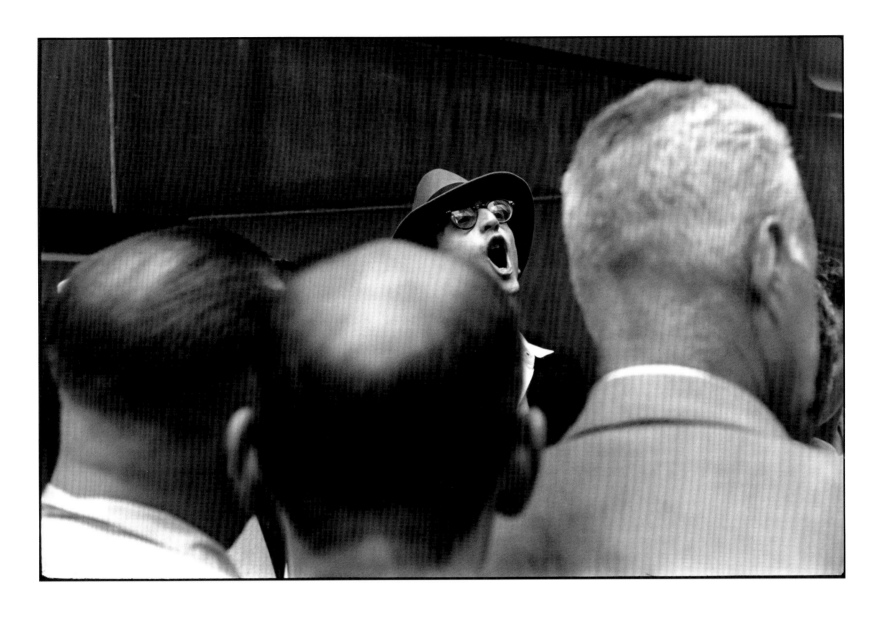

New York City, 1955

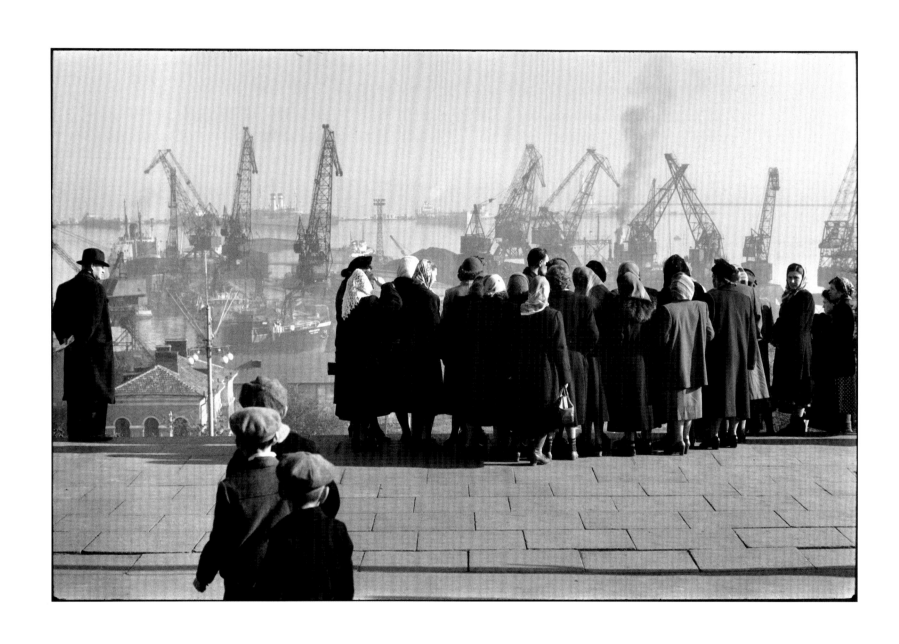

Odessa, U.S.S.R., 1957

218

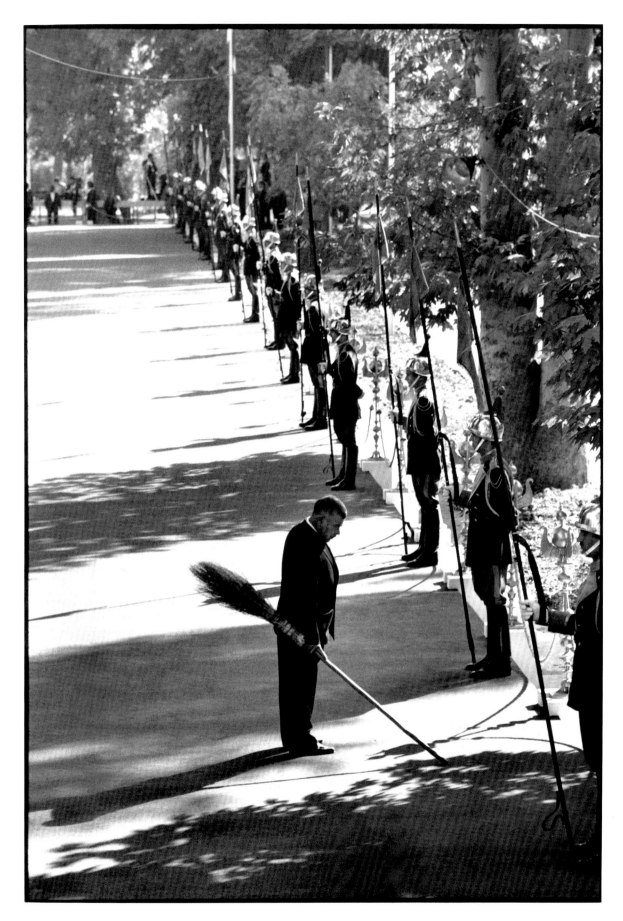

Teheran, Iran, 1967

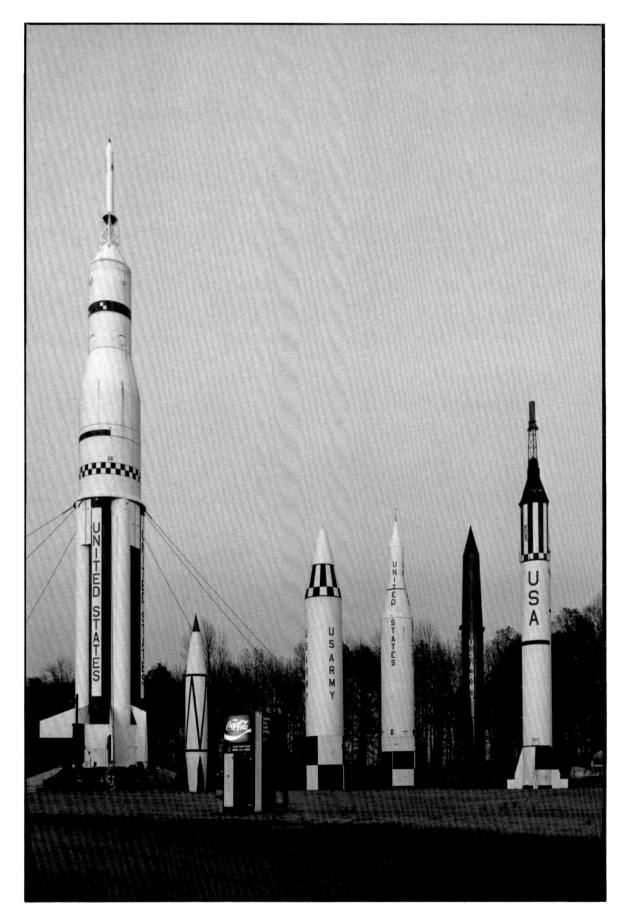

Huntsville, Alabama, 1974

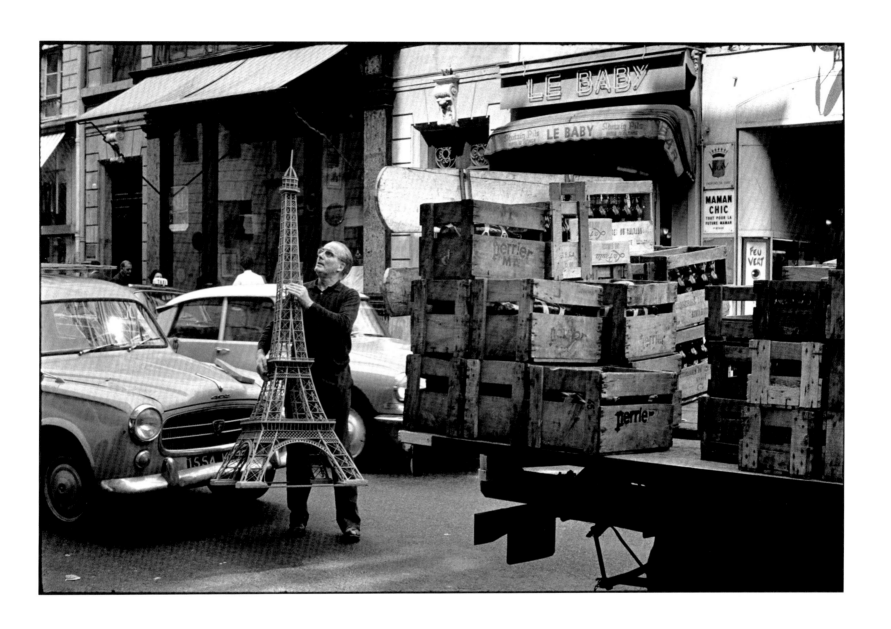

Paris, 1966

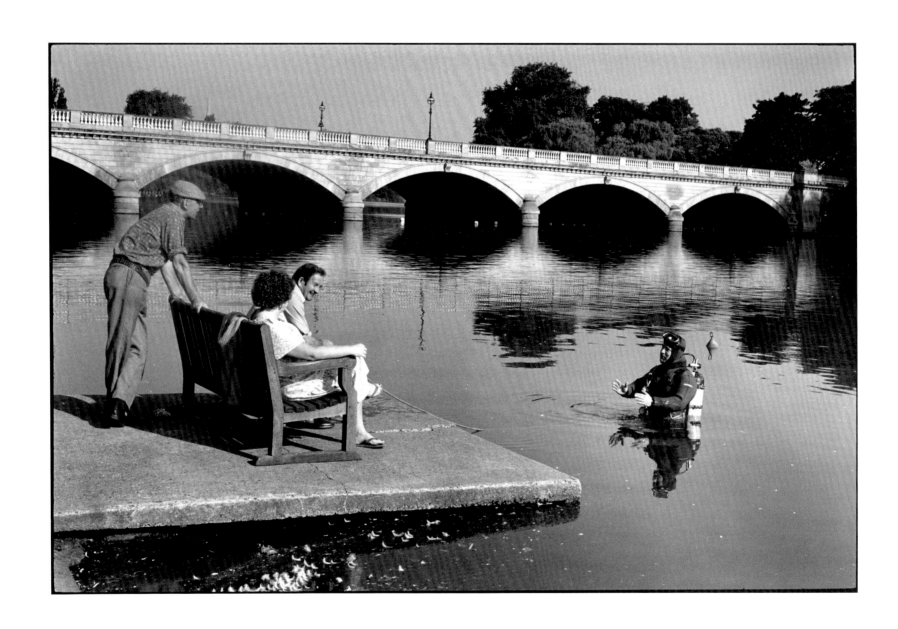

London, 1978

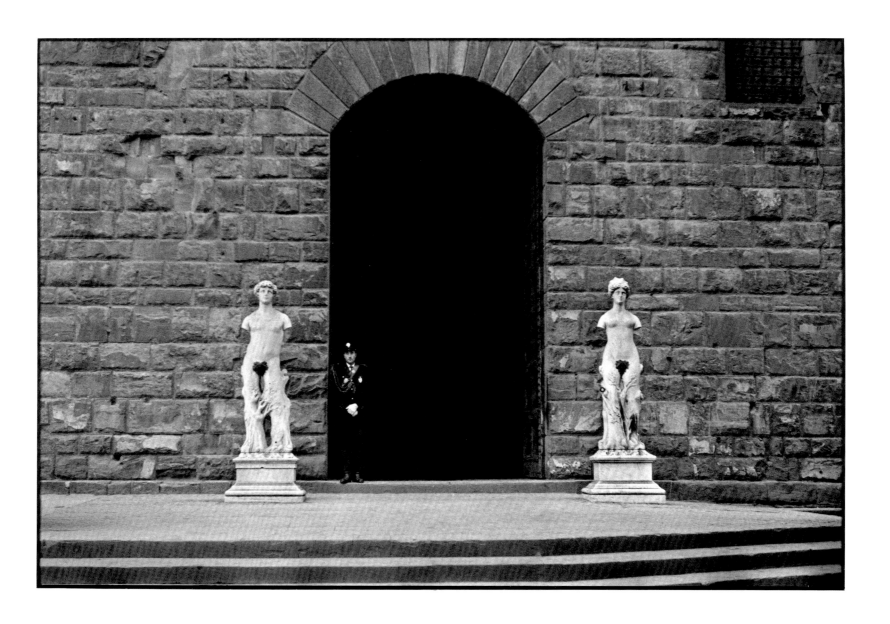

Florence, Italy, 1949

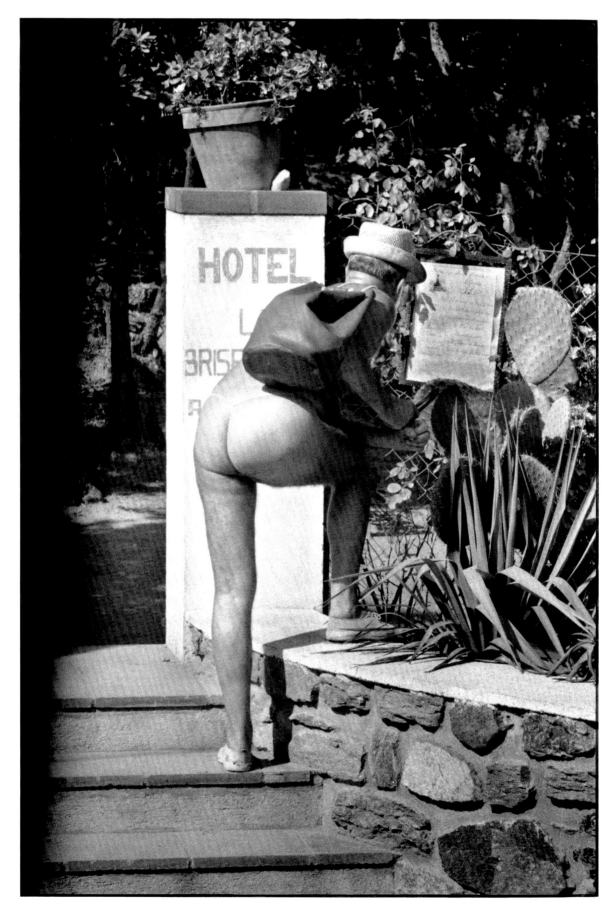

Île du Levant, France, 1968

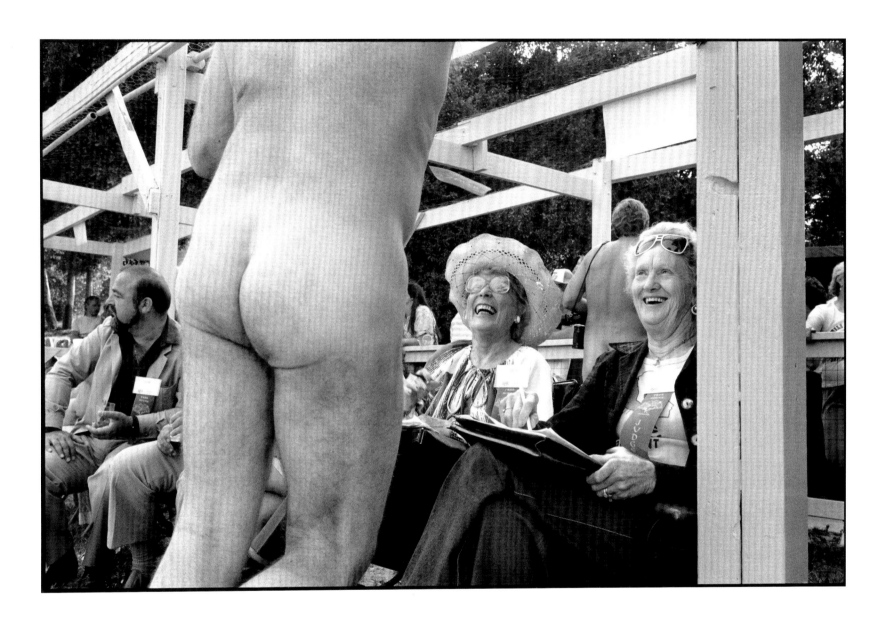

Bakersfield, California, 1983

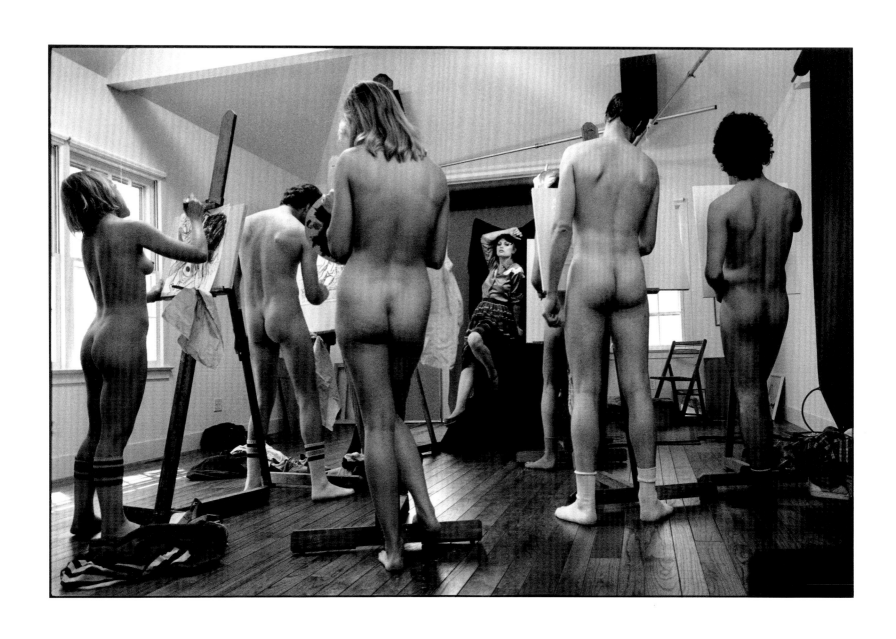

East Hampton, New York, 1983

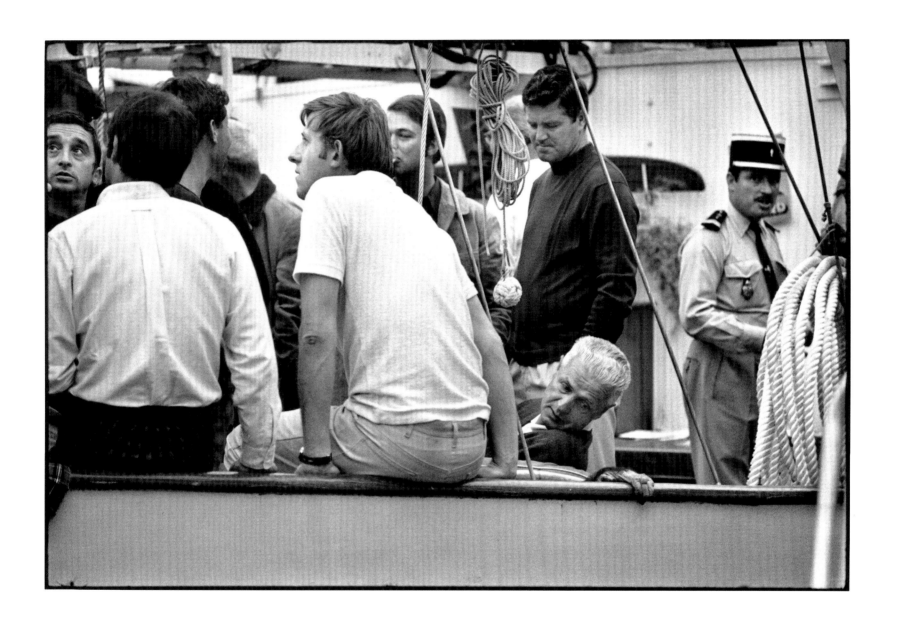

Saint Tropez, 1968

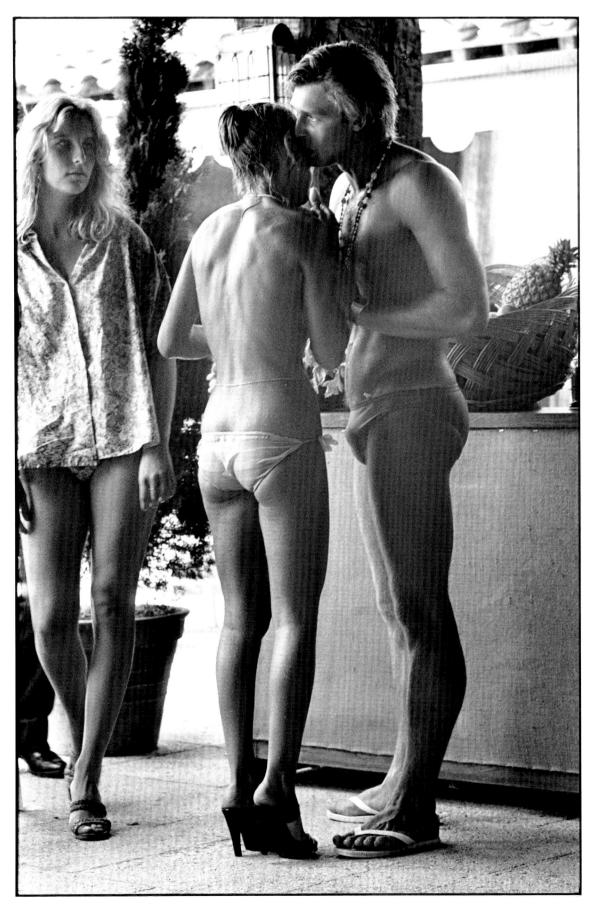

Saint Tropez, 1978

228

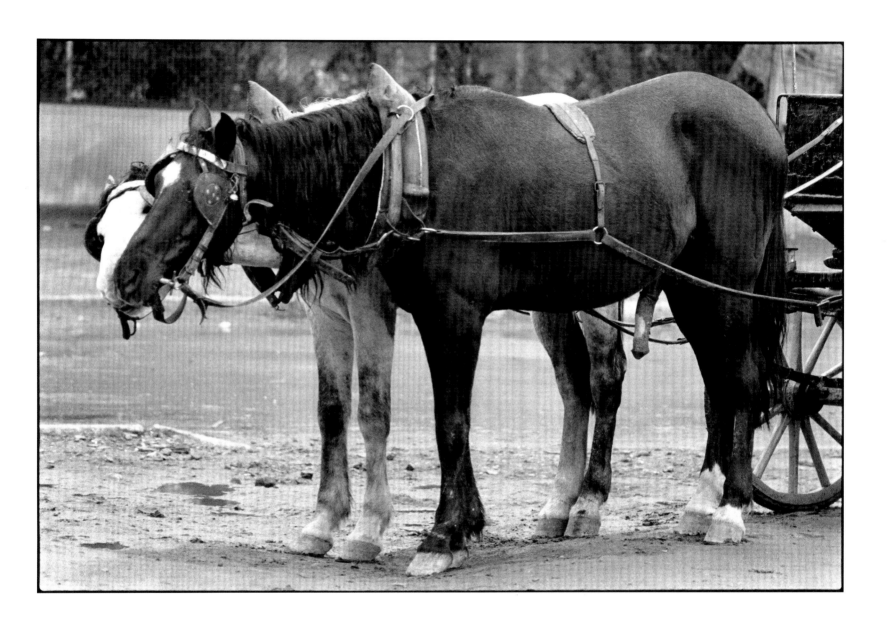

Marrakech, Morocco, 1979

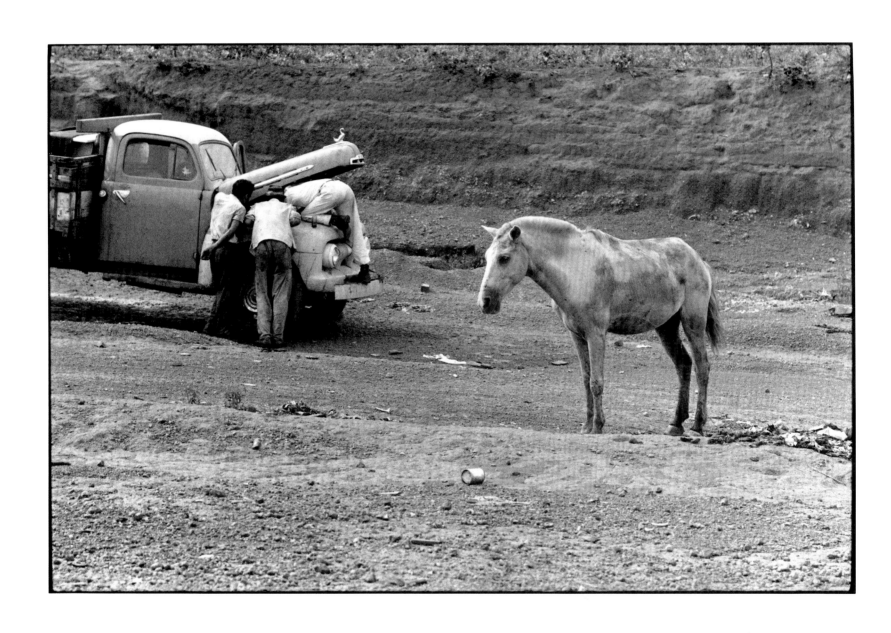

Brasília, 1961

230

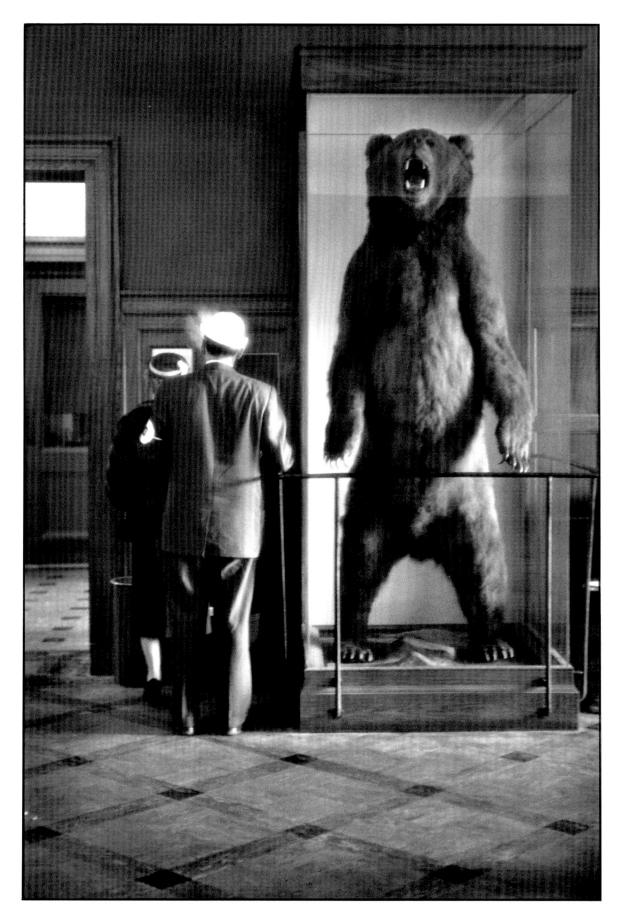

Providence, Rhode Island, 1955

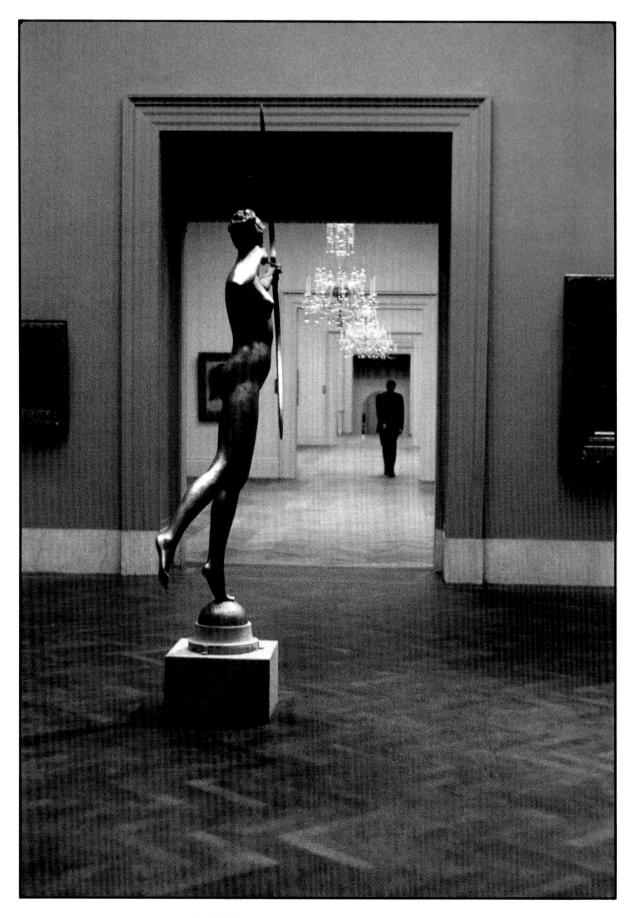

New York City, 1949

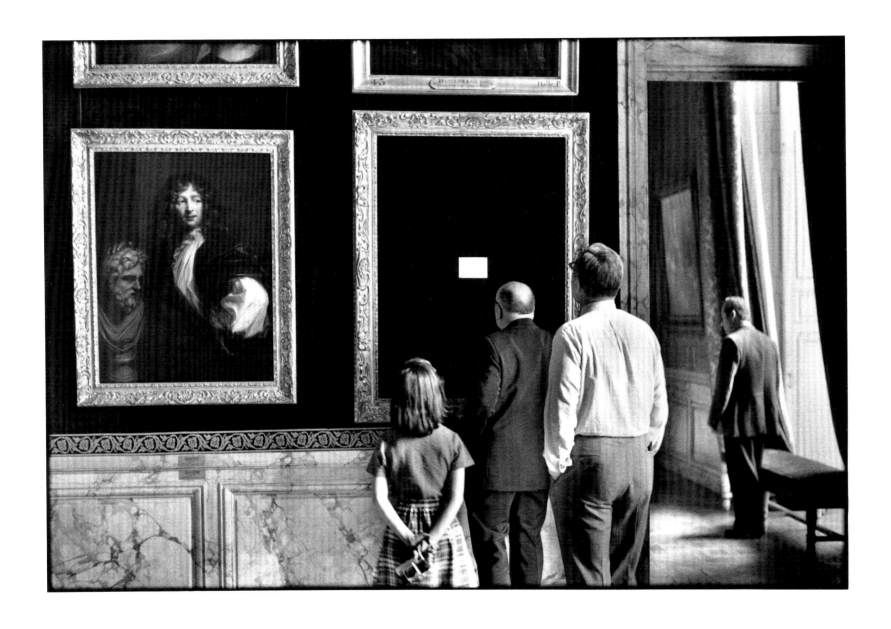

Versailles, France, 1975

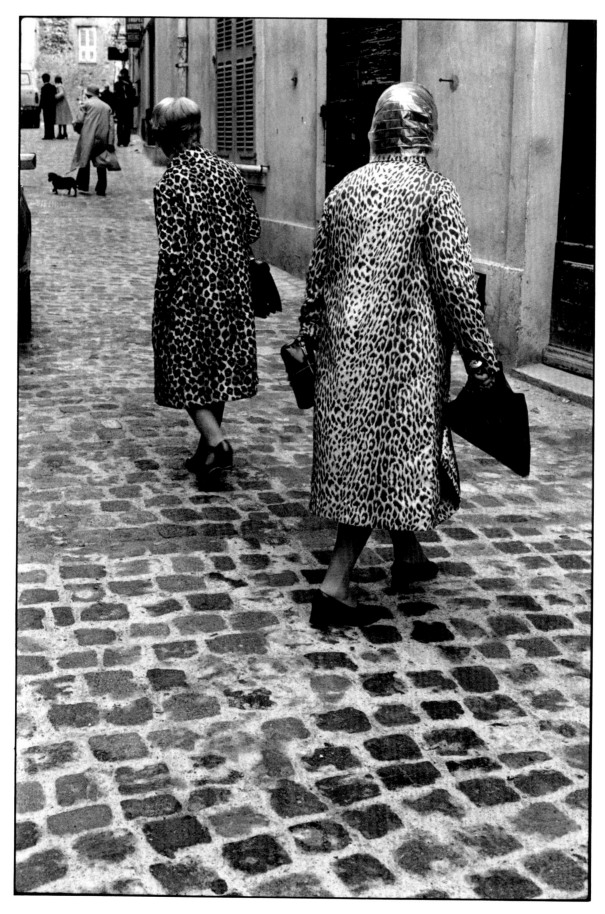

Saint Tropez, 1979

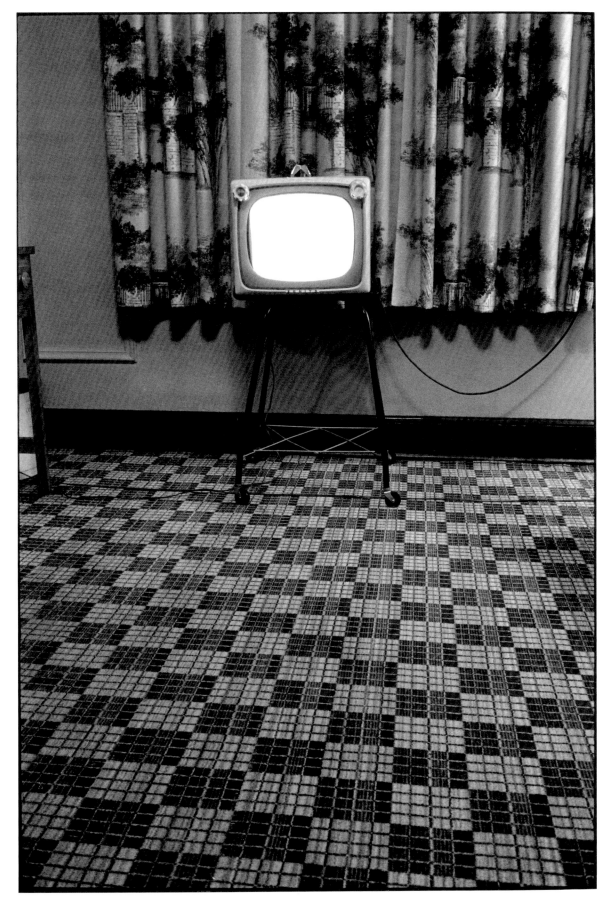

Texas, 1962

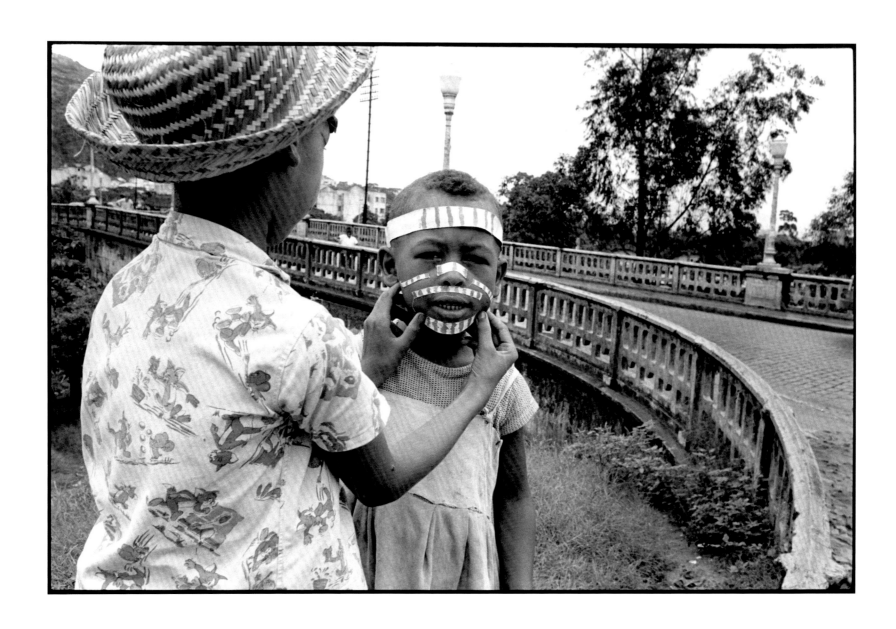

Rio de Janeiro, 1961

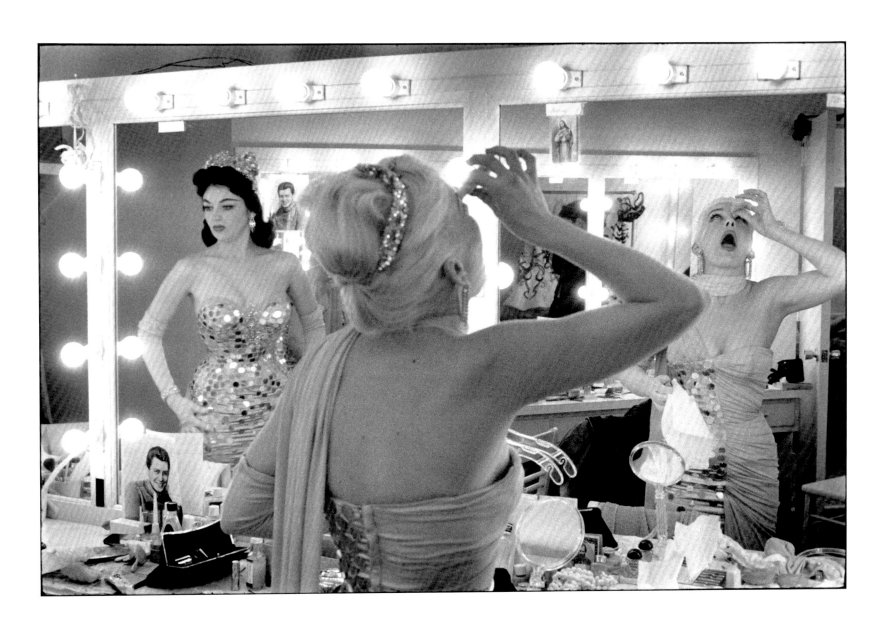

Las Vegas, Nevada, 1957

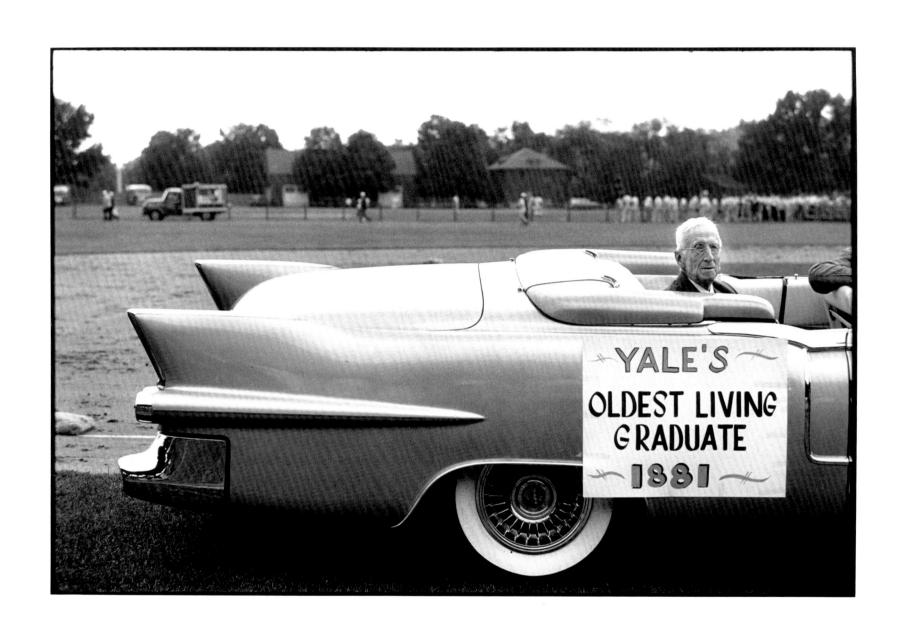

New Haven, Connecticut, 1955

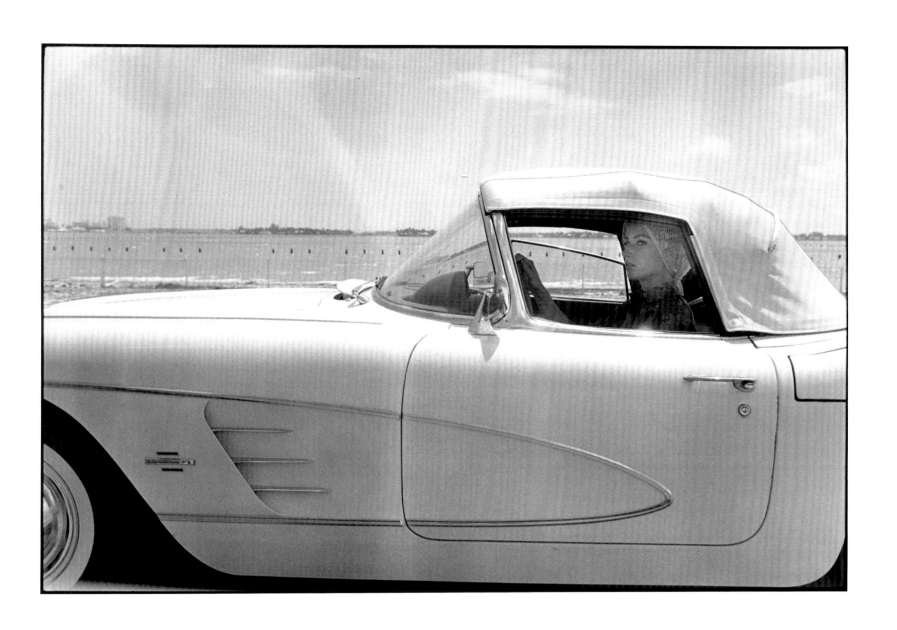

Fort Lauderdale, Florida, 1962

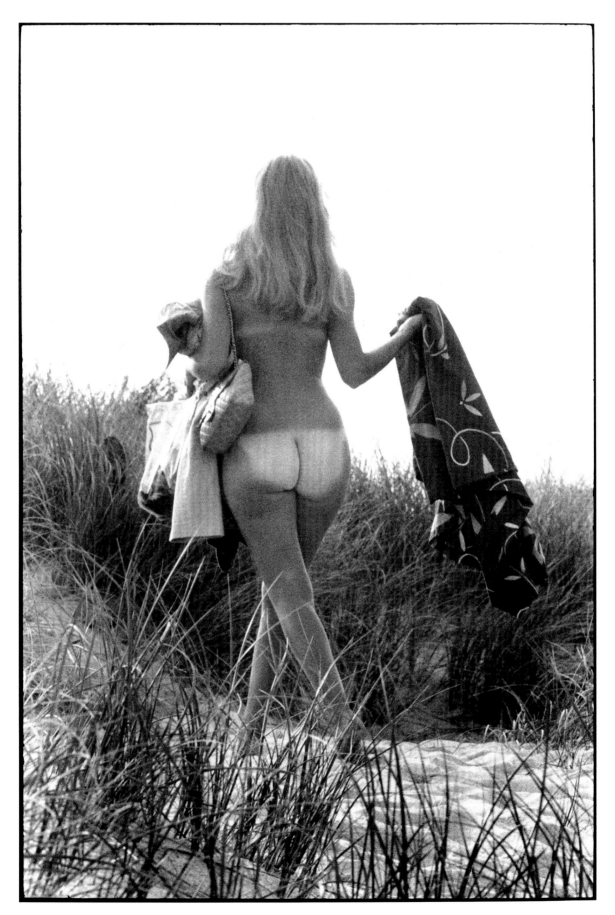

Sylt, West Germany, 1968

240

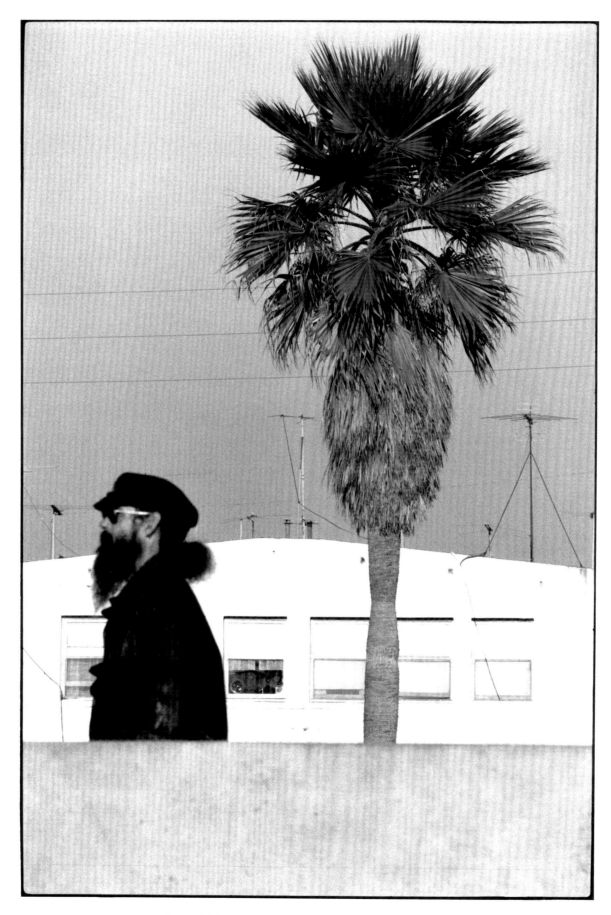

Venice, California, 1976

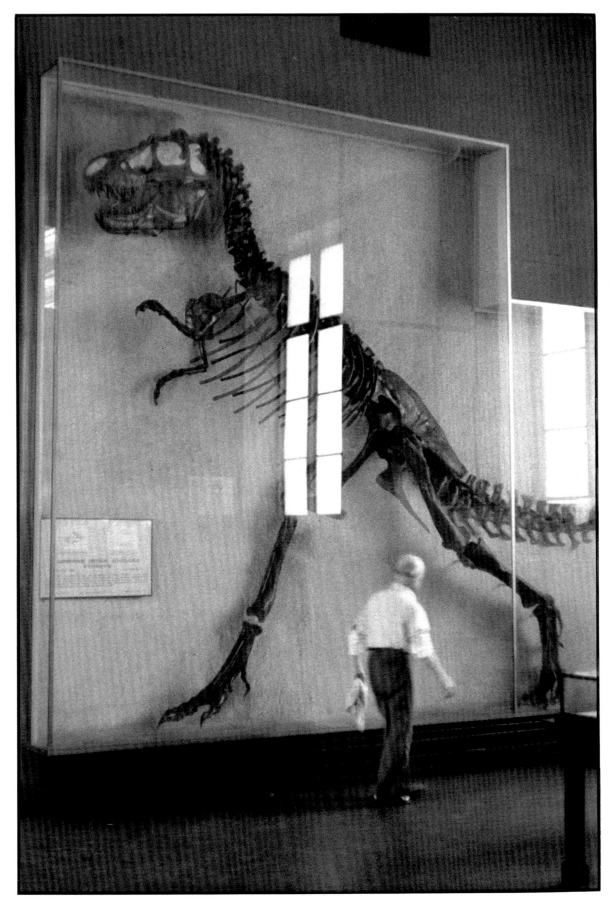

New York City, 1953

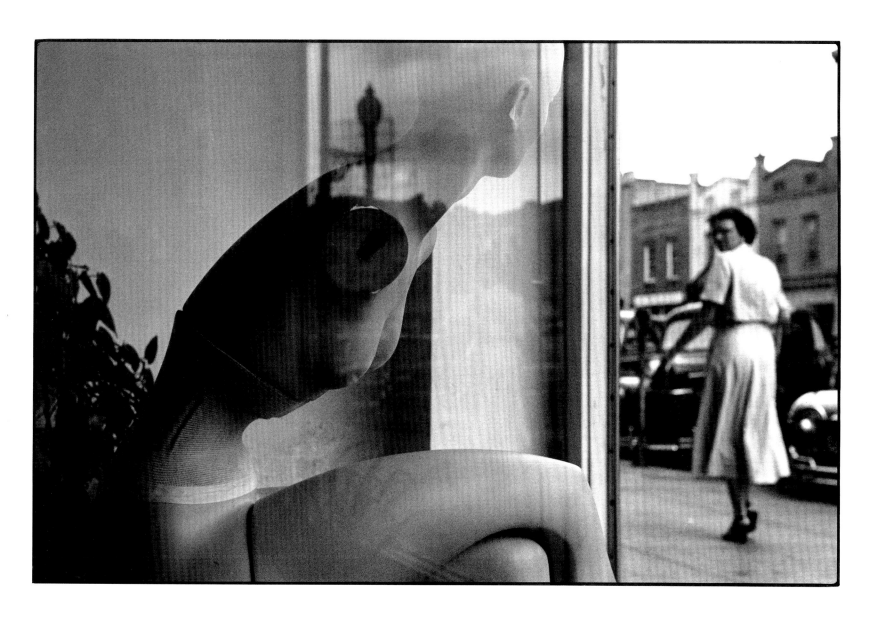

Wilmington, North Carolina, 1950

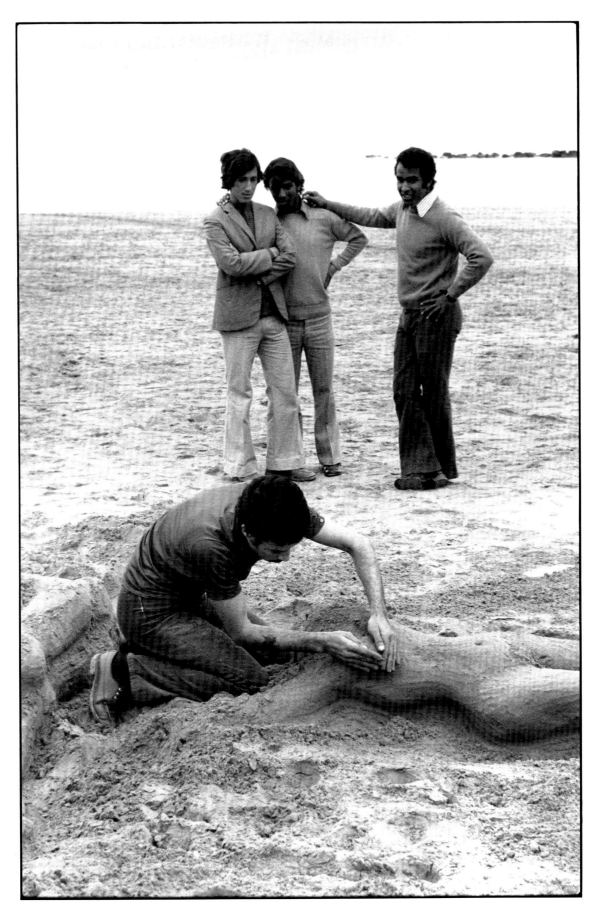

Agadir, Morocco, 1973

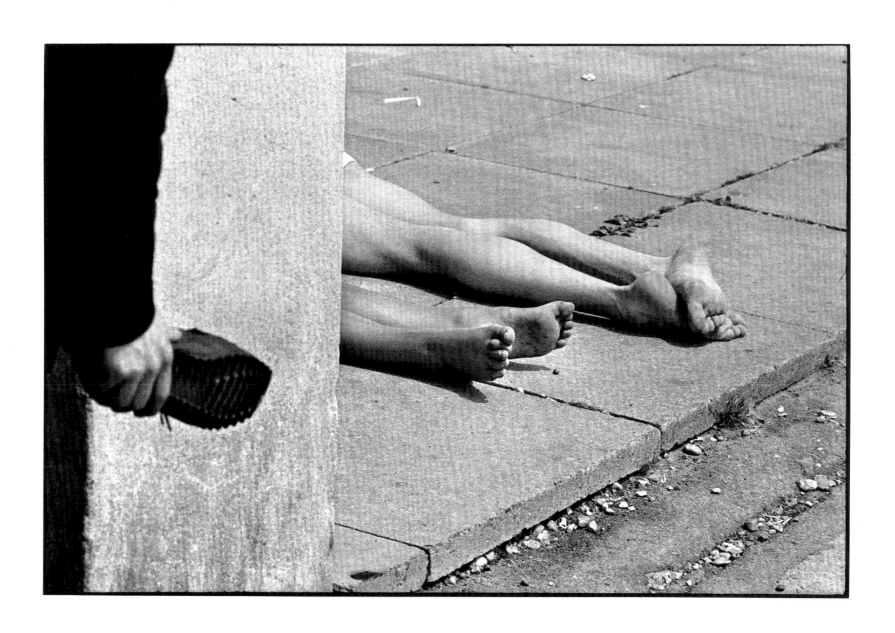

Brighton, England, 1970

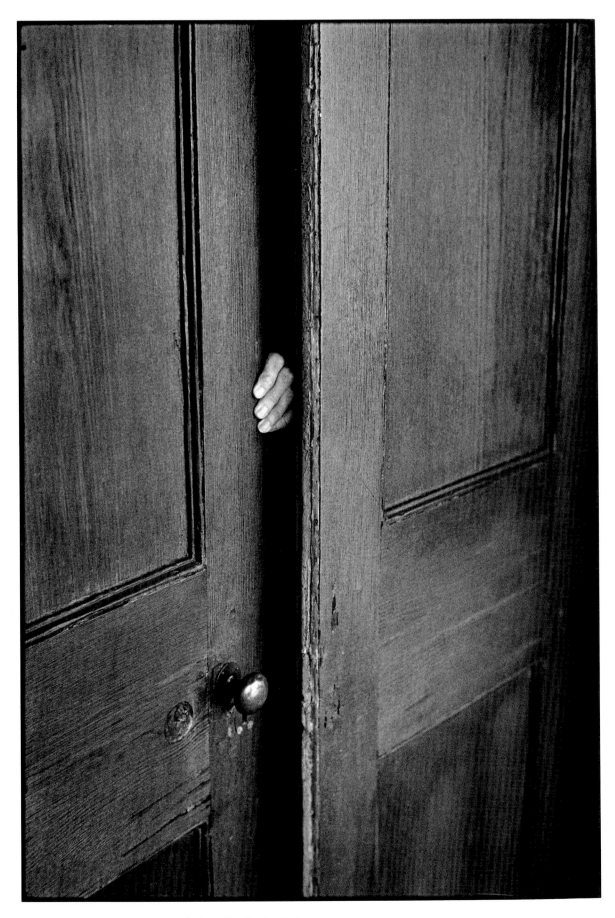

Jacksonville, Florida, 1968

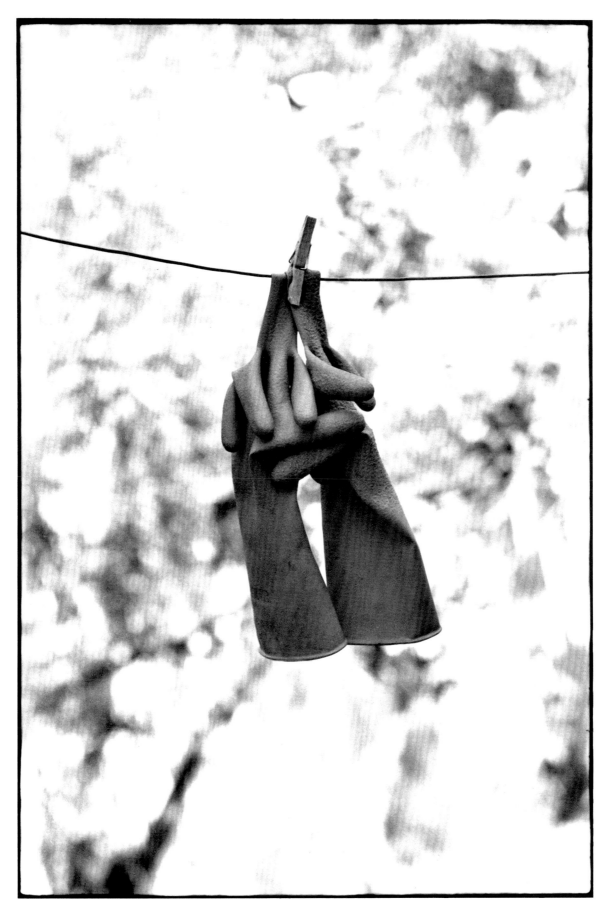

Sicily, 1965

247

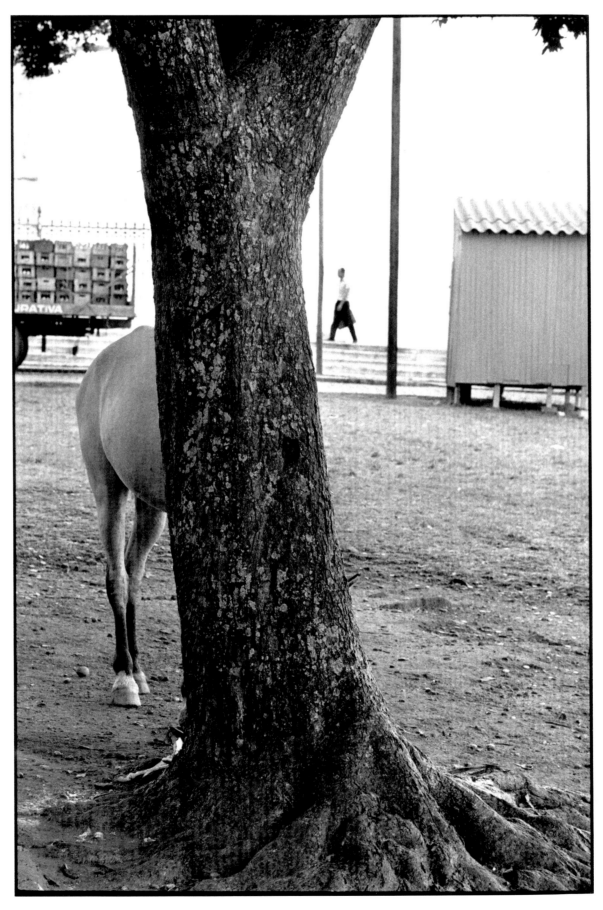

Bahia, Brazil, 1963

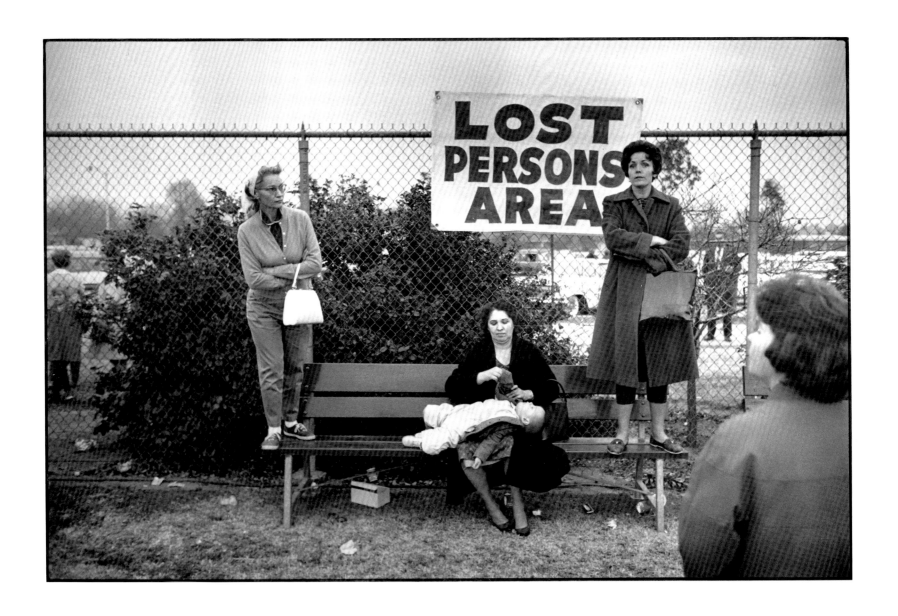

Pasadena, California, 1963

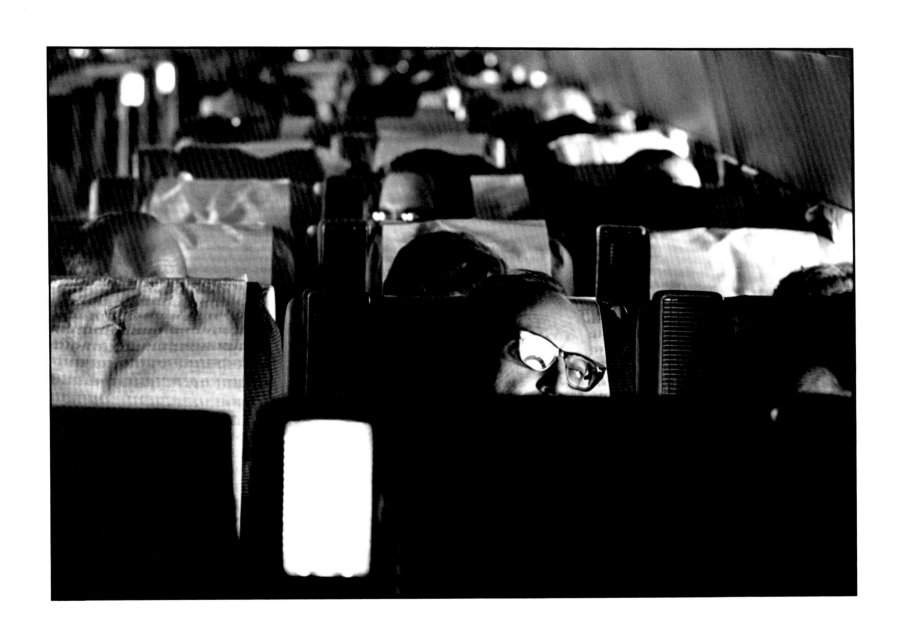

Frankfurt, West Germany, 1968

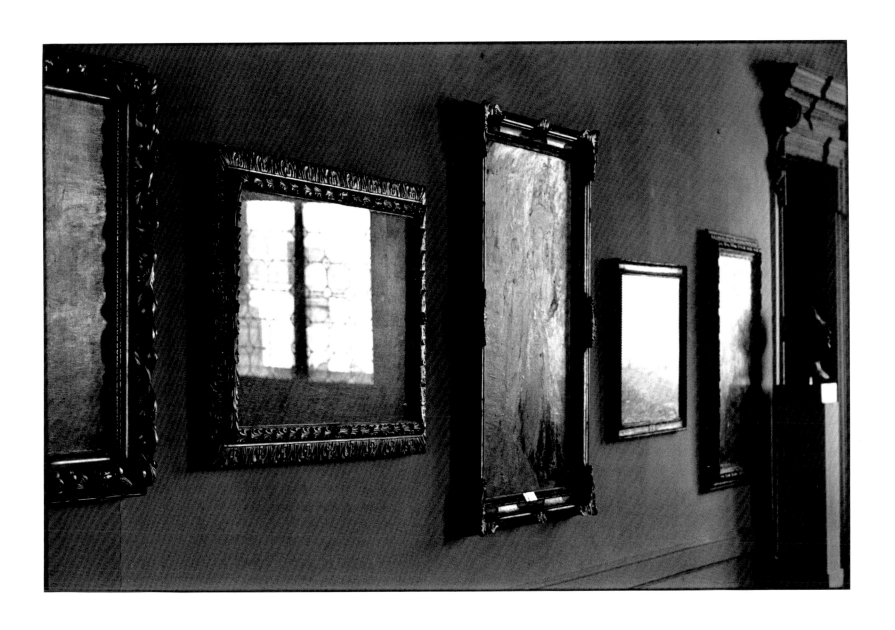

Venice, Italy, 1965

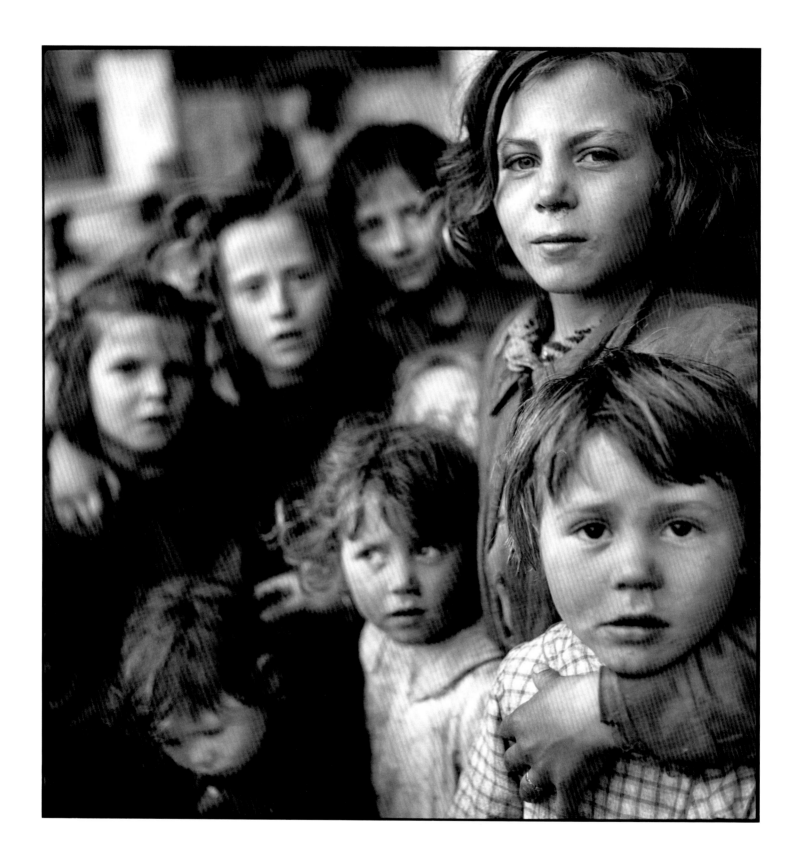

Venice, Italy, 1949

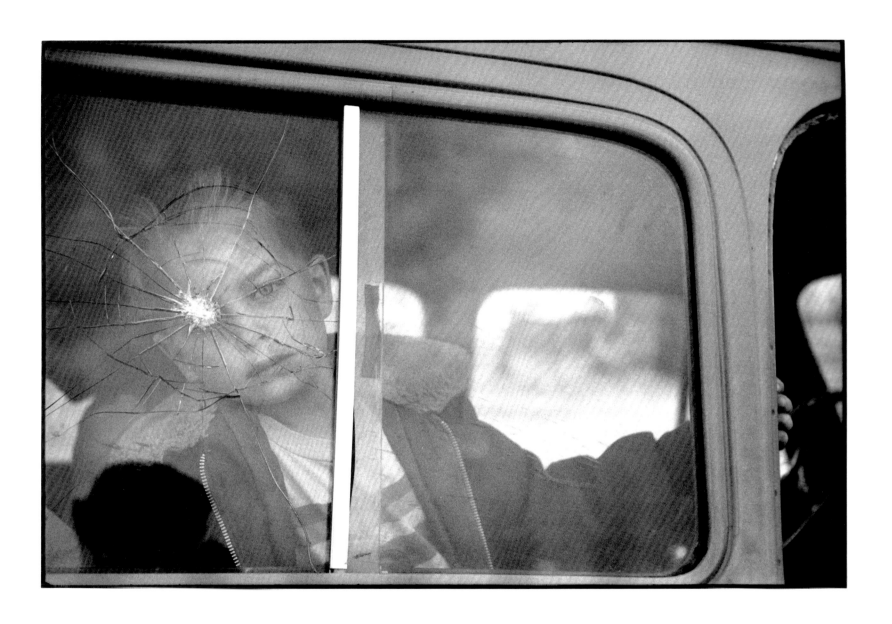

Colorado, 1955

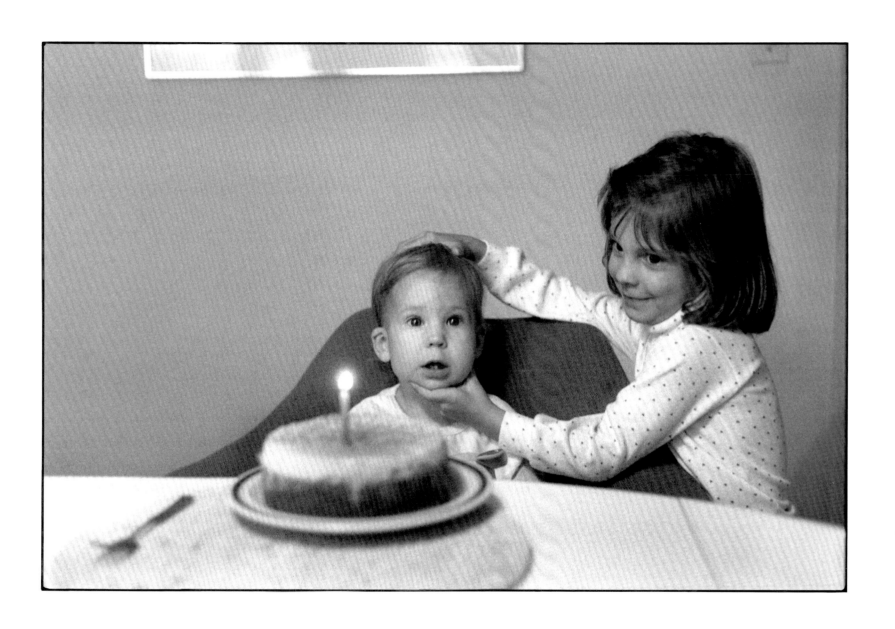

East Hampton, New York, 1981